D0266558

To Jeremy Gardos and the new generation of Torontonians.
— *George Fischer*

For Max and Simone – Torontonians both.
— *Jacob Richler*

Copyright © George Fischer and Jacob Richler, 2013

All rights reserved. No portion of this book may be reproduced or used in any manner whatsoever including graphically, electronically, mechanically or through recording or data storage systems without the prior written permission of the publisher or, in the case of photocopying or other reprography techniques, without the permission of Access Copyright, 1 Yonge Street, Suite 1900, Toronto, Ontario M5E 1E5.

Nimbus Publishing Limited
P.O. Box 9166
Halifax, NS B3K 5MB
902-455-4286

Printed in China

Graphics: Catharine Barker, National Graphics, Toronto, ON

Library and Archives Canada Cataloguing in Publication

Fischer, George, 1954-

 Toronto / George Fischer, Jacob Richler.

ISBN 978-1-55109-980-4

 1. Toronto (Ont.)--Pictorial works. I. Richler, Jacob II. Title.

FC3097.37.F57 2013 971.3'541050222 C2012-907961-8

Acknowledgments

I am grateful to those who have helped make this book happen: Susan Carnevale of Hicks Morley – *thanks for your great perspective of Toronto;* and Alex Garant – *I appreciate the chance to shoot outside the box.* Thanks very much to my models: Christine Palonek and her patience with me for *one more shot;* Jane King on the humber bridge *for getting up so very early* and Karen Green *at the MOCCA.* I am, once again, sincerely thankful to the people who help make my books a success with their expertise: to Jean Lepage for doing what needs to be done; to Sean Fischer and Ryan Fischer for their photo skills; and to Catharine Barker for her brilliant design.

—George Fischer

Additional Credits

Sean Fischer: photos pages 180, 204, 205
Ryan Fischer: photos pages 192, 197
Catharine Barker: photos pages 8, 56, 79, 96, 186

TORONTO

Photography **George Fischer**

Text **Jacob Richler**

TORONTO
from the perspective of a Montrealer

*A*fter seventeen years in Toronto I still need four more before I can say that I have lived longer here than anywhere else – namely Montreal, where I spent my youth and then some after a four-year start in London. But it does not feel that way to me. Toronto is where my children were born, where my career took shape, where I met my wife, and where my friends live. This is home. I have thought of myself as a Torontonian – and nothing else – for a long time.

All of which is to say that while my perspective on things local will always be informed by my experiences elsewhere they are no longer defined that way. Looking back I am not so sure that they ever were. But seeing Toronto through lenses tinted with Montreal was precisely what was expected of me when I arrived here in 1995. Back then, that ailing metropolis limping towards another referendum was all that anyone seemed to want to know about. I was constantly being asked if I missed the place.

And when I answered in the negative by pointing out the obvious – that I had moved by choice – the questioning invariably continued unabated.

"There must be *something* you miss?"

"OK, the bistros. I miss French bistros."

"Ah - so you don't like the food here?!"

Fortunately it did not take me long to catch on to the early signs of such imminent entrapments. I quickly learned how to defuse them with denials and expressions of local enthusiasm before I could be boxed in. In any event it has been such a long time since anything like this happened to me that I mention it now only for contrast. Because I cannot imagine this sort of thing occurring to new arrivals today – even if they were freshly arrived from, er, "World Class" cities like London or New York. Toronto's inferiority complex has deservedly passed. Certainly, Torontonians no longer spend time thinking about how they measure up to Montreal. I know I don't – in some large part because Toronto is such an improved place from the city to which I arrived nearly twenty years ago. And that is the crux of the matter: Toronto keeps improving, all the time. Or at least it does so if you are willing to exclude considerations of a few inconvenient sore sports – like traffic, the current mayor, and the Toronto Maple Leafs, whose prospects of a twelfth Stanley Cup remain precisely as dim as those of 77-year-old Henri Richard, with whom the team is tied at eleven.

Like most people, though, I did not come to Toronto for the hockey, but rather for work – in my case, a job as an editorial intern at *Saturday Night* magazine, now defunct, but then the best periodical in the country. Our offices were then situated in a non-descript low-rise at the corner of Front and Princess Streets, a block from the *Toronto Sun*. Ken Whyte – who would later launch the *National Post* – had just taken over the editorship from John Fraser, now Master of Massey College. And while it was Whyte who had offered me the job, I still considered myself heavily indebted to Fraser, because in his last year at those offices – just before he

quit smoking – he had convinced proprietor Conrad Black of the need to install a monstrously expensive ventilation system for a "staff" smoking room. In the Montreal I left behind, there were still stand-up ashtrays in bank machine booths, so the smoking room eased my transition considerably. And it was there, while editing a story over a few Gitanes, that I met associate editor Ernest Hillen, author of a splendid memoir of his youth in a Japanese internment camp on Java called *The Way of a Boy*. Hillen was also a veteran of *Weekend* magazine, and thus a member of that last generation of Canadian journalists who had earned their chops in

Montreal in the 1970s, its last decade as a national media hub.

"Tell me," he said, when we first got to chatting, "do journalists in Montreal still meet for drinks at the end of the workday?"

"And during," I assured him. Then, unsure whether my comment really provoked a wistful look or I was just projecting, I suggested that we repair across the street for a quickie. And thus was born our occasional tradition of having afternoon drinks at the nearby Montreal Bistro – a frightful place, that spoke nothing of Montreal – where we reminisced about how journalists met for afternoon drinks in Montreal. Embarrassingly, the irony escaped me.

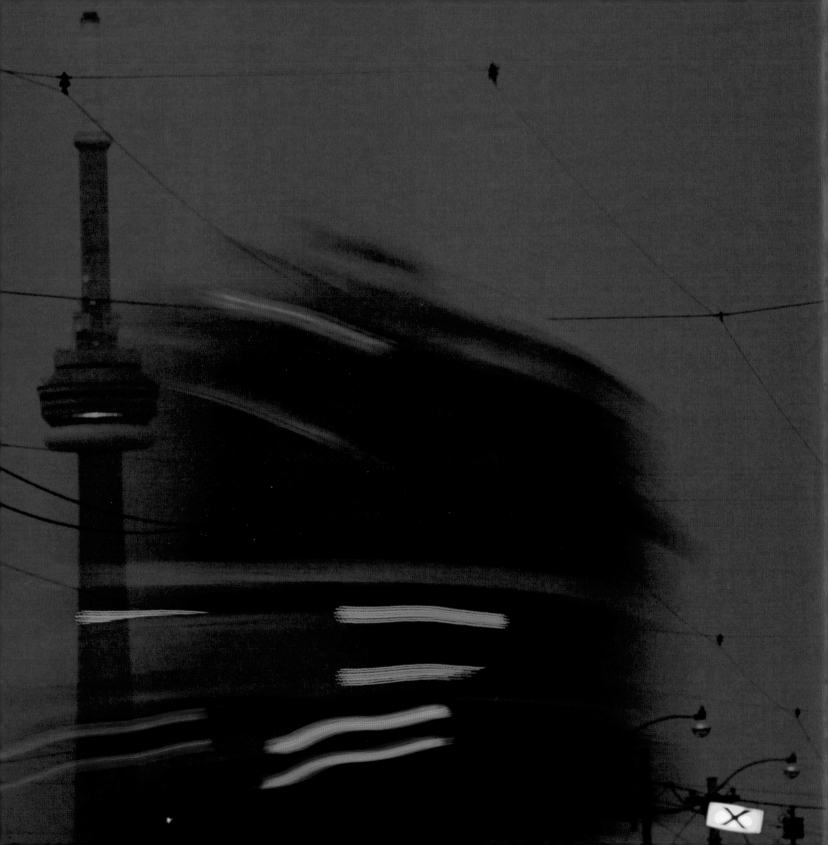

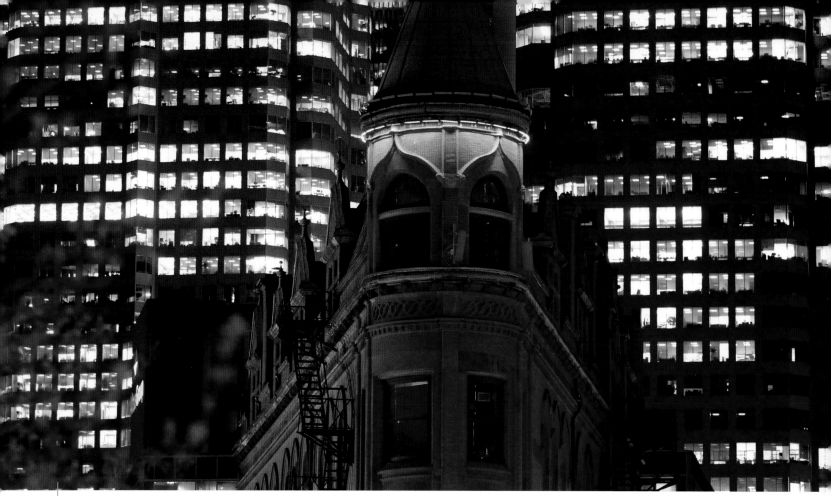

OLD AND NEW: Flatiron and skyscraper

At the time I lived in a seedy high rise on Bloor Street East, at Huntley. So my walk to work and back took me the length of Sherbourne Street, from Bloor to Front, and in those early days of Mike Harris's Common Sense Revolution, with all the local rooming houses being emptied to save cash, the experience was something else. The combination of all those grand, century old residences in such an alarming state of disrepair, with all the mad homeless people, streetwalkers, and gutters strewn with detritus of urban depravity (needles, condoms, Big Mac wrappers, etc.) gave me a big city charge that I found energizing. Okay,

it was sometimes depressing, too. All things considered I preferred my walks at midday; for while the commercial street fronts of so much of Toronto possess a numbing sameness, the stretch of King Street East that led from my office to the bookshops, newsagents, sandwich shops, and taverns of the downtown core was the prettiest I knew.

The intersection of King and Sherbourne itself was – and remains – unremarkable. But head west and the facades improve steadily. The most striking building on the stretch is easily St. Lawrence Hall, a renaissance revival building erected in 1850 to serve the old city as its premier meeting place and concert

hall. Across King Street is St. James Park, probably downtown's prettiest, with its charming fountain and gazebo and all those lovely flower beds tended by the Garden Club of Toronto. Lovely St. James Cathedral looms gracefully in the background. Usually I would next head south, past the latest whimsical installation in the Toronto Sculpture Garden, past the Gooderham Building, which everyone calls the Flatiron, and down to Front Street. There I would collect a magazine or two at one of the local newsagents, browse at my preferred Toronto bookshop – the lovely Montreal import Nicholas Hoare – and then it was back to the

THE TOWER AND THE ROCKET
Twin symbols of the city

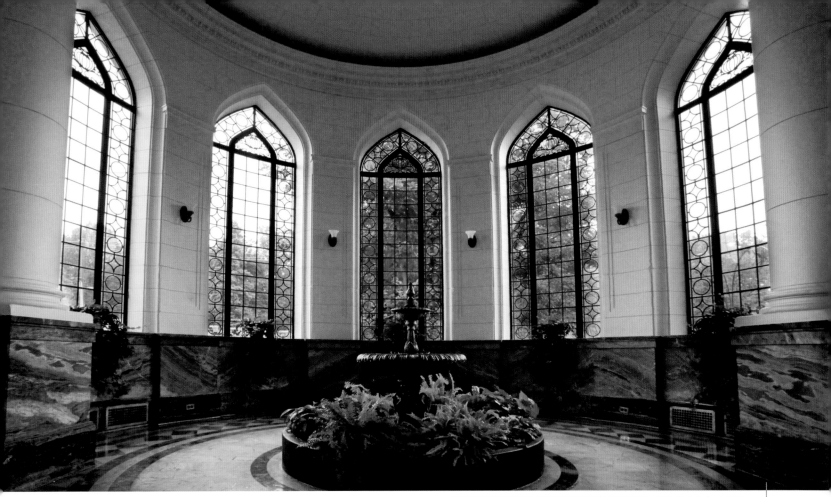

office with a sandwich from Mövenpick Marché or St. Lawrence market.

A decade after I finished working in the area I am still drawn back to that picturesque stretch of town, probably because it satisfies this ex-Montrealer's need for a glimpse of an old building now and then. I bank at the RBC branch in St. Lawrence Hall, even though they have other branches much nearer to my home. I mail things from the post office at Adelaide near Frederick, built in 1834 to service the new Town of York, because the trek there is nothing compared to the horror of the fluorescent glare of the impersonal Canada Post counter of my local Shoppers

Drug Mart (okay, the lack of a queue does not hurt, either). And I buy a lot of food at St. Lawrence market, drawn by its quirky charm even when I could buy the same thing more conveniently elsewhere.

When I want to go to a pub, I still consider my local to be P.J. O'Brien's, on Colborne Lane at the eastern flank of the King Edward hotel – not just because it is a hugely engaging cornerstone of Irish life in Toronto, but because it is built authentically on a street corner, as pubs are invariably built in the UK. (The street corner in question, with venerable Tom Jones steakhouse to one side and the King Edward at the other, is

pleasantly anomalous by dint of old age and lack of height, amidst all the neighbouring shiny skyscrapers). If I want to eat oysters, I head to Starfish Oyster Bed & Grill – the country's finest oyster bar, immeasurably superior by virtue of selection and presentation to anything on offer in Montreal (which for decades somehow scraped by on the very modest virtues of Chez Delmo, in Old Montreal). Through a large picture window Starfish looks south over St. James Park, from Adelaide Street – and while that vantage of its curving paths and hilltop gazebo is never more splendid than on a clear, blue-skied summer day, my

THE GRACEFUL LANDSCAPING OF CENTRE ISLAND

preference is for those drab days when the park is only sparsely populated, rain is pelting down, and the mist is moving in. Oysters and chowder are enhanced by the chilly, damp gloom, with the fog moving in and eclipsing parts of the trees.

Parks are everywhere in Toronto. Growing up I thought that Montreal was blessed with a surplus of them – and then eventually I worked out that the prosperous suburb of Westmount where I grew up and went to school was maybe not so representative. In the bigger picture it turns out that the city of Montreal has just 1.2 hectares of green space per 1000 residents, while Toronto has nearly

triple that, at 3.24 hectares per 1000 residents. That makes parks blissfully unavoidable here. Sure, we do not have a Frederick Law Olmstead number like Mount Royal, with its rolling topography and glorious vantage on the city below. But I do love a long walk in the grand expanse of Sunnybrook Park – which represents 60 of Toronto's 1473 hectares of green space. There, at daybreak, while my wife takes to Sunnybrook Stables for her morning riding lesson, I sometimes take our dog Bonkers for a trek along the winding paths and burbling streams, and marvel at the racket the birds get up to.

Meanwhile, we live on a park – in Cabbagetown, where our house sits nestled between the southern end of Wellesley Park and the Necropolis, Toronto's oldest cemetery, home to the remains of George Brown, amongst others. Wellesley Park is small, spanning just a couple of city blocks, but over its yearlong cycle it packs as much of a microcosm of our city life as does any place. Early morning belongs to dog walkers and joggers, who in the winter evolve to cross-country skiers. Spring brings the forsythia festival, and a concomitant racket of street vendors and shrieking kids. Municipal cutbacks have long ago left the

ball court untended, the grass unseeded and the wading pool is often inexplicably dry. But no matter. As the season warms up, the sandlot playground fenced off behind Terry's Gate at its northern tip fills up by mid-morning on every sunny day, the kids screaming and laughing tirelessly while their mothers read in the shade on the sidelines. At night, the forgotten Tonka toys fill the place like an airport parking lot. Then South Asians gather for barbecues under the trees, and aromas of spice and charcoal smoke waft on the breeze. They leave a mess, alas – but nothing so alarming as the bloody clumps of fur and bone that fall from the nest of Cooper's hawks at the foot of the park.

The high street – Parliament Street – is another world, five minutes away. The northern end still belongs to South Asian grocers, with dodgy fish markets tucked into the back peddling shark steaks, and bags of goat meat sitting on the counter by the cash – and the freshest, sweetest, cheapest Alphonso mangoes you can find outside of Little India. At the corner of Amelia we recently acquired a trendily ambitious Italian restaurant with a *de rigueur* wood-burning oven. Across the street, there remains a Pizza Pizza, and many other businesses from the shabby past linger on – like a hair salon called Bond, for which the sign mistakenly reads "Bond Saloon." By and large the face of things is changing: the last few years have brought all sorts of trendy new businesses to service the prosperous new local residents busily renovating the old local Victorians. We now have an organics shop, designer eyeglass frames boutique, a "gourmet" burger counter, two sushi bars, and an izakaya. Looking back, the turning point was surely – as usual – the arrival of Starbucks.

I have seen all this unfold here before – on Queen West West, where in the late 90s I bought my first Toronto house, on Beaconsfield Avenue. There, out of the blue, the crackhouse nightclub called Stardust at the foot of our street was suddenly shuttered and gutted and reborn as the (new) Drake Hotel, a development that single-handedly spawned a trendy neighbourhood. To the west, a makeover of the ratty Gladstone Hotel followed. Then trendy restaurants sprouted up one after another, all the way to Parkdale. The trendy Queen Street West that once had a western boundary at Trinity Bellwoods Park joined from the east, with art galleries filling in the void – and for the clincher, at the corner of Claremont, the local goth bar Sanctuary gave way to that customary signal change – Starbucks.

Making a long list of things that keep me intrigued and satisfied in Toronto is easy. The results are as diverse as the place. They run from Asian food markets to direct-flight schedules to all my regular destinations, from the sandwiches at Porchetta & Co. to the 500-strong single malt whiskey list at Allen's on the Danforth, from Frank Gehry's rethink of the AGO to the nearly unbelievable variety of cheese at The Cheese Boutique in Etobicoke, from TIFF to visits to Soma chocolate in the Distillery District. But what it really all comes down is a singular quality: Toronto keeps getting better all the time, and no end to that wonderful trend is yet in sight. But maybe it appears that way more readily if, like me, you work at home instead of commuting at rush hour, and do not watch hockey any more, either.

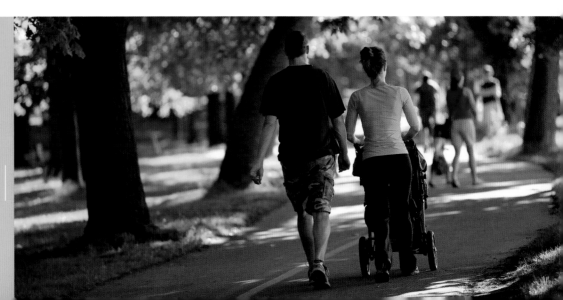

STROLLING THE
PROMENADE
AT THE BEACHES

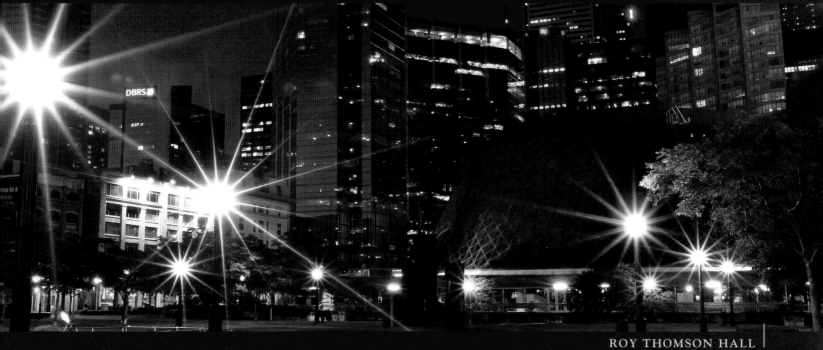

ROY THOMSON HALL

CITYSCAPES

Arrive in Toronto the old-fashioned way, by train, and you will spill out of Union Station and onto Front Street with the rest of the crowd to look upon a city block that tidily encapsulates the spirit of the financial district. It spans just two buildings, the Fairmont Royal York hotel, opened 1929, and Royal Bank Plaza, of which the 14,000 windows are infused with 2,500 ounces of gold (at today's prices, a $4.3-million paint job). A little history, a lot of money – this is the face of the downtown core. What lies behind, to the North, frequently mirrors this juxtaposition of old and new. Think of the nineteenth-century facade of the Merchants Bank building, tucked under the shimmering glass atrium of Brookfield Place, or the Hockey Hall of Fame, latest tenant of a one-time Bank of Montreal building that dates to 1885, with all those office towers looming behind it. The most striking of them may well be Mies Van der Rohe's TD Centre, a cluster of towers soaring to fifty-six floors, but with a deceptively dainty footprint. On the fifty-fourth floor of its TD Tower, you can enjoy drinks or an excellent dinner at Canoe, along with the view of Lake Ontario as unimpeded as that which the Royal York was conceived to enjoy, before reclaimed land, raised highways, and lakeshore condominium towers ruined the sightlines. The Air Canada Centre is tucked in there too – like the Rogers Centre at the foot of the CN Tower, a testament to the city's taste for enjoying their sports and entertainment downtown, rather than after an impractical excursion to the suburbs. Jack Diamond's Four Seasons Centre for the Performing Arts at Queen and University, the Daniel Libeskind-tweaked ROM at University and Bloor, and the Frank Gehry redesigned AGO on Dundas West say the same for the arts. Around this core you find the old neighbourhoods. To the west, the cornucopia of Kensington Market, its spice emporiums and food markets, along with the city's original and incomparable Chinatown. Then there's the sprawling campus of U of T, and the Annex, with its sprawling Edwardian and Victorian homes. To the north, the shops and residences of perpetually trendy Yorkville. To the east, historic Cabbagetown, the largest concentration of Victorian houses in North America. Each of these diverse neighbourhoods and districts shares a single, common downside: traffic. The best way to get from one to another is the TTC.

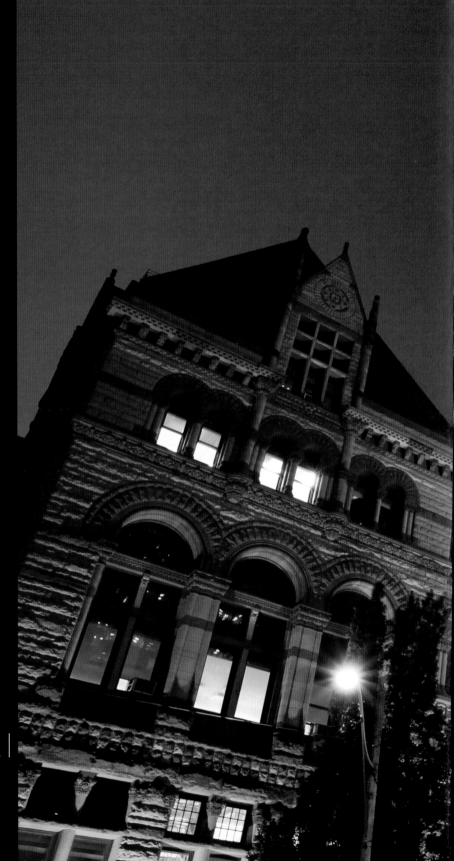

OLD CITY HALL

The bells in the clock tower
first rang on December 31, 1900

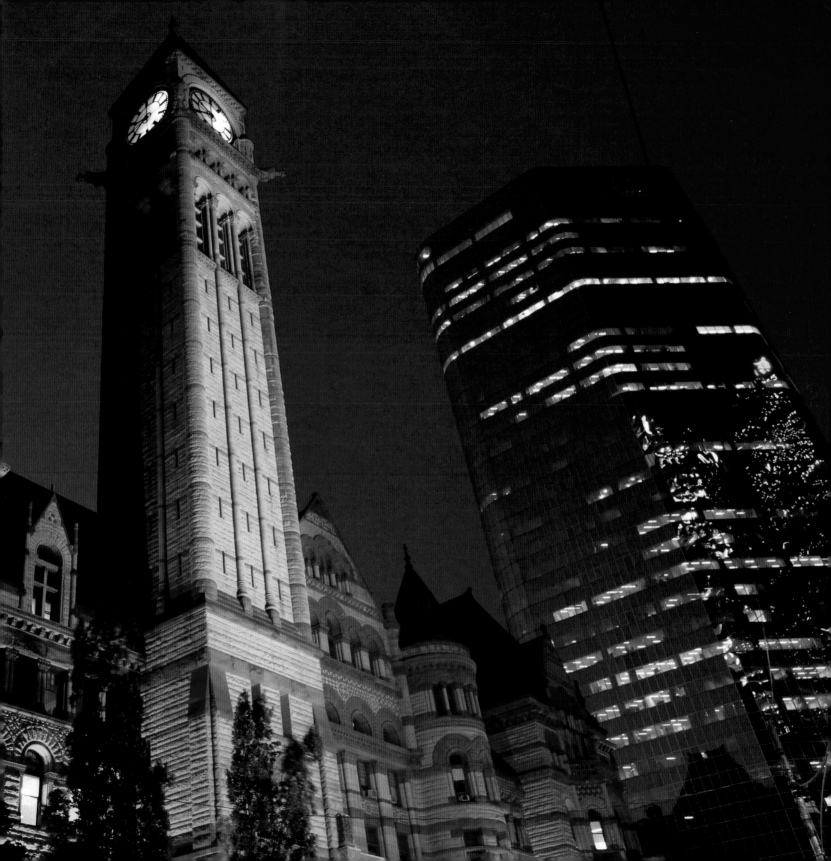

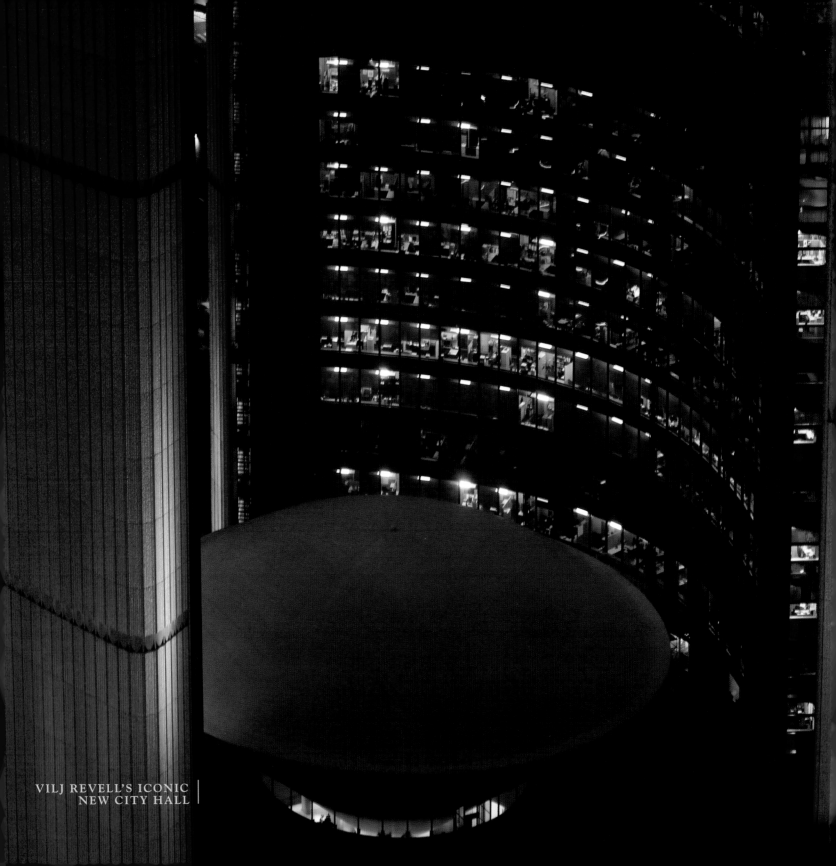

VILJ REVELL'S ICONIC
NEW CITY HALL

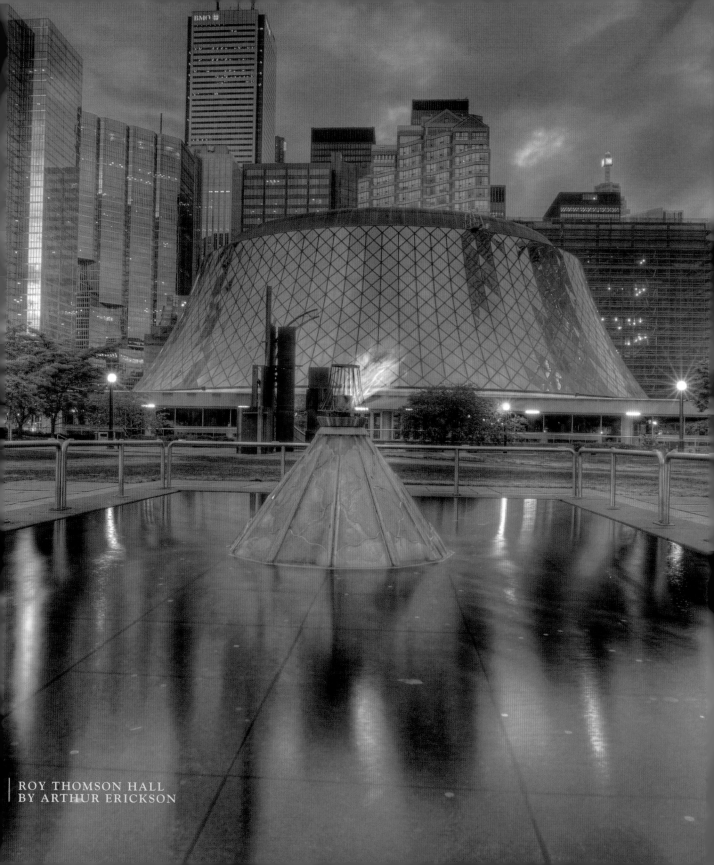

ROY THOMSON HALL
BY ARTHUR ERICKSON

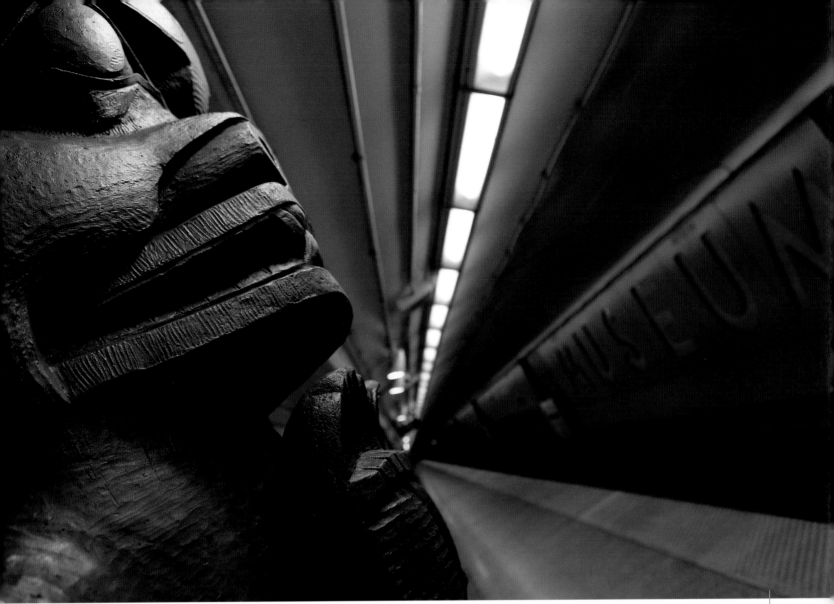

ECHOES OF THE ROM

The Museum subway stop. Column pictured, *The Wuikinuxv First Nation Bear House Post*, was designed by architects Diamonds and Schmitt's. Five column designs are on station platform, each representing Canada's First Nations.

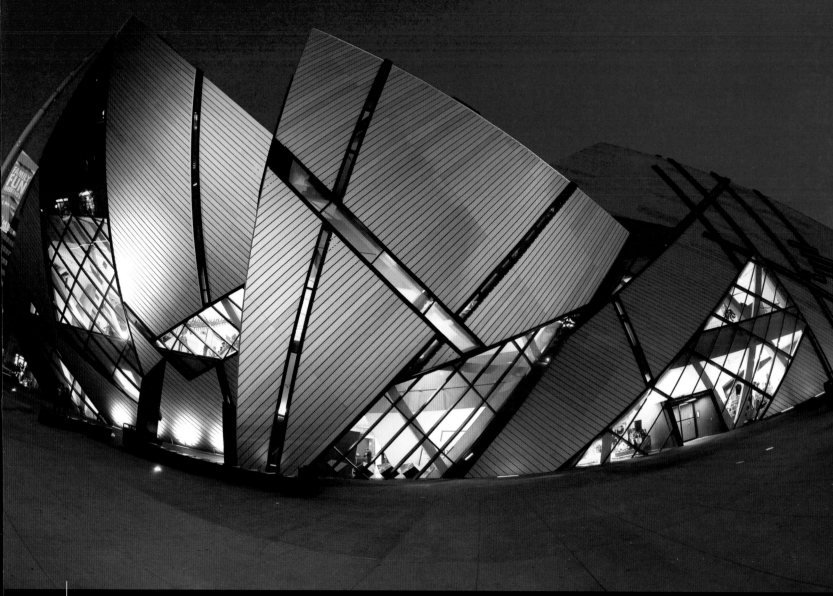

THE ROYAL ONTARIO MUSEUM – ROM
Michael Lee-Chin Crystal by Daniel Liebskind

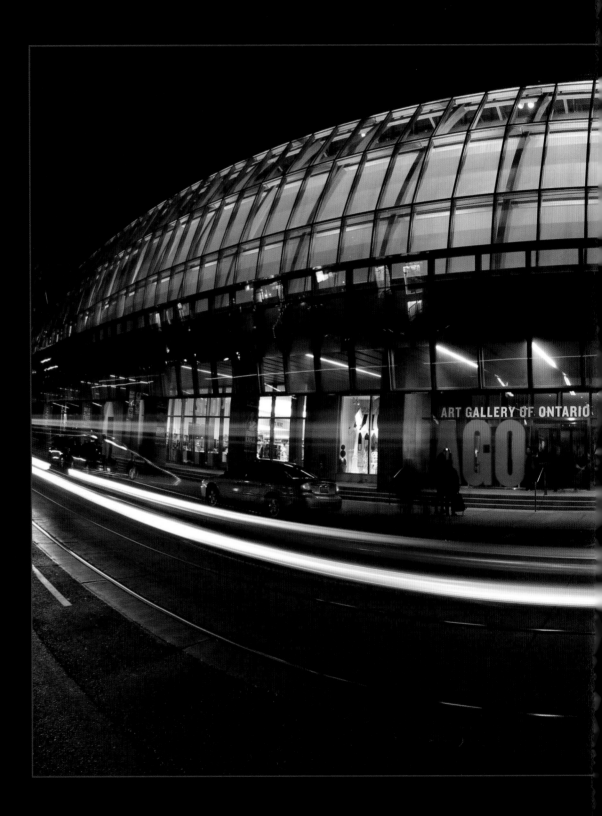

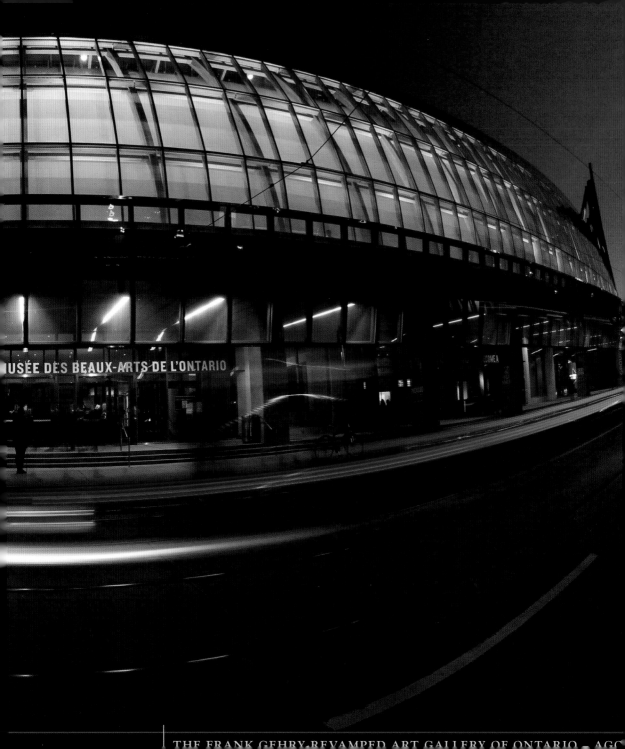

USÉE DES BEAUX-ARTS DE L'ONTARIO

THE FRANK GEHRY-REVAMPED ART GALLERY OF ONTARIO – AGO

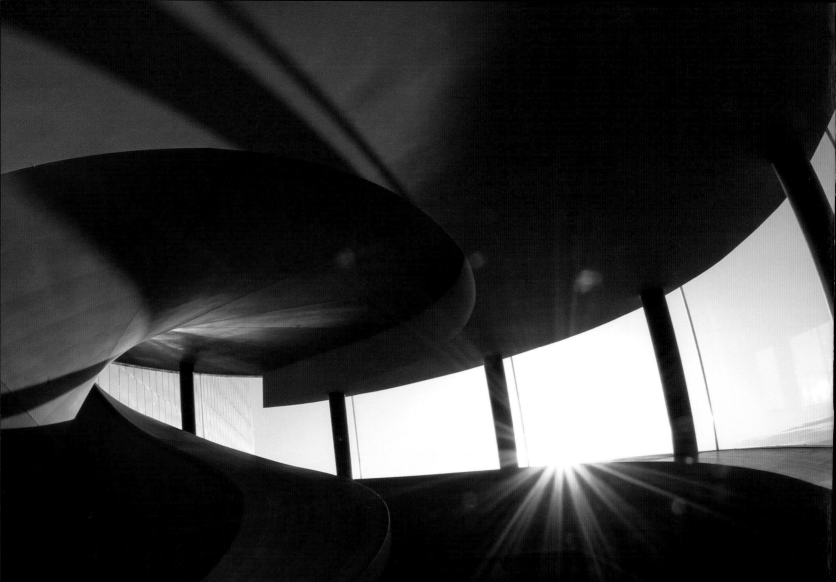

THE SPIRAL STAIRCASE OF WALKER COURT
IN THE AGO

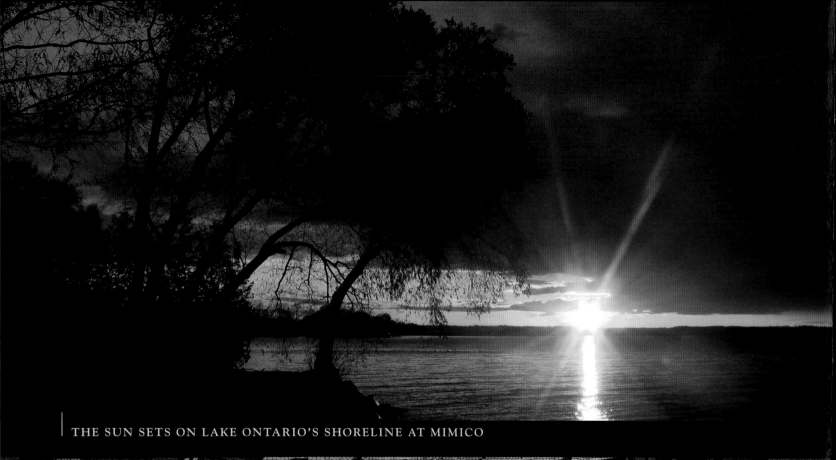

THE SUN SETS ON LAKE ONTARIO'S SHORELINE AT MIMICO

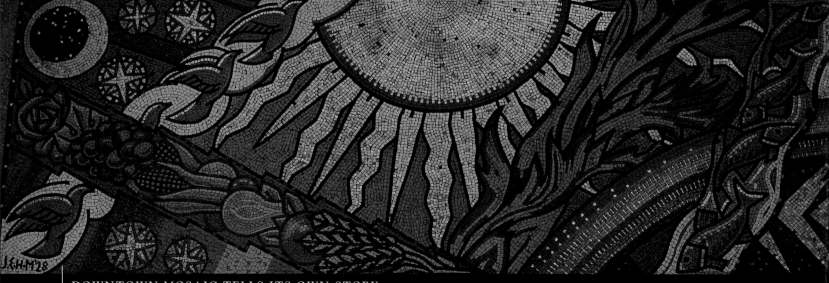

DOWNTOWN MOSAIC TELLS ITS OWN STORY

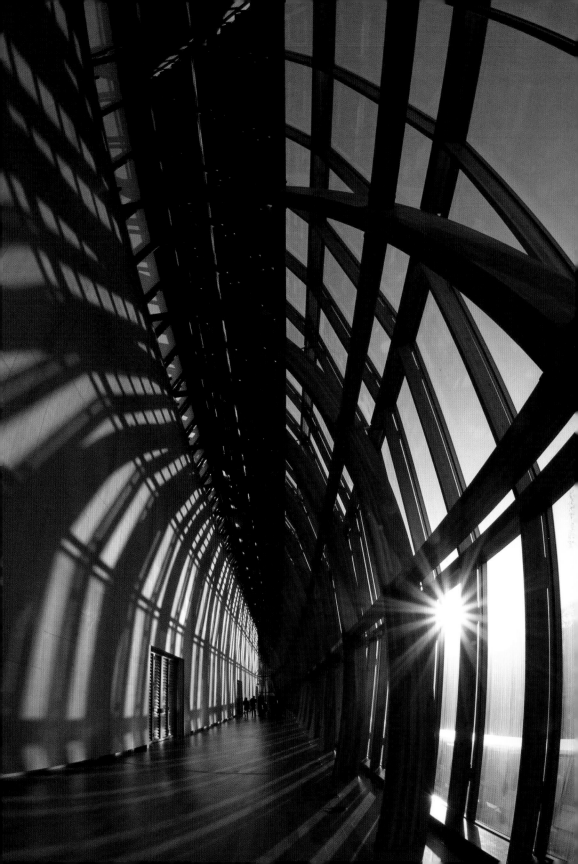

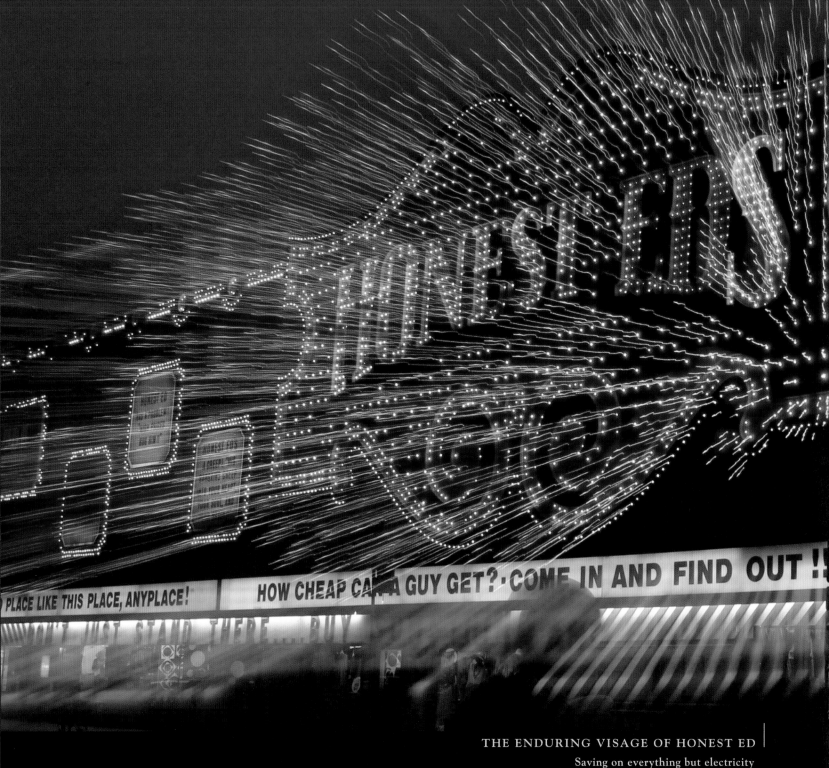

HOW CHEAP CAN A GUY GET? · COME IN AND FIND OUT !!

PLACE LIKE THIS PLACE, ANYPLACE!

THE ENDURING VISAGE OF HONEST ED

Saving on everything but electricity

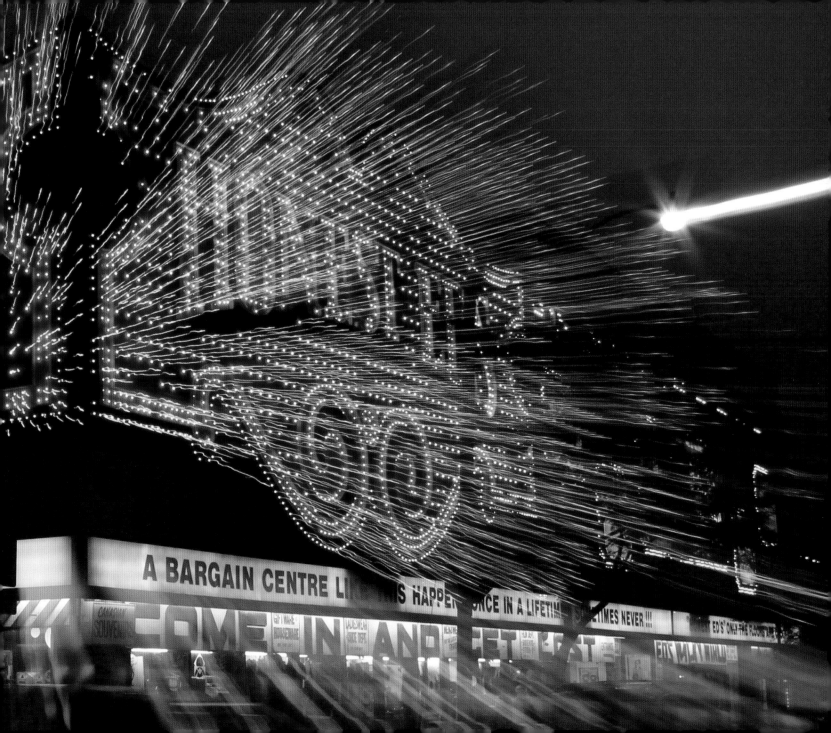

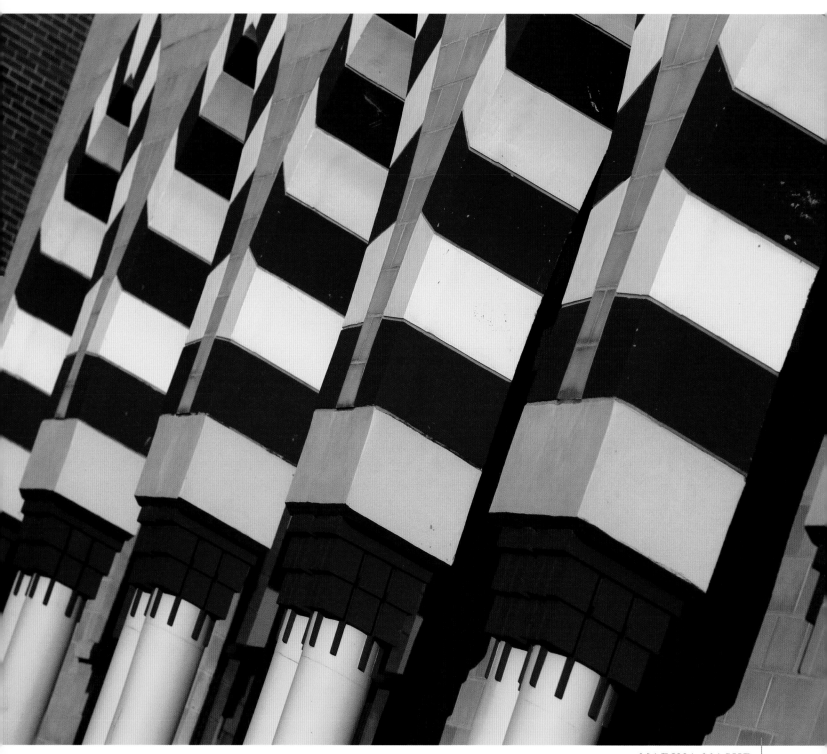

MADINA MASJID
The Jamiatul Muslemin of Toronto

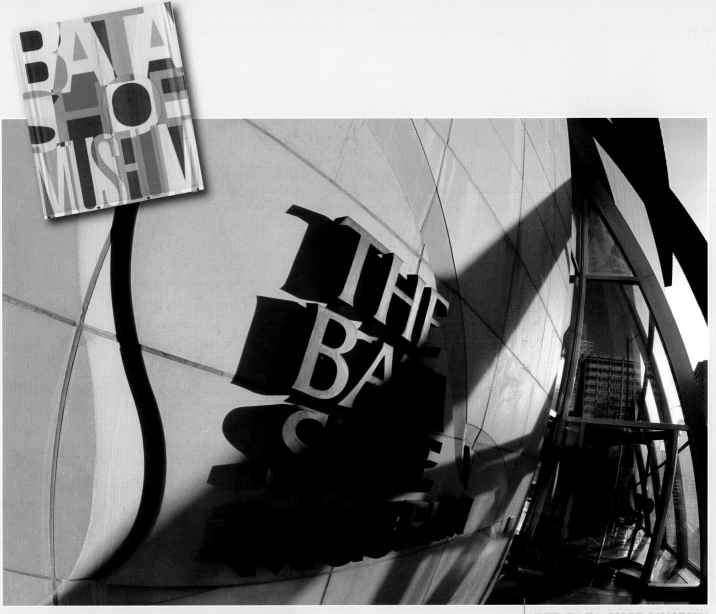

THE BATA SHOE MUSEUM
& the display on the street

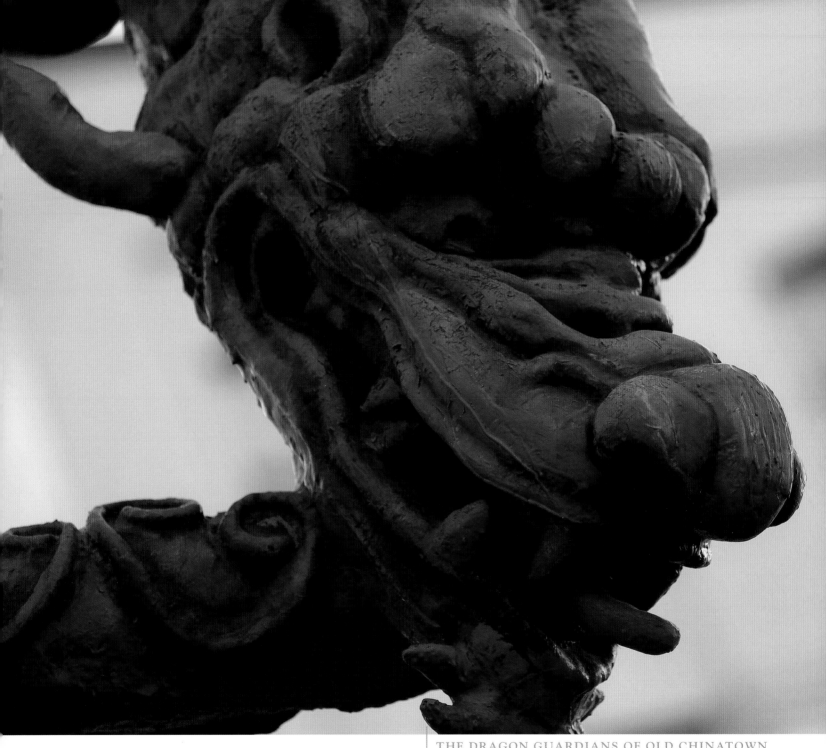

DETAILS FROM KENSINGTON MARKET

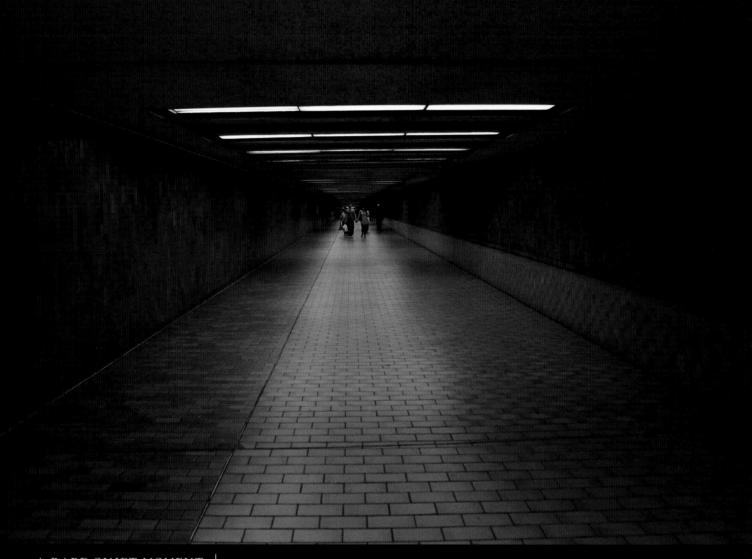

A RARE QUIET MOMENT,
OFF-HOURS AT ST. GEORGE

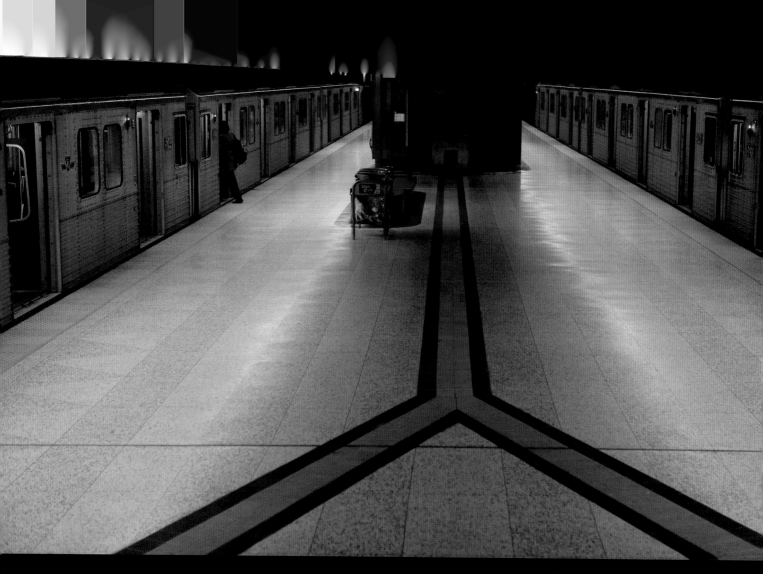

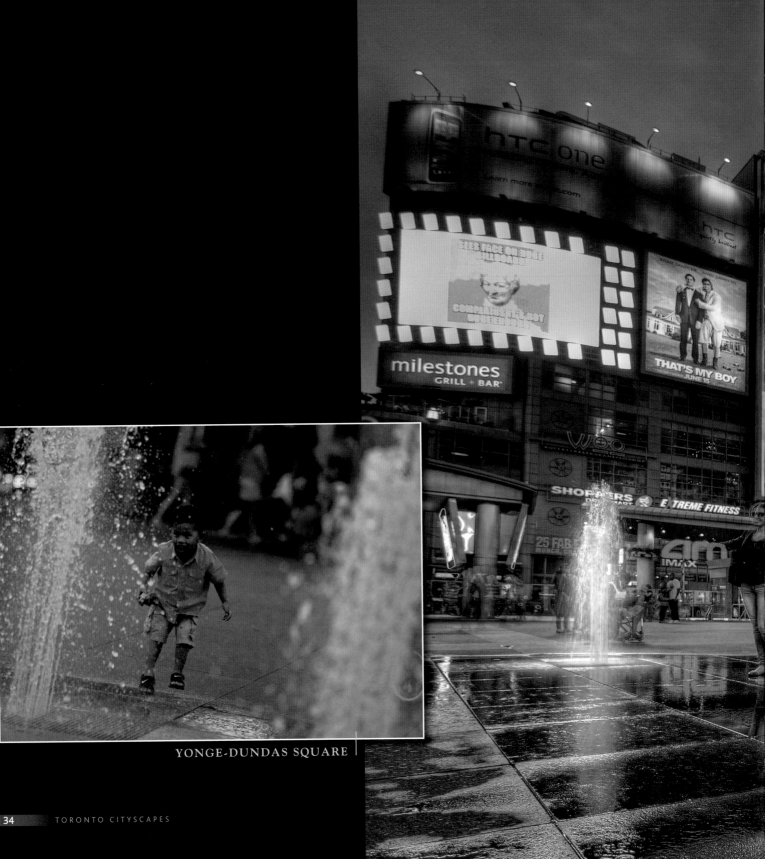

YONGE-DUNDAS SQUARE

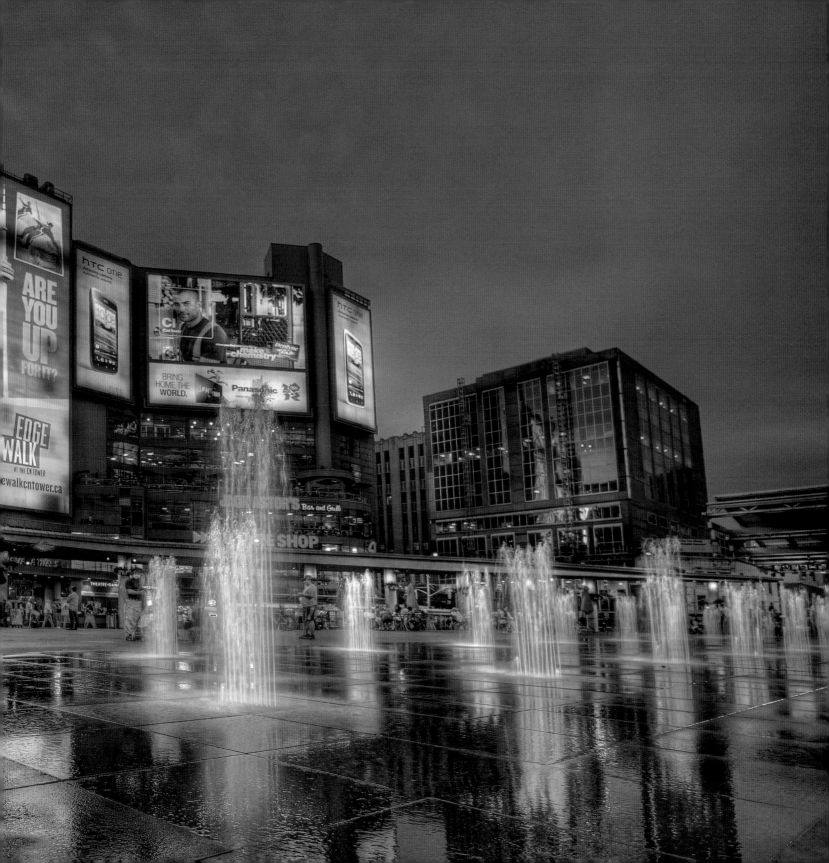

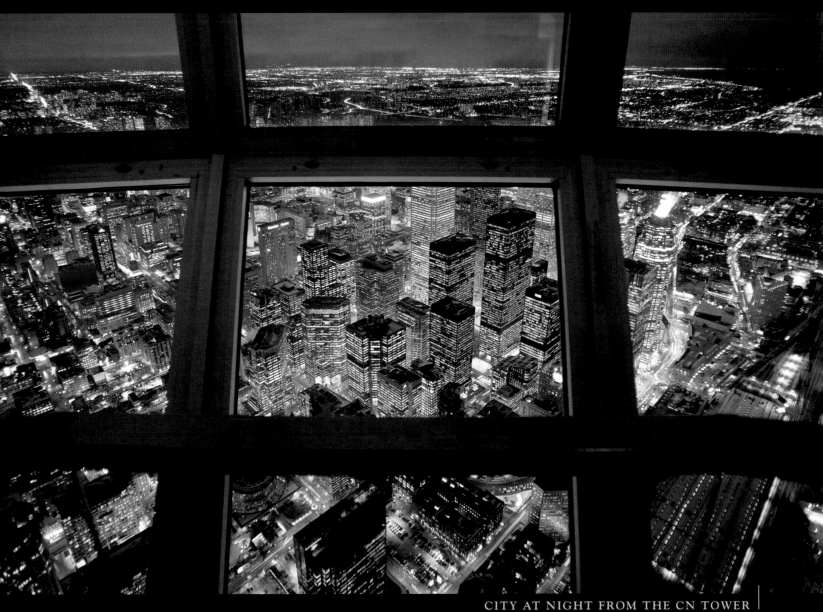

CITY AT NIGHT FROM THE CN TOWER

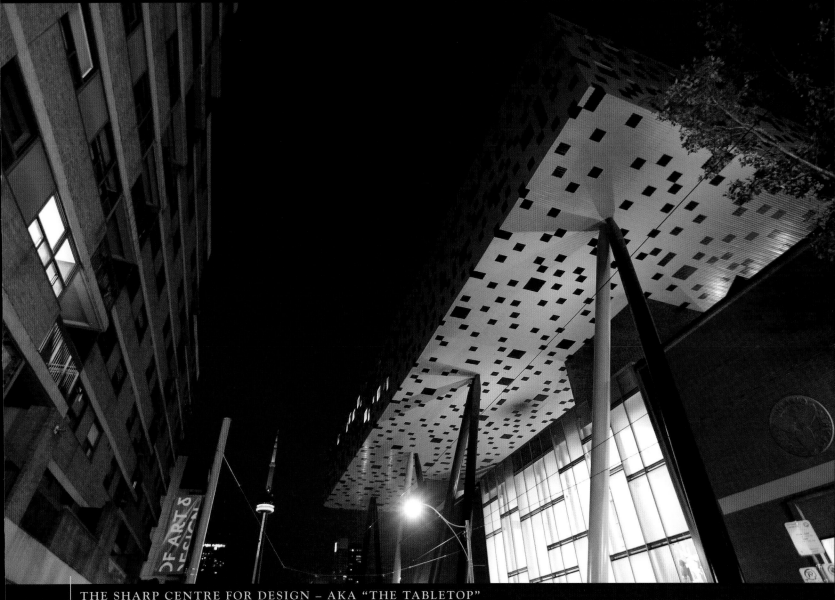

THE SHARP CENTRE FOR DESIGN – AKA "THE TABLETOP"

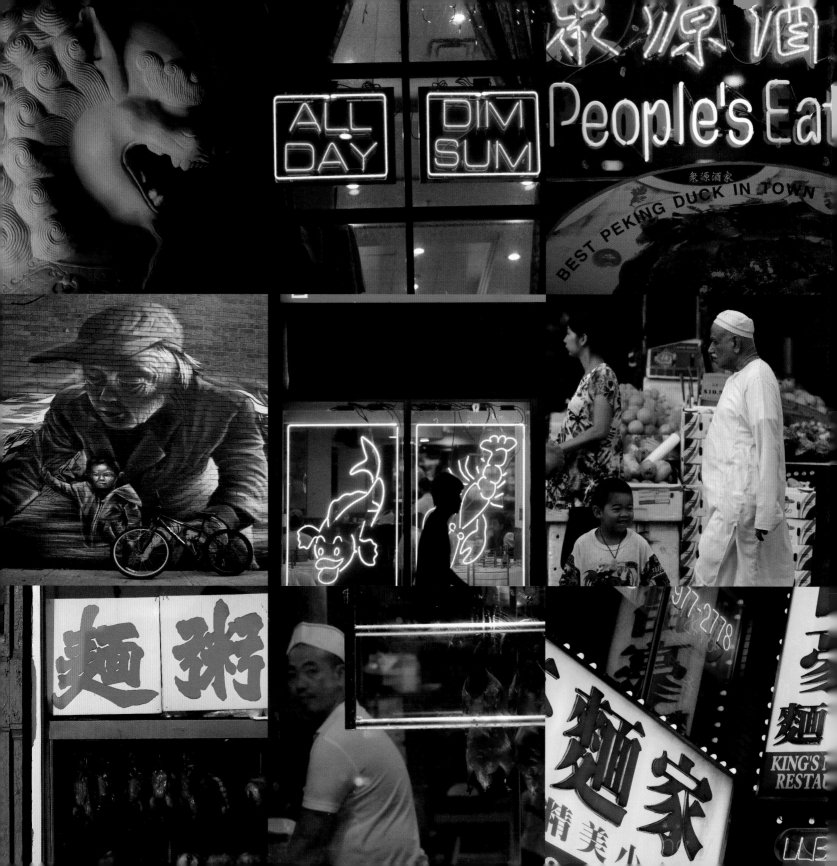

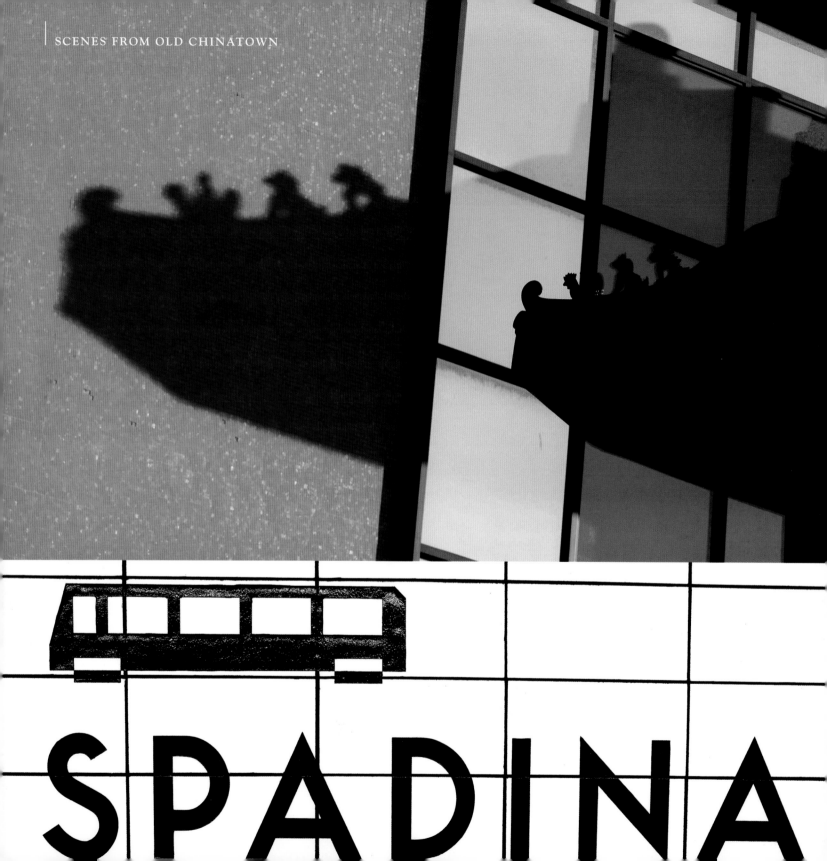

SPADINA

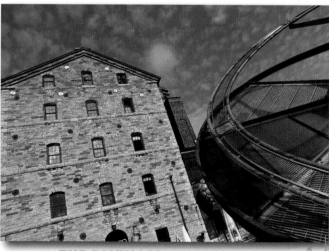

THE DISTILLERY HISTORIC DISTRICT
Formerly the Gooderham and Worts Distillery

LOOKING DOWN ON TANKHOUSE LANE

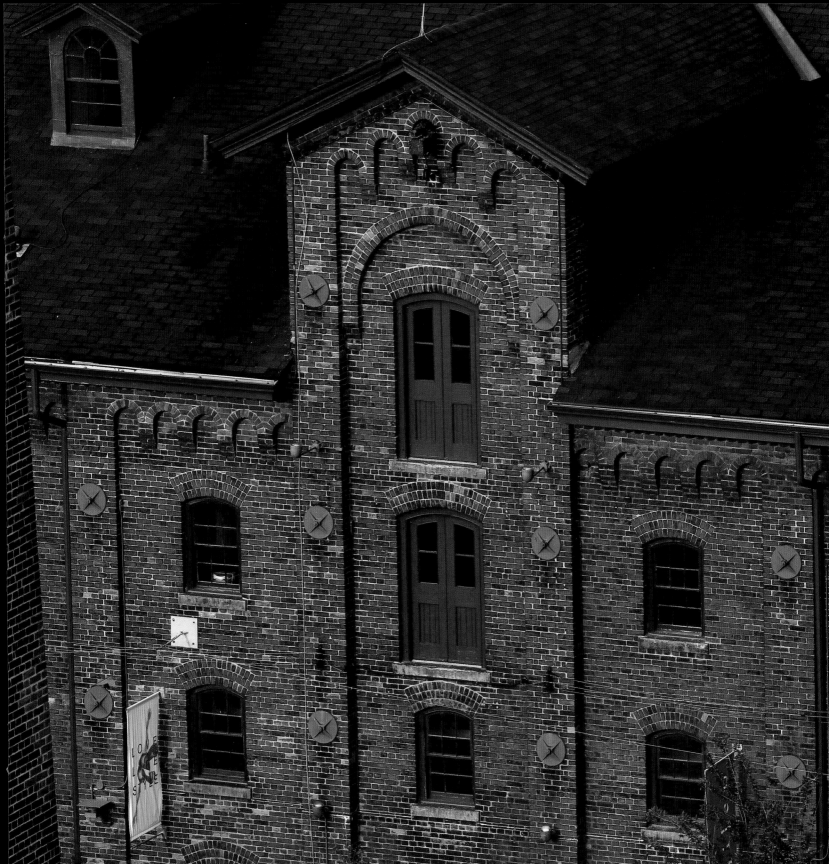

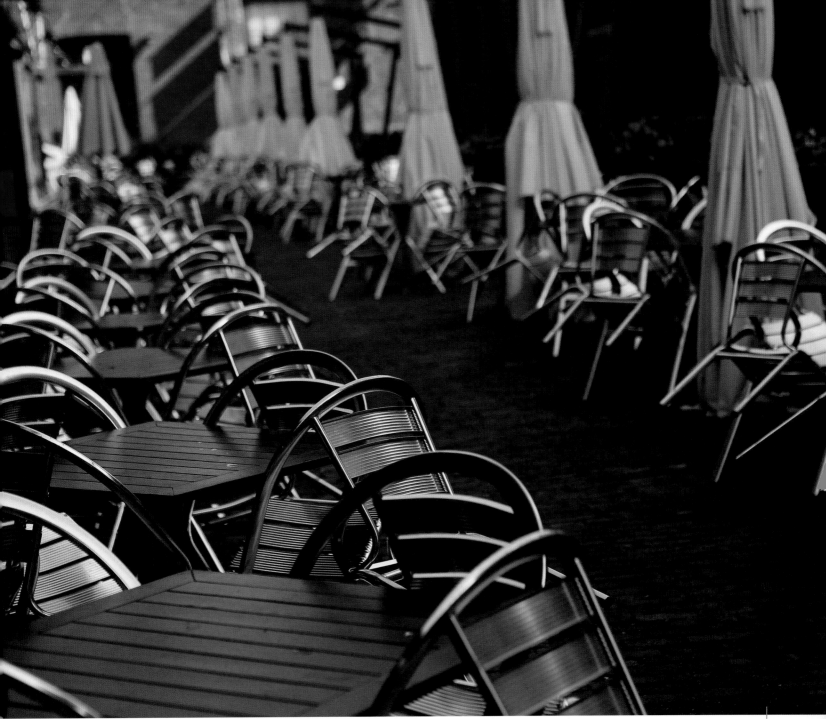

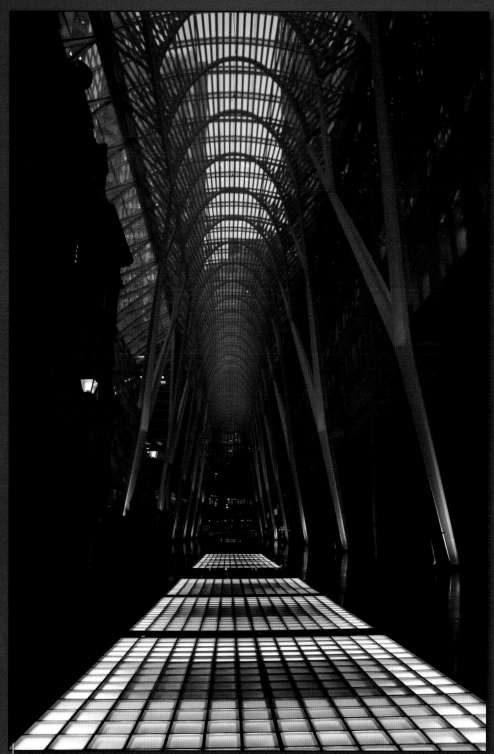

THE ALLEN LAMBERT GALLERIA AT BROOKFIELD PLACE

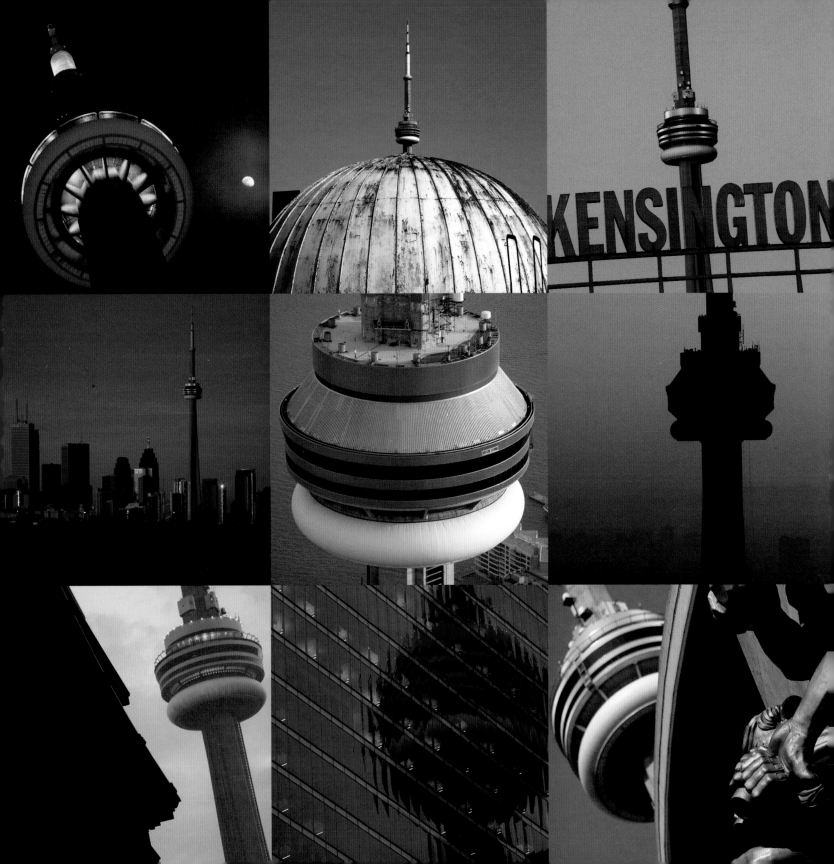

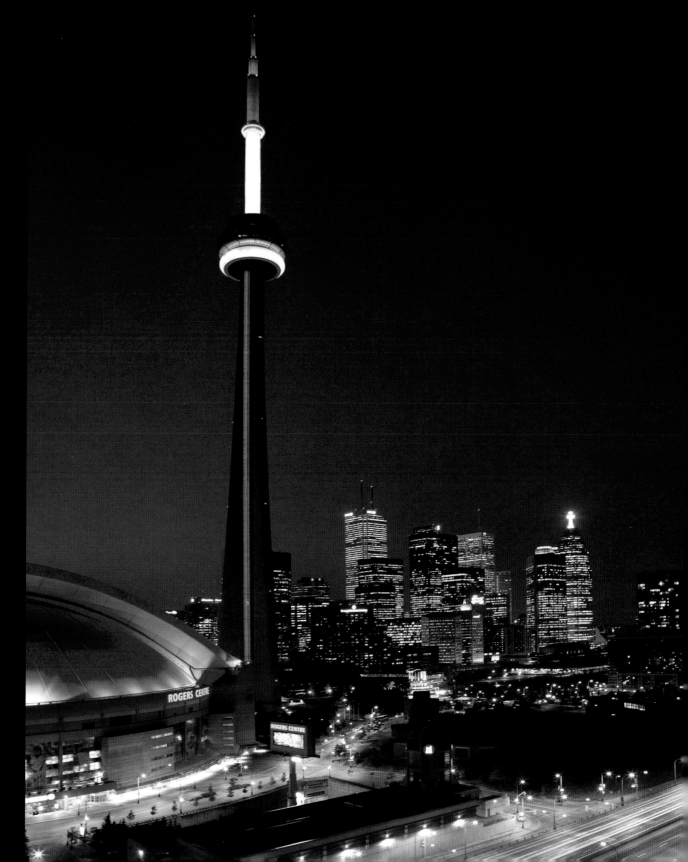

THE MANY
FACES OF THE
CN TOWER

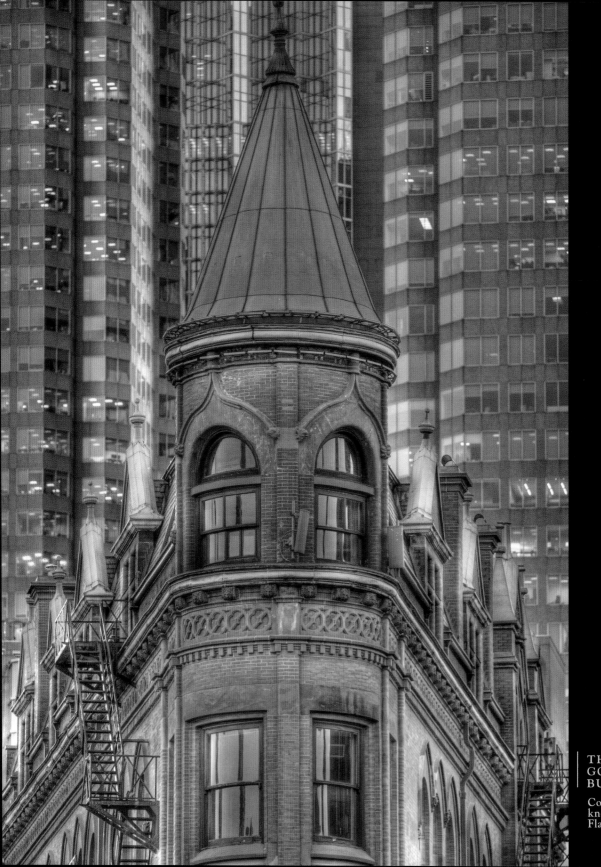

THE
GOODERHAM
BUILDING

Commonly
known as the
Flatiron Building

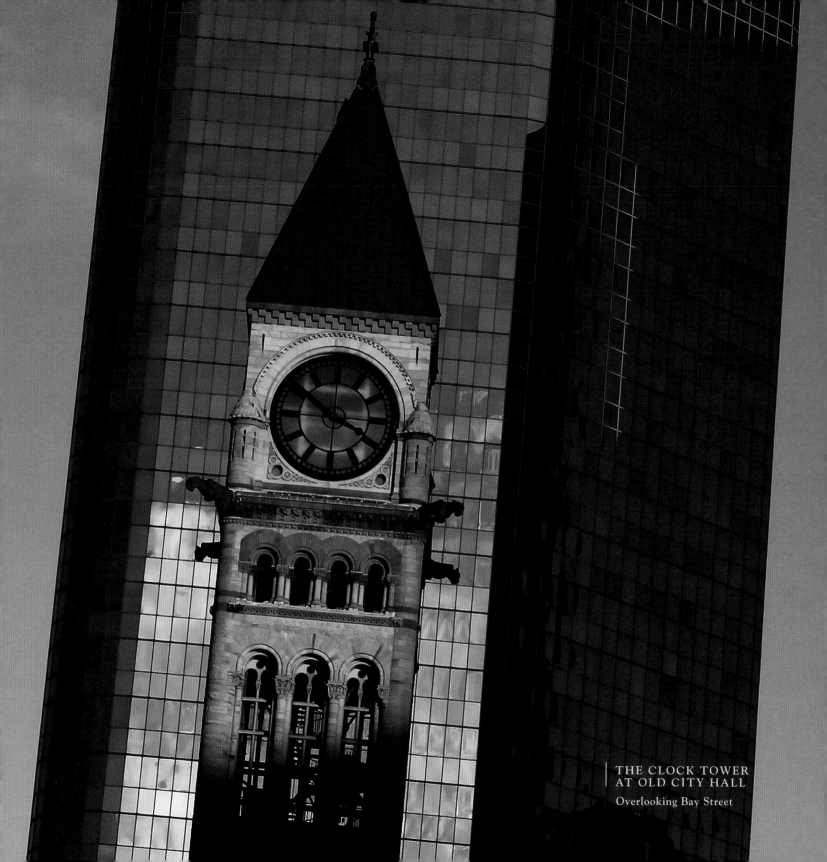

THE CLOCK TOWER
AT OLD CITY HALL

Overlooking Bay Street

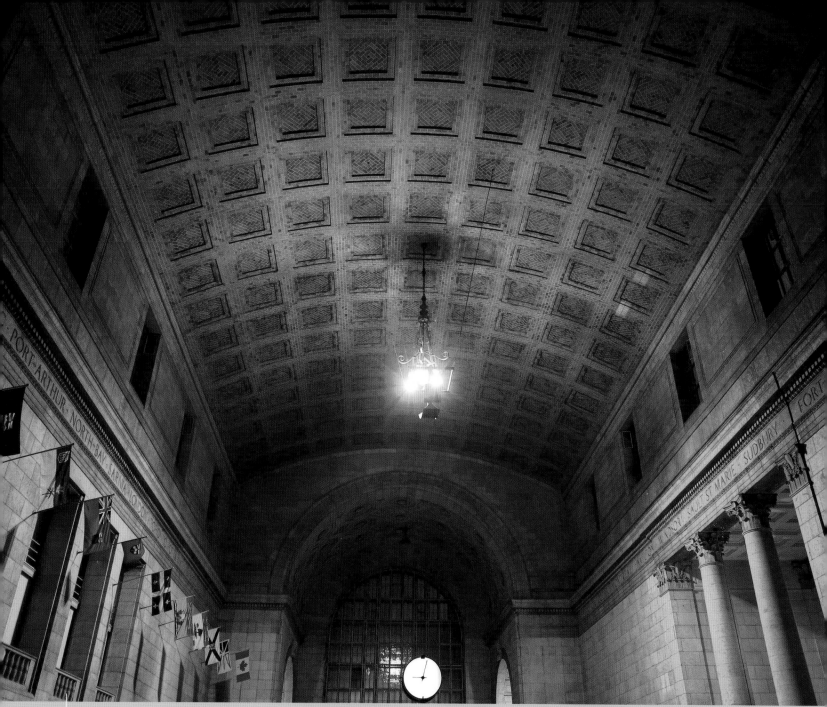

UNION STATION

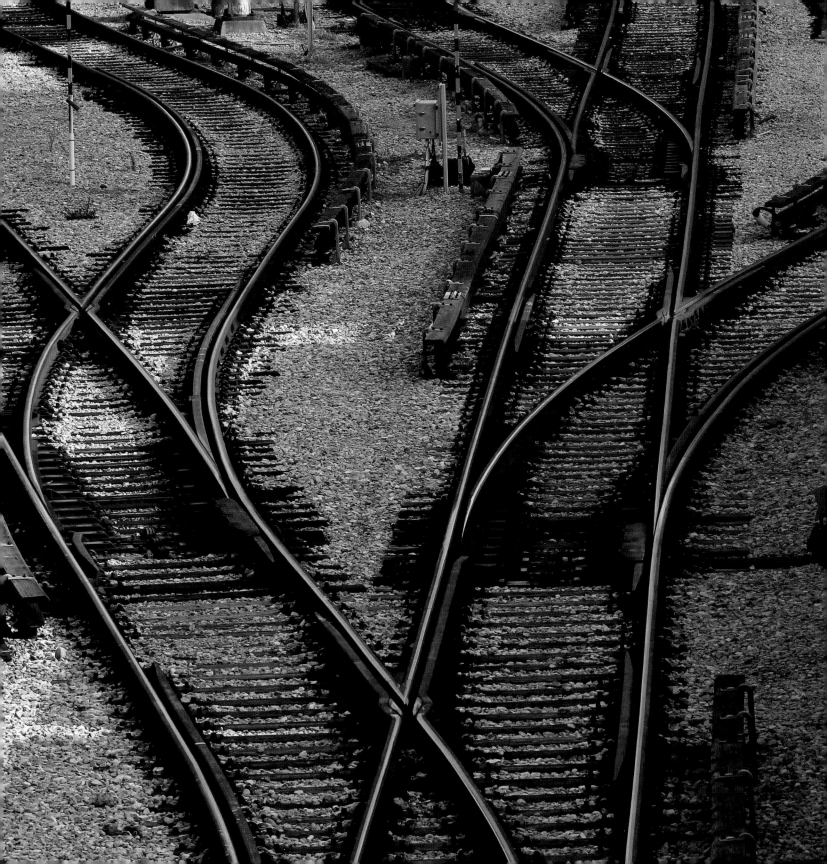

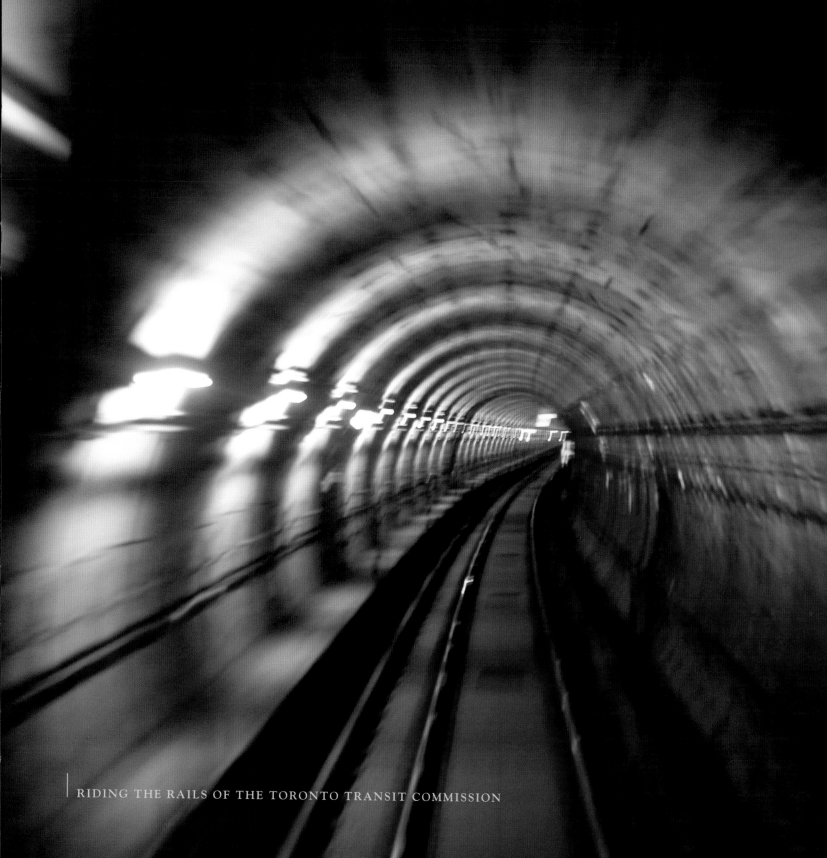

RIDING THE RAILS OF THE TORONTO TRANSIT COMMISSION

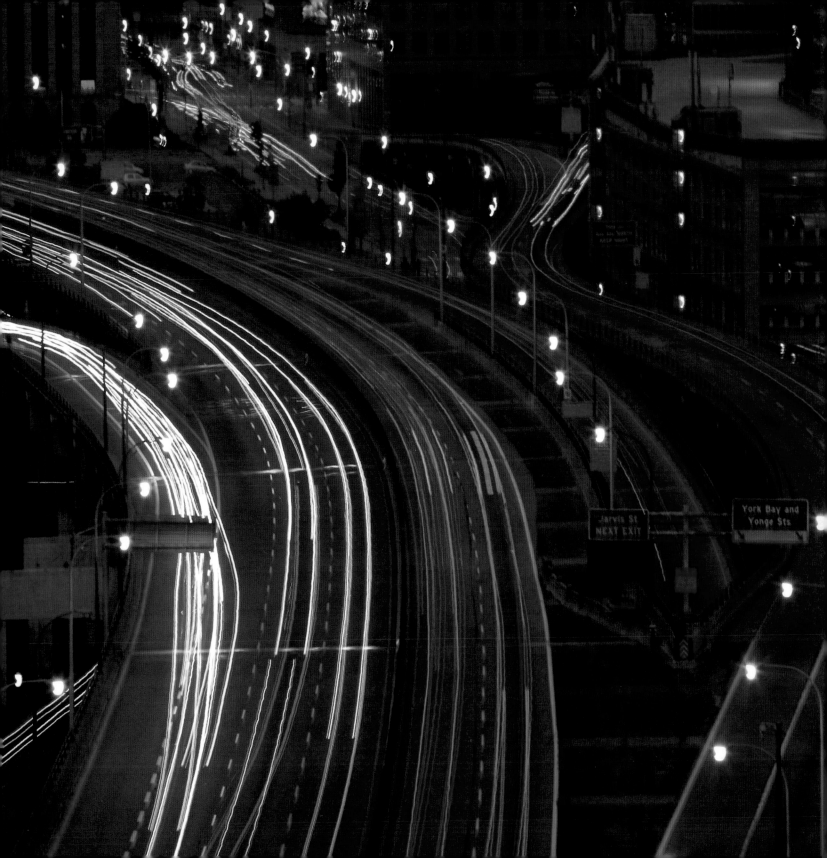

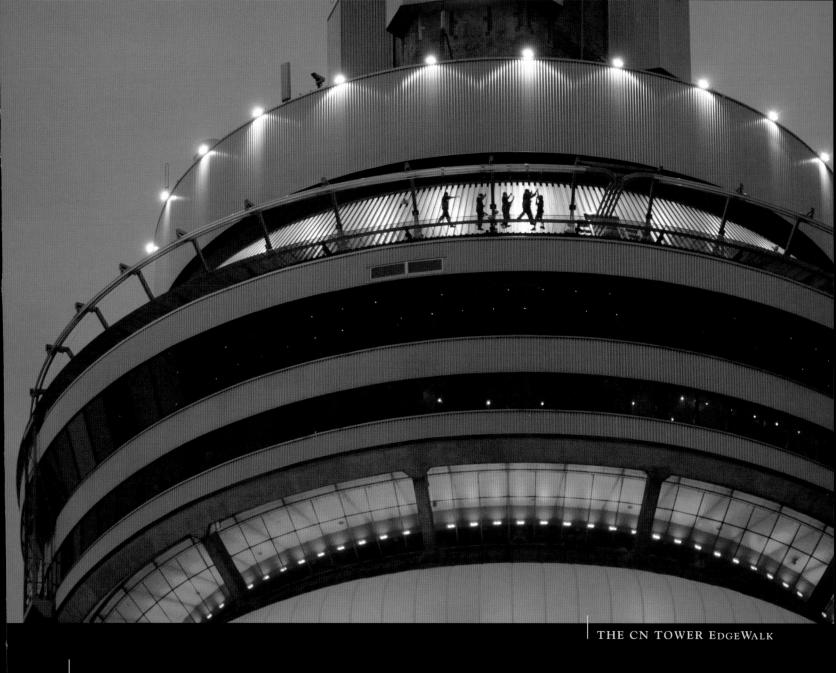

THE GARDINER EXPRESSWAY

Running close to the shore of Lake Ontario

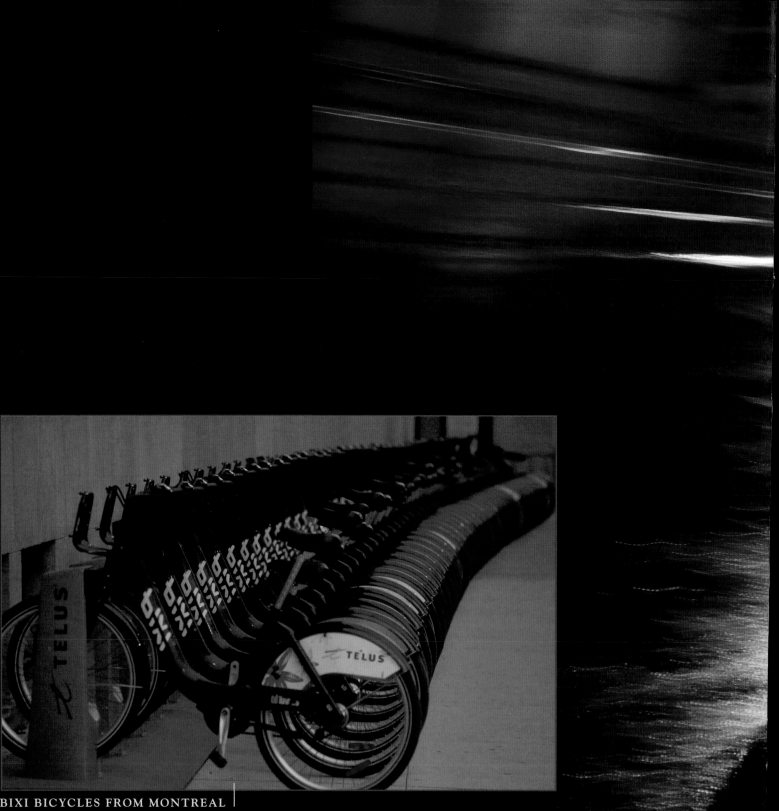

BIXI BICYCLES FROM MONTREAL

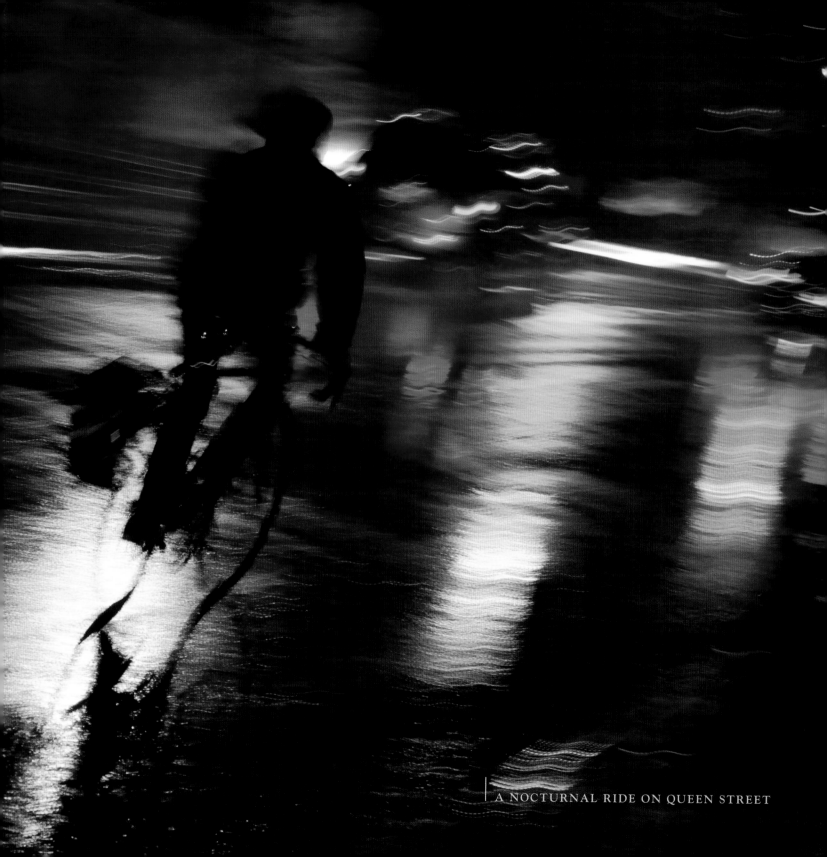

A NOCTURNAL RIDE ON QUEEN STREET

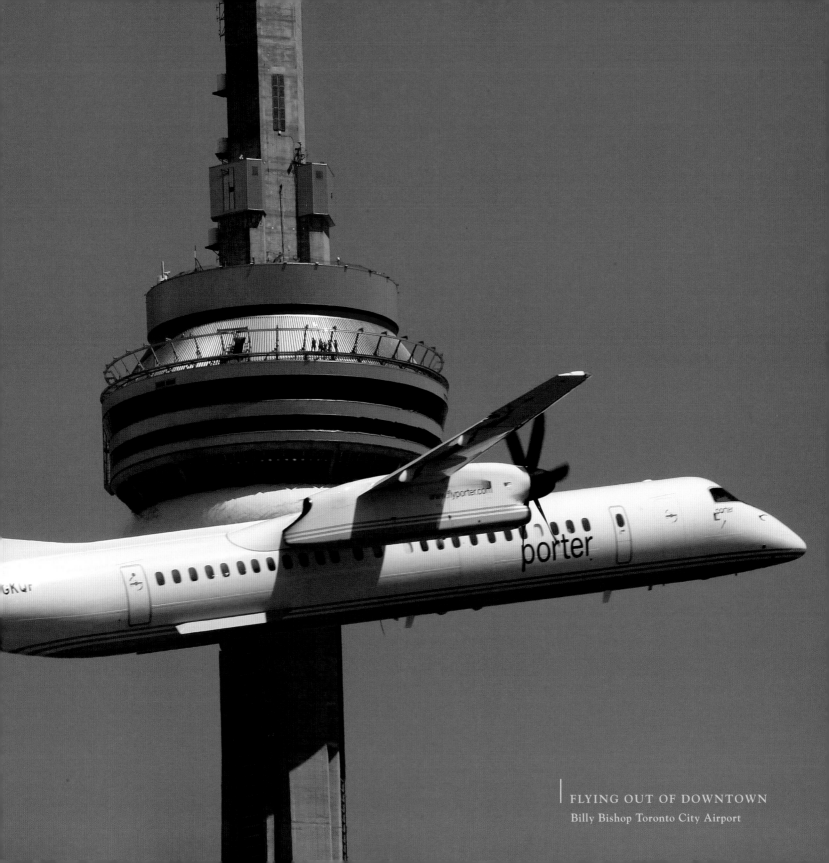

FLYING OUT OF DOWNTOWN

Billy Bishop Toronto City Airport

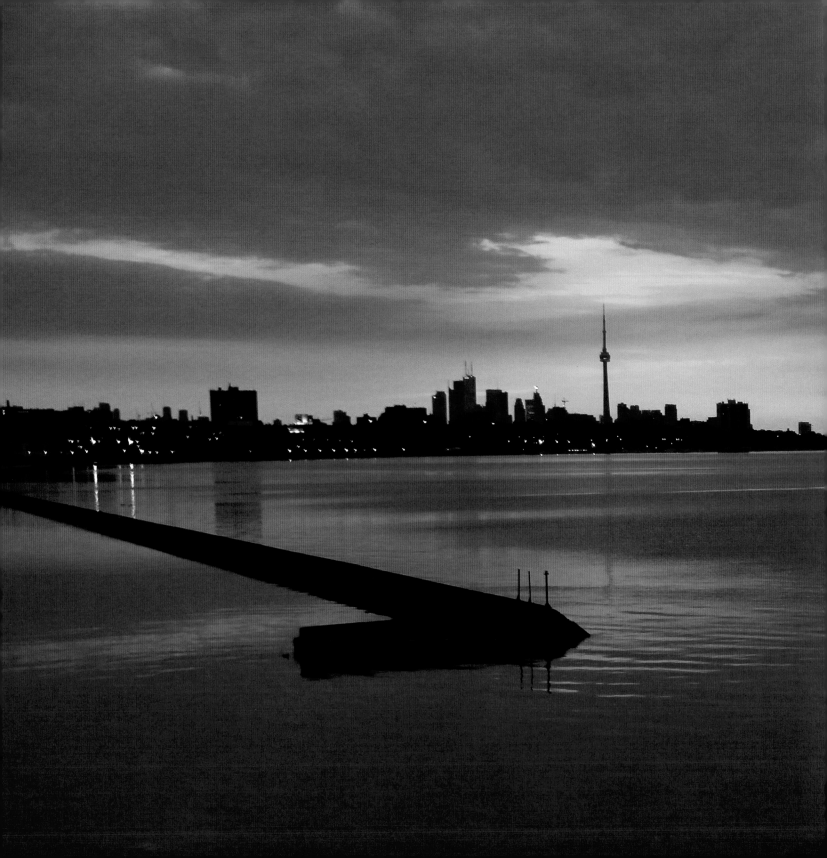

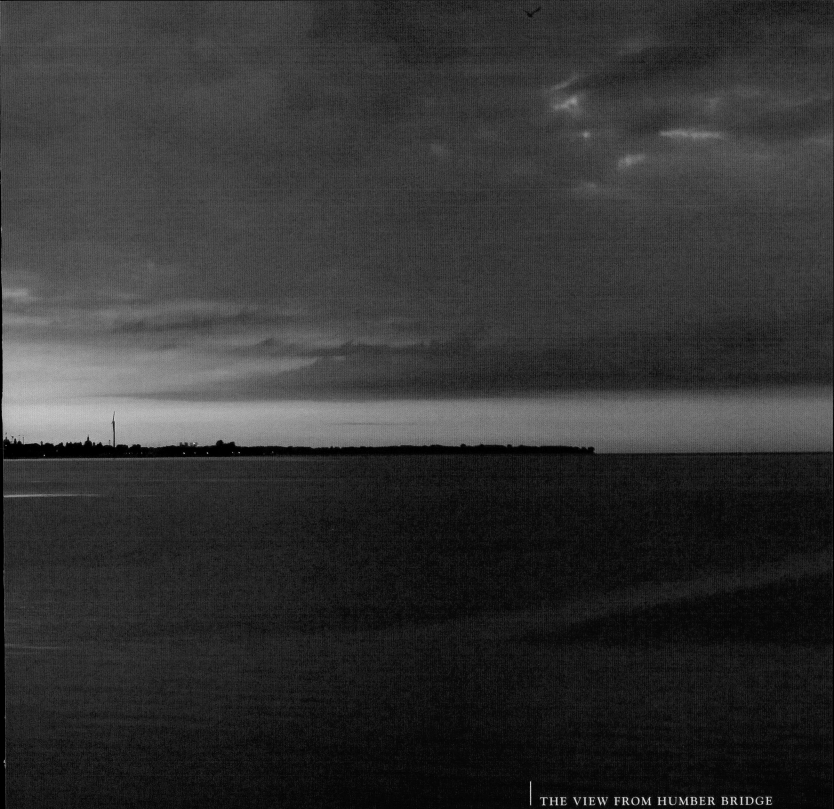

THE VIEW FROM HUMBER BRIDGE

UNIVERSITY OF TORONTO
& OCAD

THE CORNER SUITES AT PURE
SPIRITS LOFTS & CONDOS
in the Distillery District

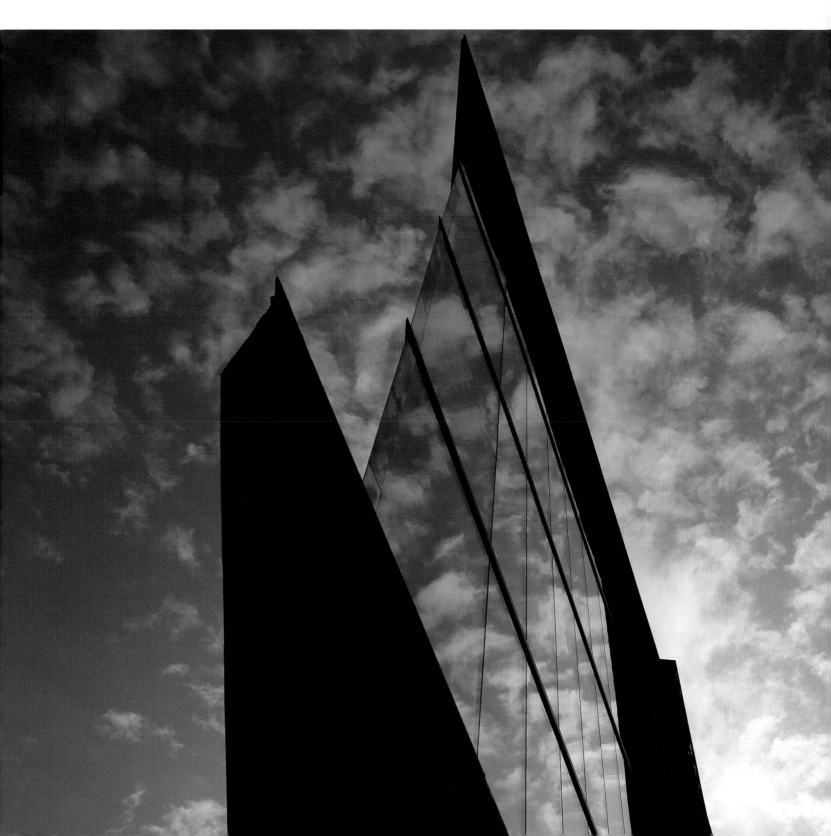

FRANCESCO PIRELLI'S MONUMENT TO MULTICULTURALISM

Outside Union Station

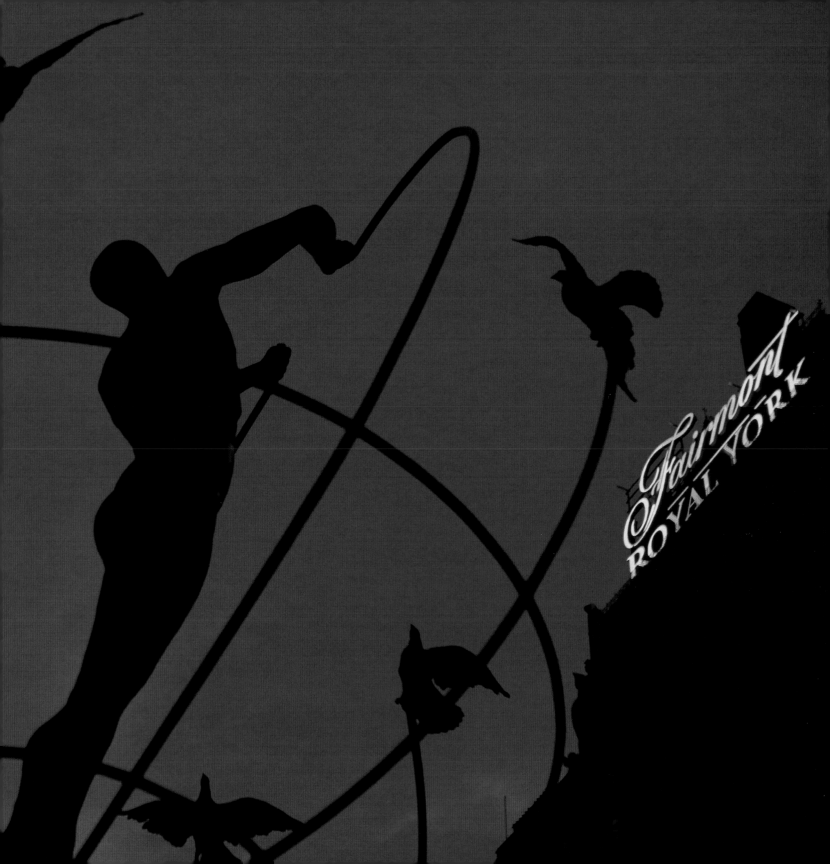

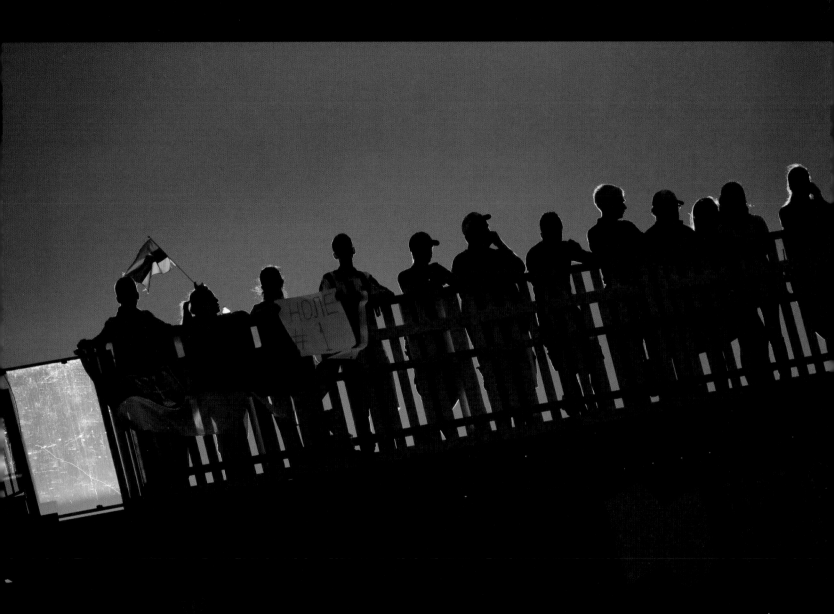

FANS OVERLOOK ROGERS STADIUM

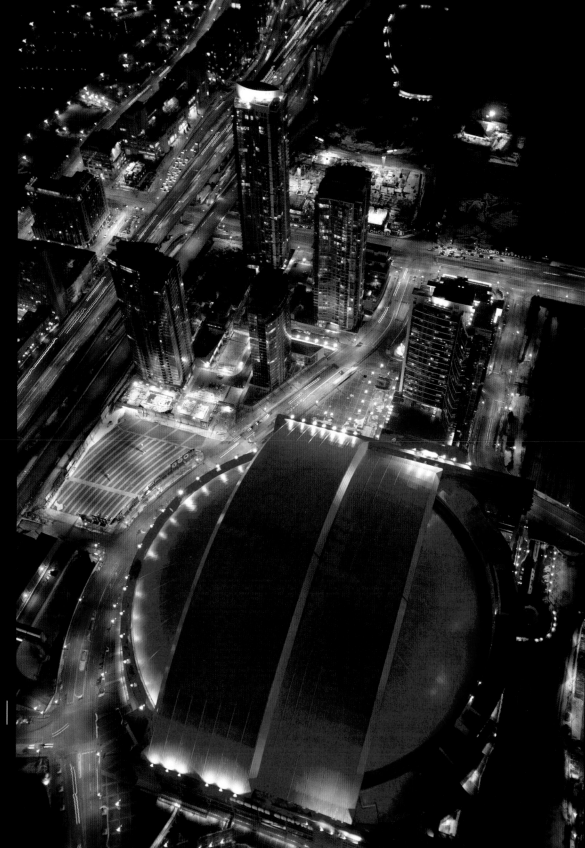

DOWNTOWN
FROM ABOVE

Overlooking the
Rogers Centre

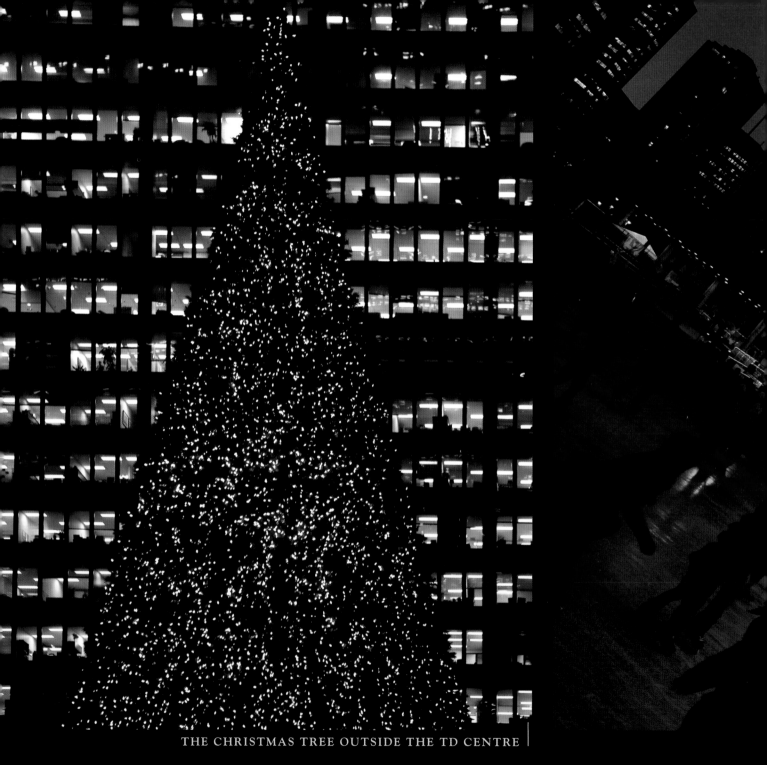

THE CHRISTMAS TREE OUTSIDE THE TD CENTRE

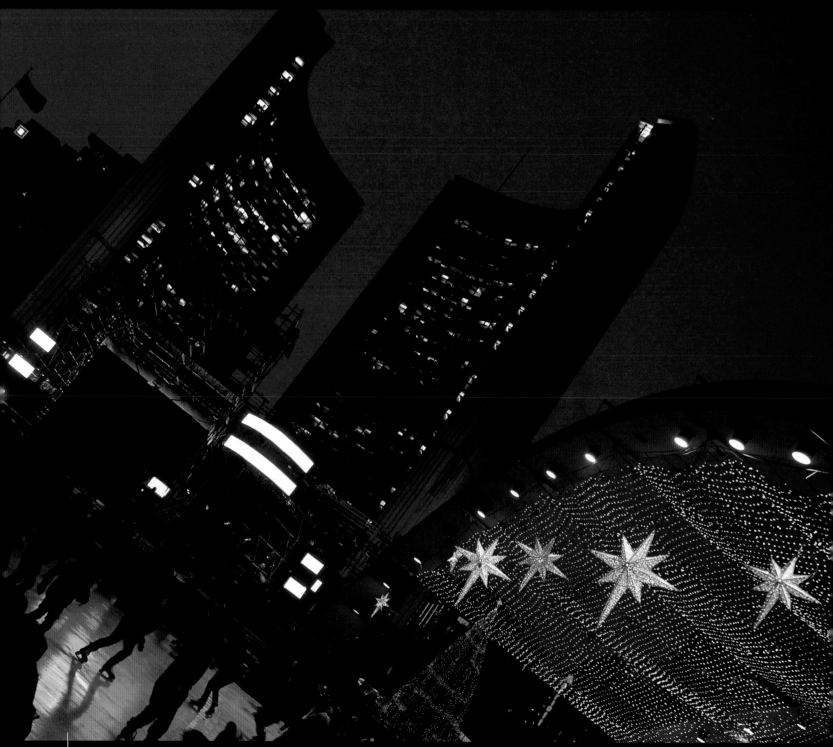

SKATING AT NATHAN PHILLIPS SQUARE

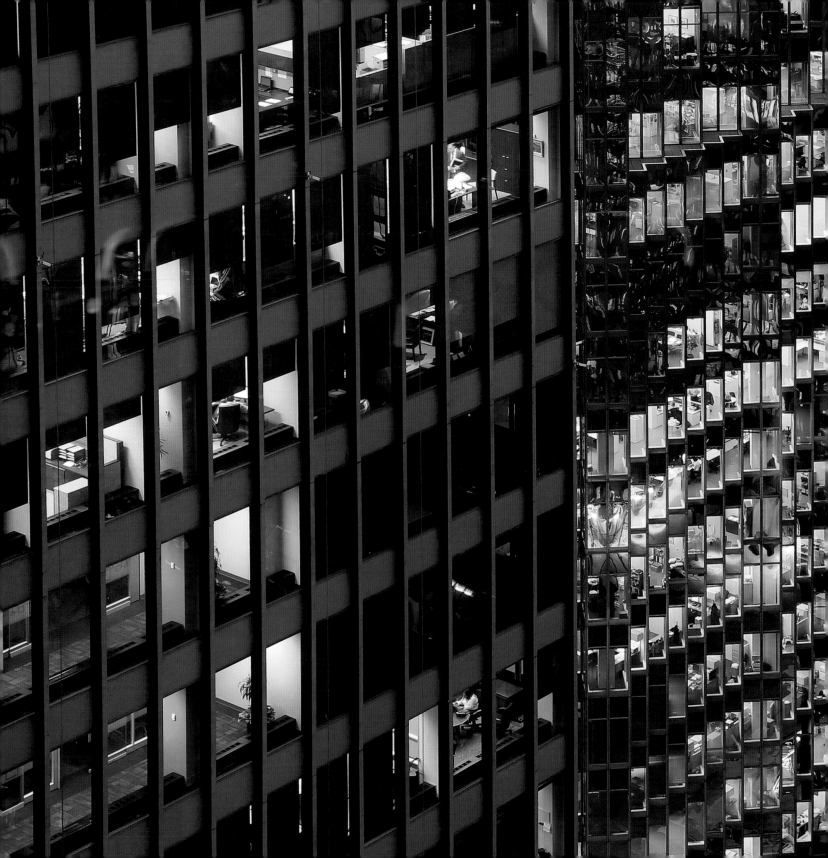

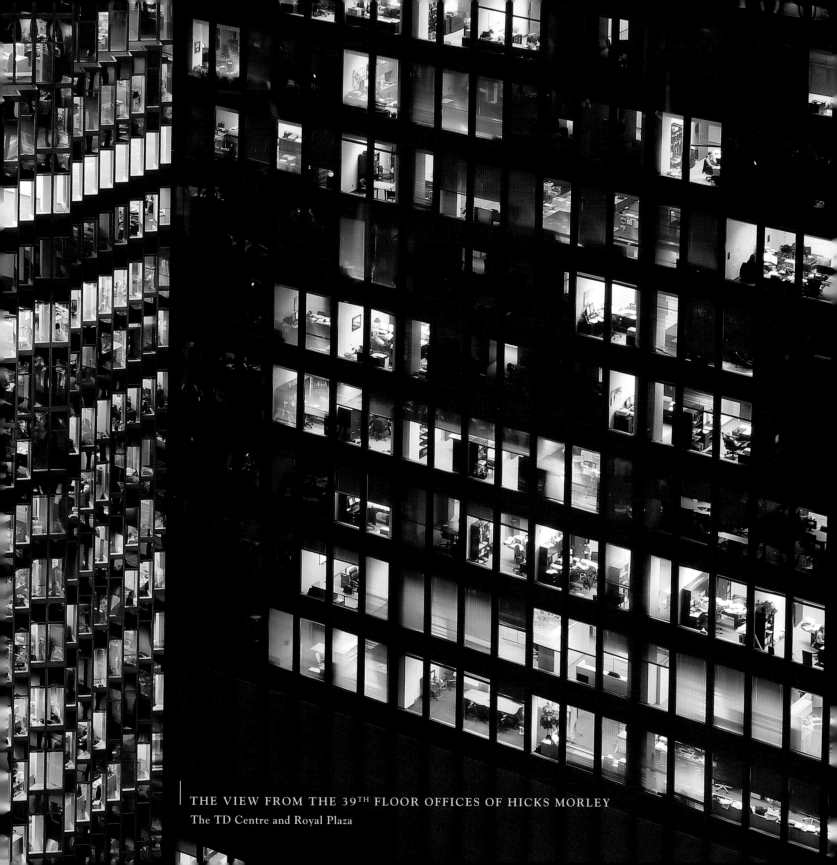

THE VIEW FROM THE 39ᵀᴴ FLOOR OFFICES OF HICKS MORLEY
The TD Centre and Royal Plaza

GLIMPSES OF THE CORE BY NIGHT

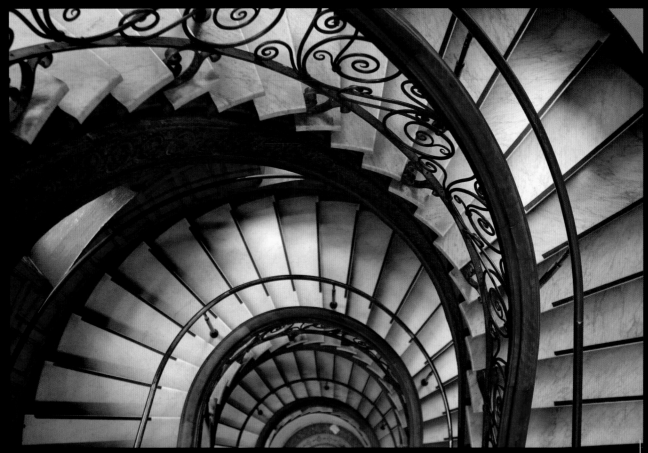

THE STAIRCASE AT OLD CITY HALL

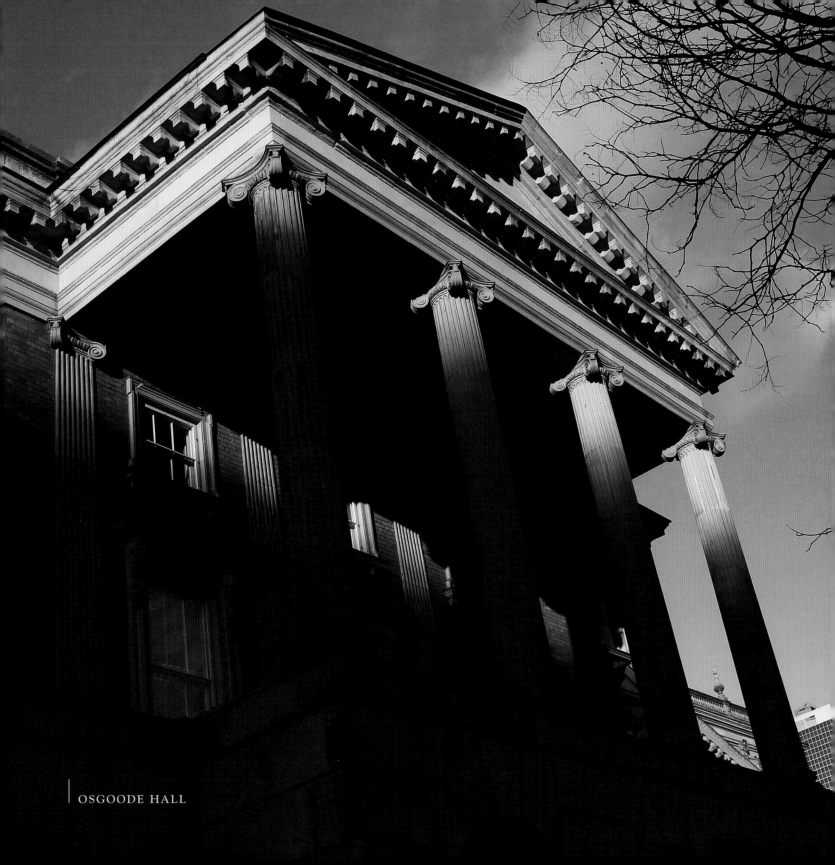

OSGOODE HALL

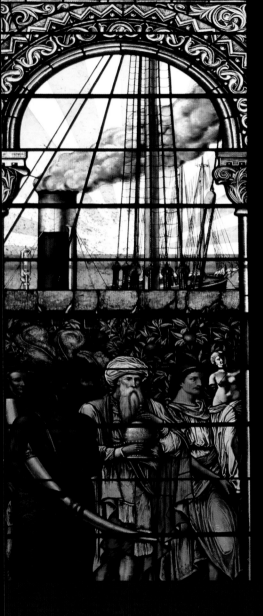
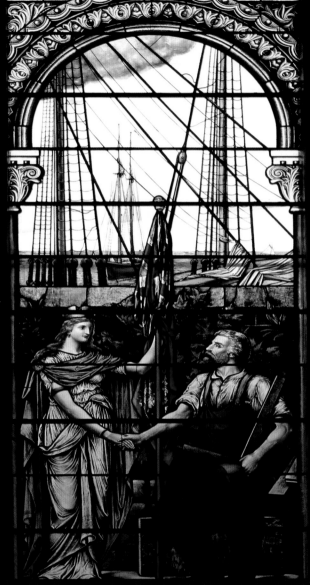
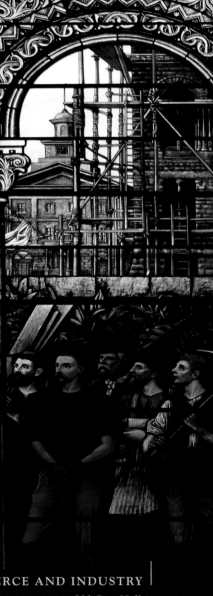

ROBERT McCAUSLAND'S THE UNION OF COMMERCE AND INDUSTRY

Old City Hall

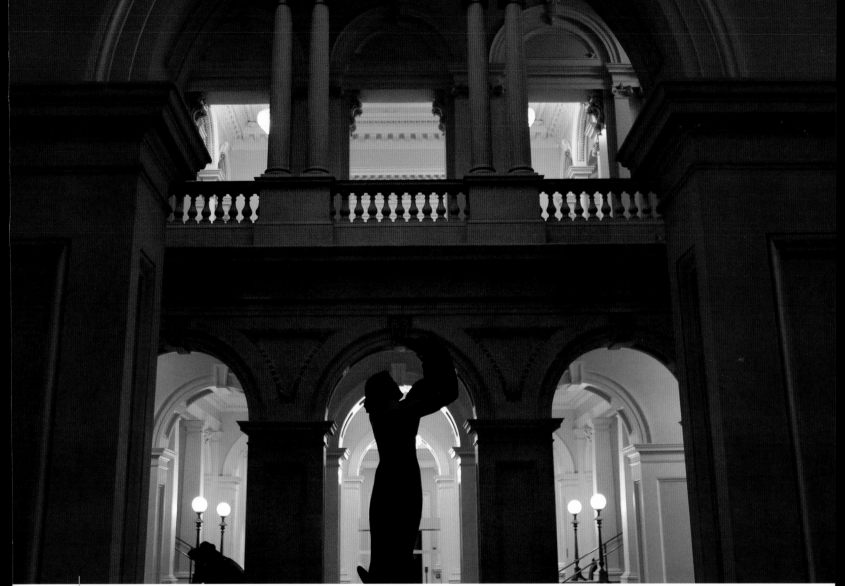

OLD CITY HALL

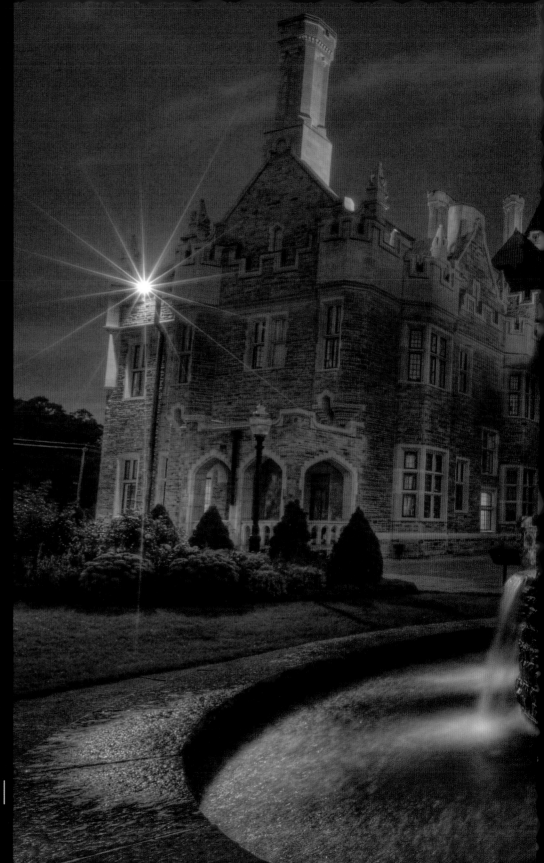

CASA LOMA

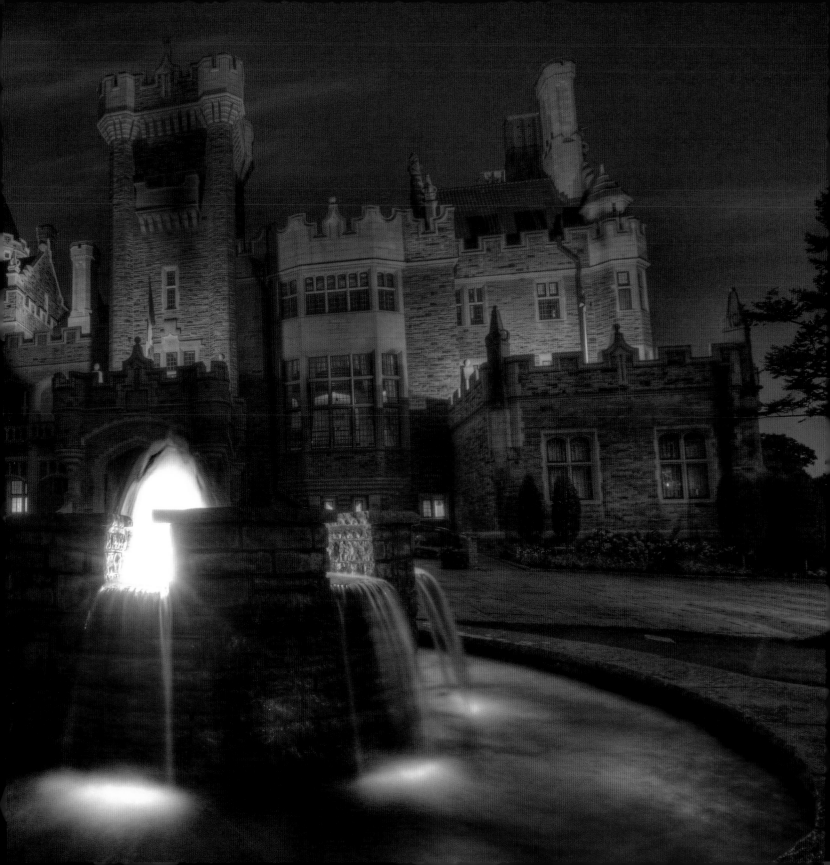

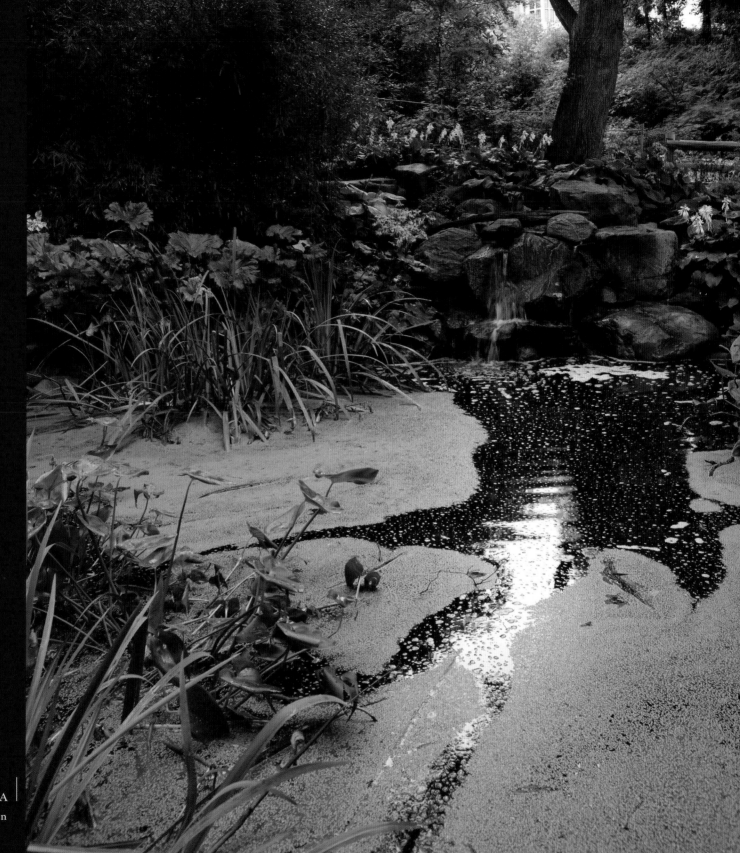

CASA LOMA
Water Garden

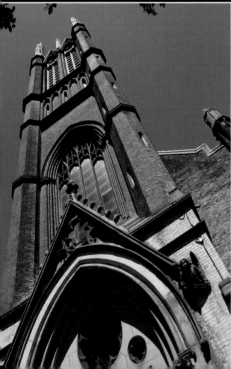

METROPOLITAN UNITED CHURCH

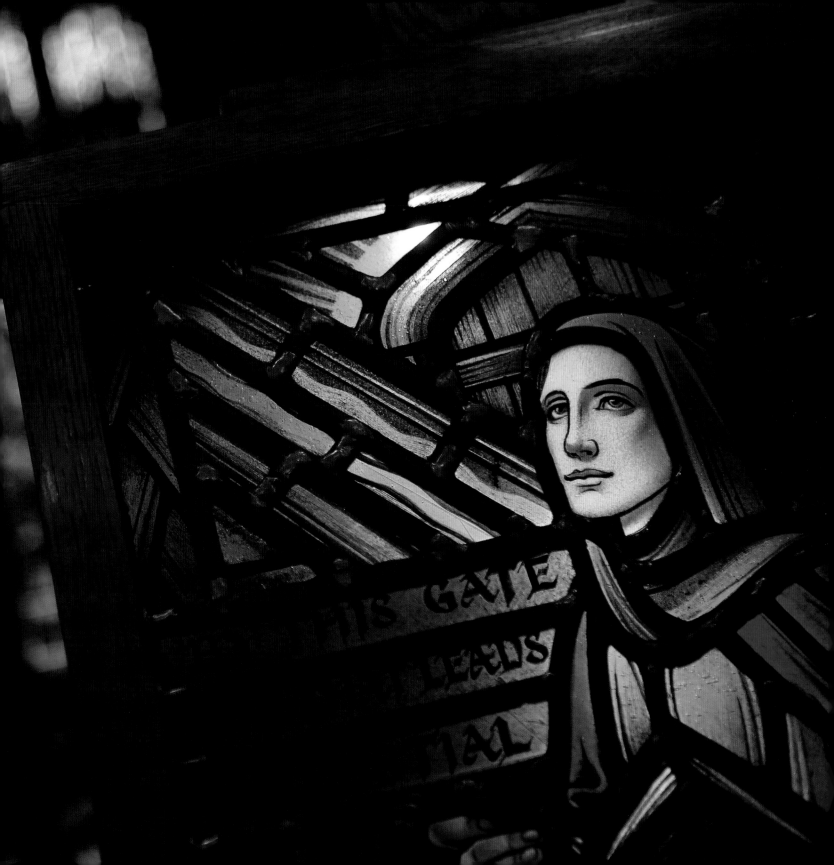

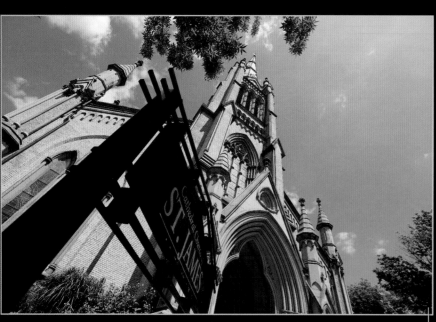

CATHEDRAL CHURCH OF ST. JAMES

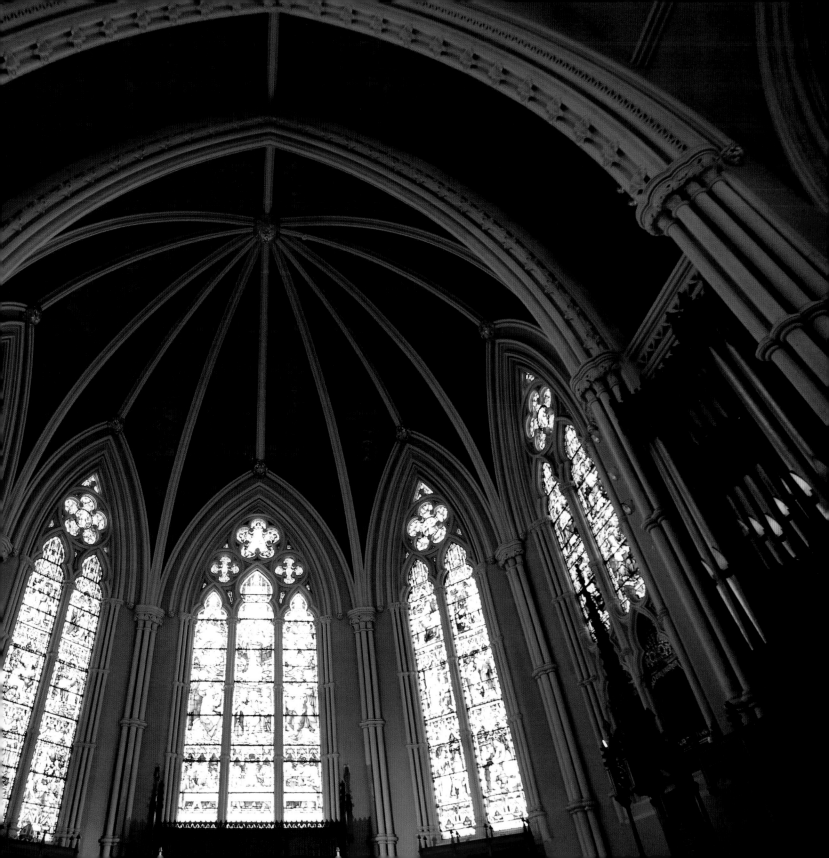

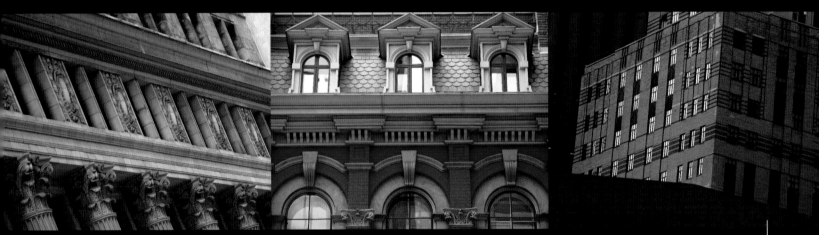

GLASS AND BRICK – OLD AND NEW
Downtown

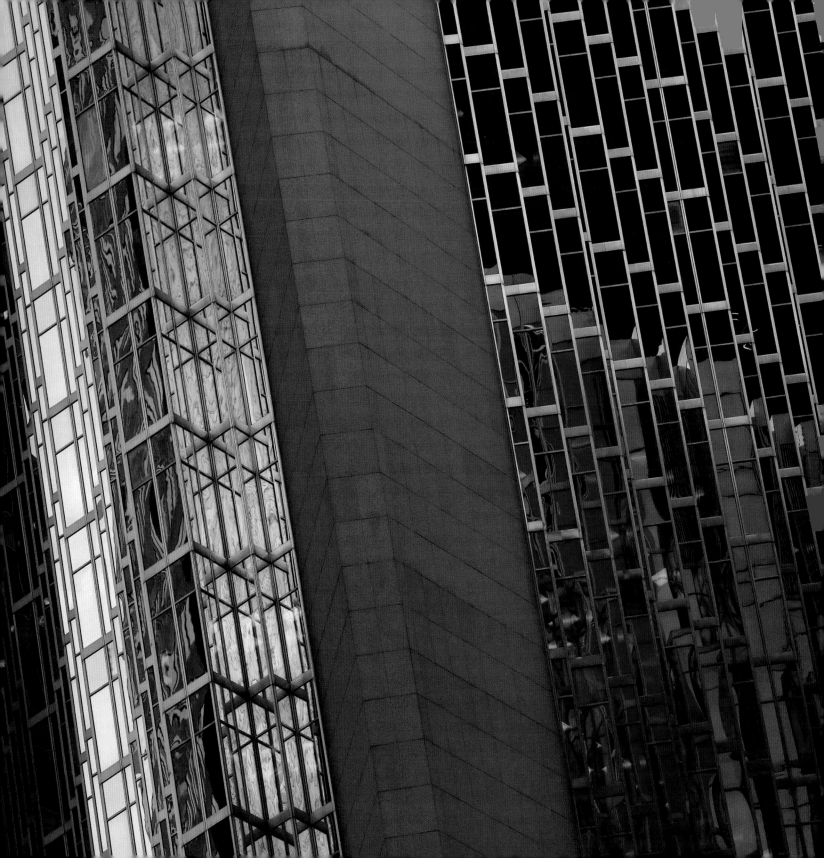

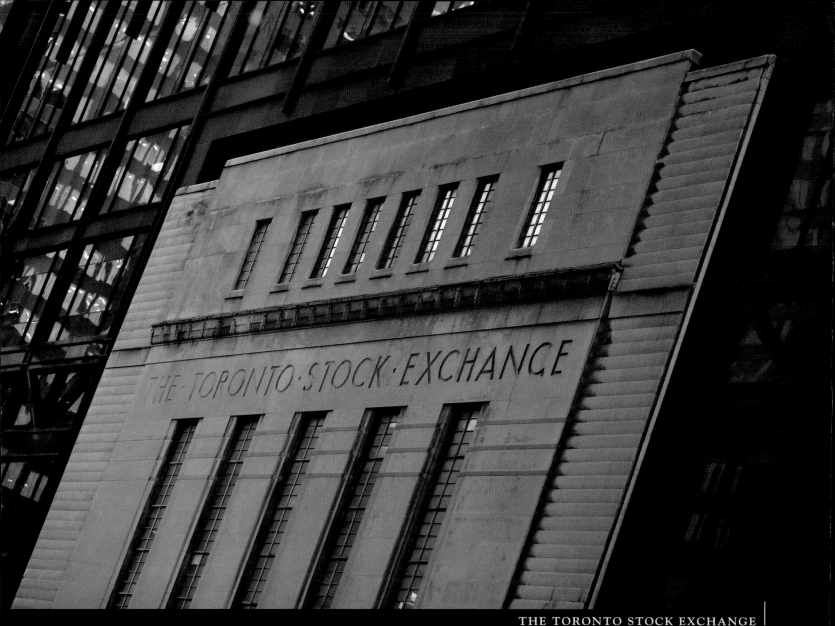

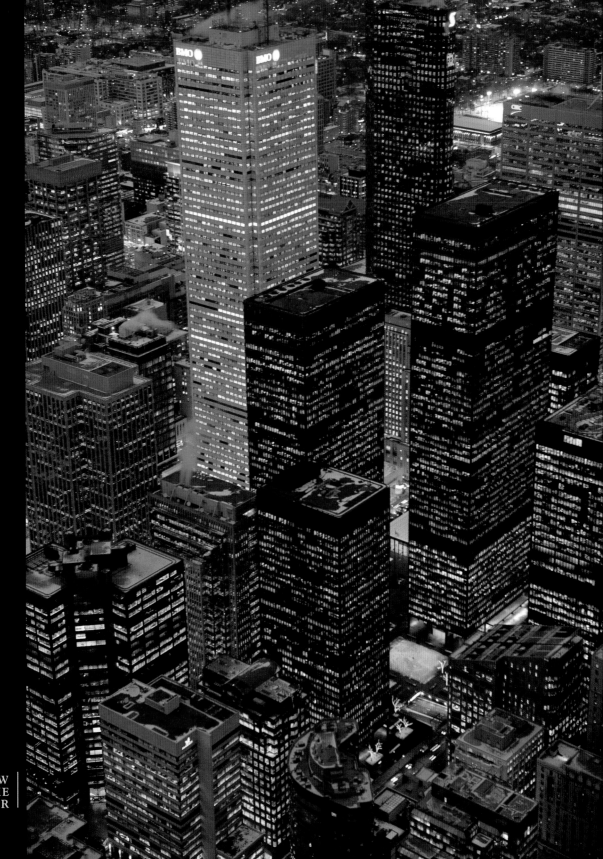

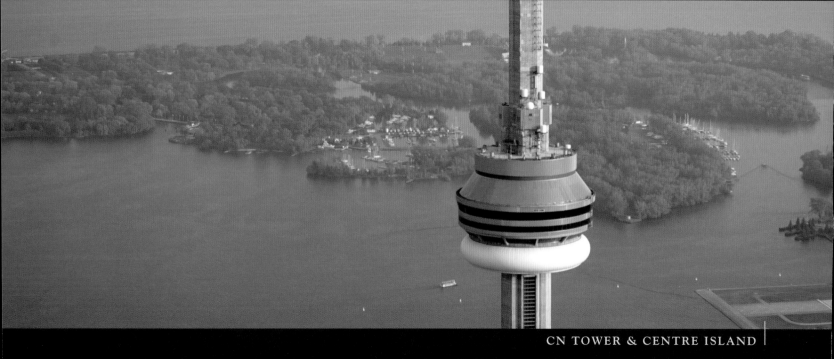

LANDSCAPES

The best way to arrive in Toronto is by air – and specifically, by turboprop – descending over the water to land at the northwestern tip of the Toronto Islands at Billy Bishop Airport. The approach affords a view of the city skyline unlike any other. Sizing up the metropolis from the north, you get a sense of the face it showed to Lake Ontario in the late 1920s, when the Royal York Hotel was new, and the Harbour Commission Building marked the southernmost extremity of the natural shoreline. But mostly you will be struck by the size and scale of the place, and of its great clusters of skyscrapers – from downtown to Mississauga, North York to Scarborough. There is nothing like the view on a clear, sunny day for range. But then, the sea of glimmering lights of the nighttime approach is singularly dramatic – an image that lingers. Arrival at dusk is an ideal compromise. Whatever the time of your approach your eye will be drawn to the blinking lights atop the CN Tower that soars above the rest of the skyline, with the dome at its base bathed in coloured light. The tower is a something of an anomaly in contemporary Toronto; the idea of wanting to build such a thing speaks of a different era, when the city was less confident, and overeager to force itself onto the international map. But the tower is very much here to stay – and periodically adds a new attraction so as to continue to draw the crowds. For anyone who has not had the privilege of flying over Toronto in a small plane, the view from the observation deck there offers some decent part of that experience at a fraction of the cost. In 1994, when it was still the tallest building in the world, it acquired something new that adds to that experience: a solid glass floor, for a clear view to the ground 342 metres below – one vantage you cannot get from a passenger plane, at least when all is going well. And those bold enough to find that an inadequate thrill may venture outside onto the EdgeWalk, an open ledge that encircles the tower at a height of 356 metres, which makes it the world's highest (and least relaxing) deck.

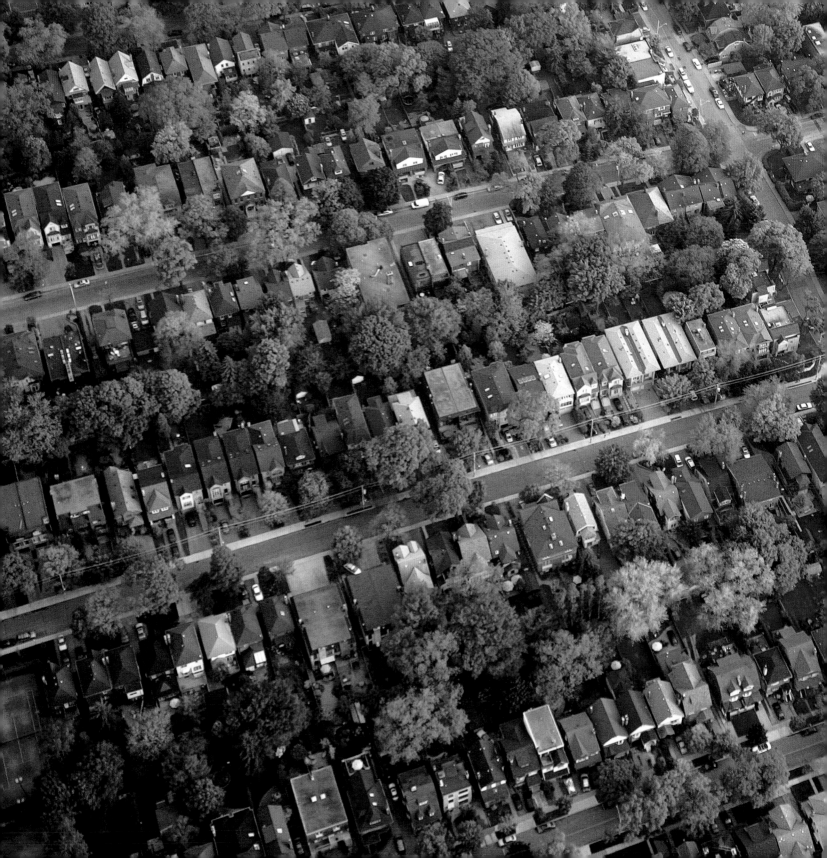

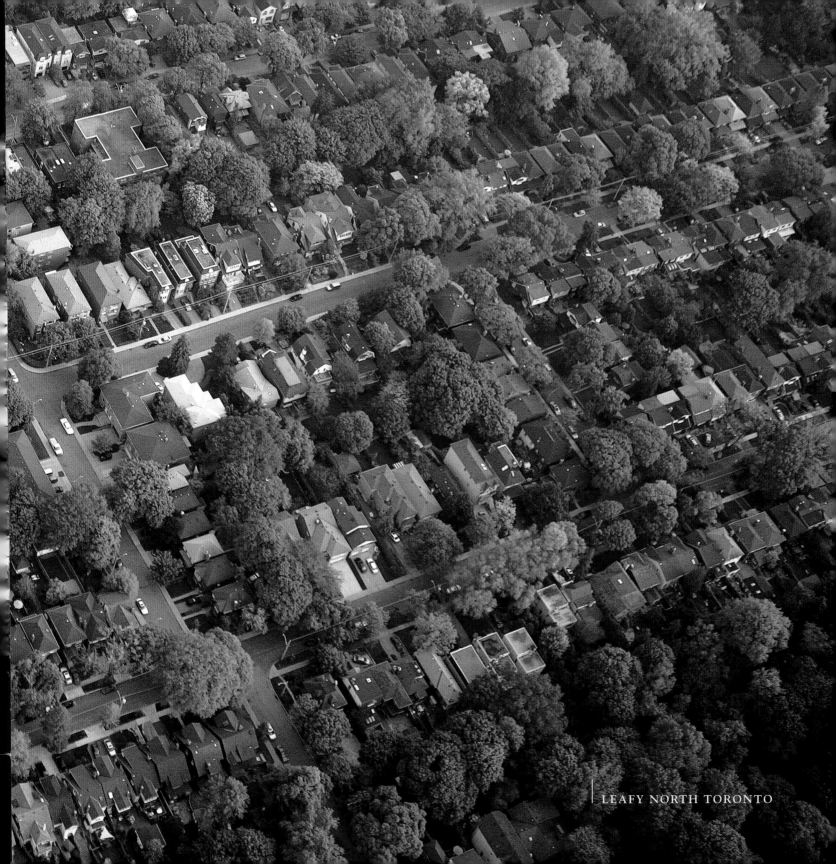

LEAFY NORTH TORONTO

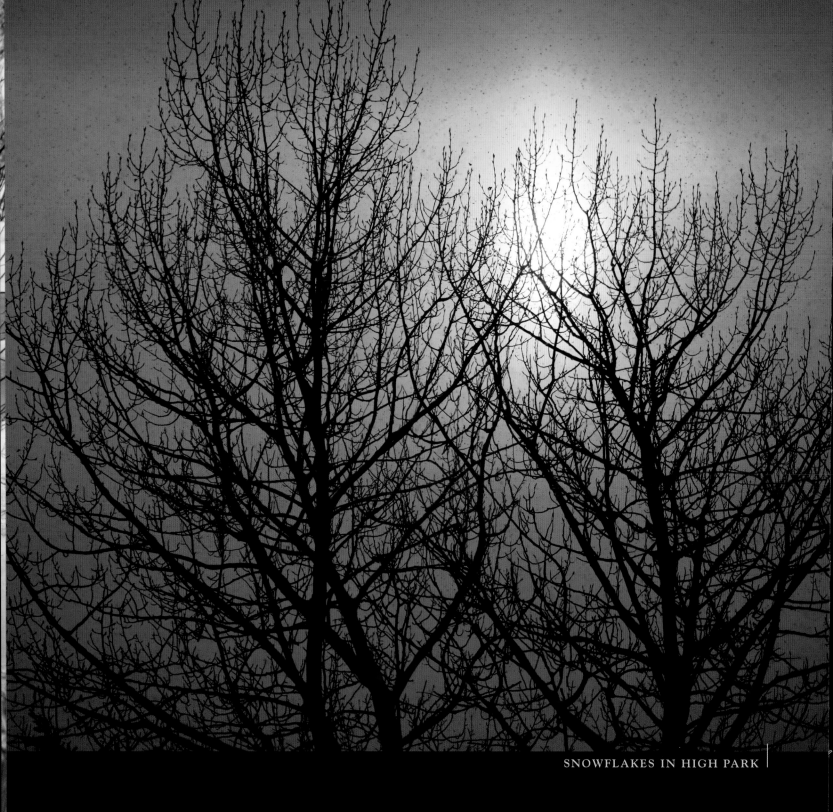

SNOWFLAKES IN HIGH PARK

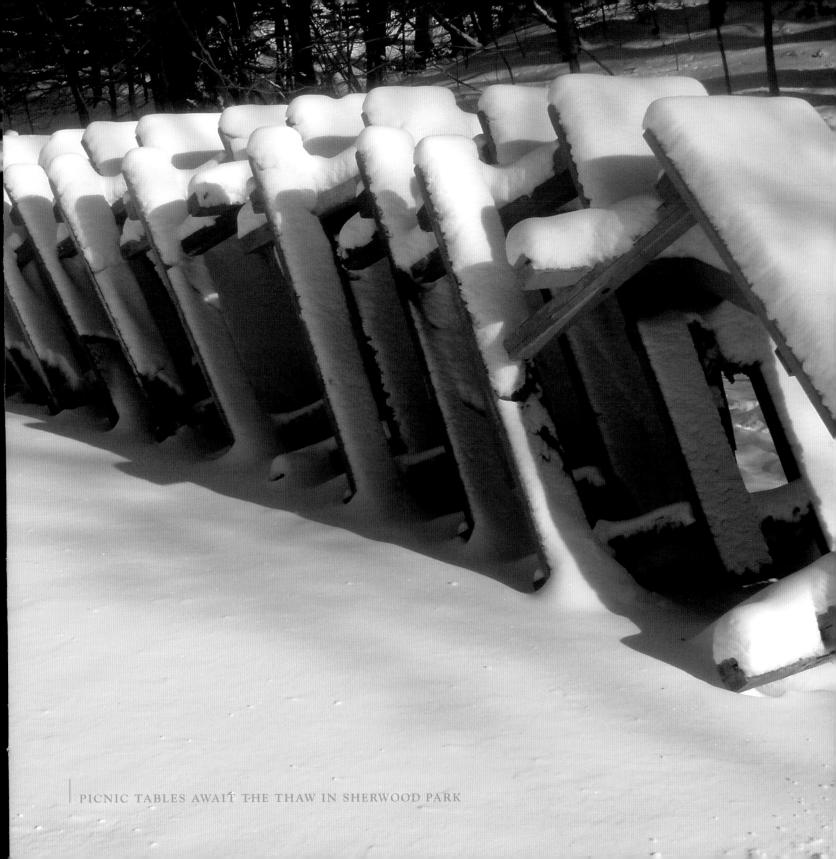

PICNIC TABLES AWAIT THE THAW IN SHERWOOD PARK

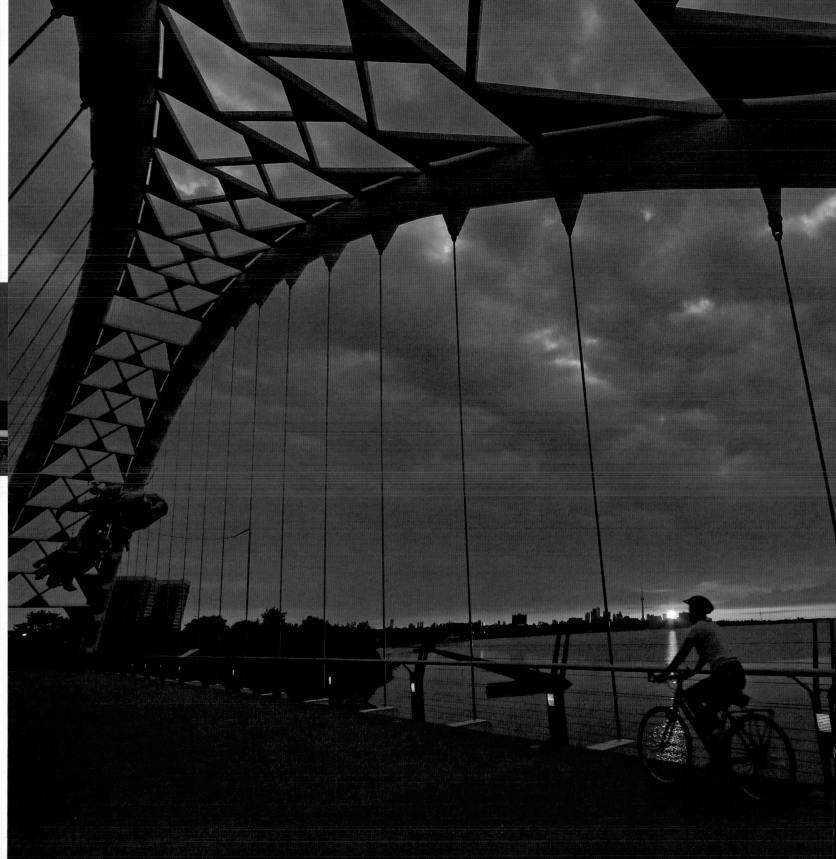

HUMBER BRIDGE AT SUNRISE

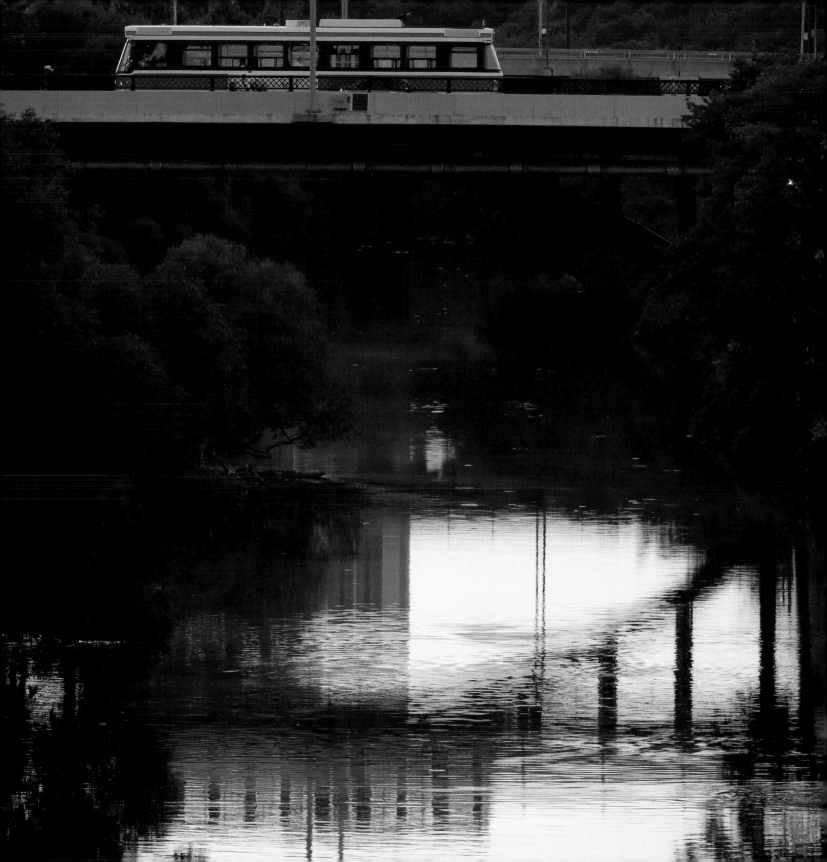

STREETCAR CROSSES THE DUNDAS STREET BRIDGE OVER THE DON RIVER

*This river I step in
is not the river I stand in.*

THE QUEEN STREET BRIDGE

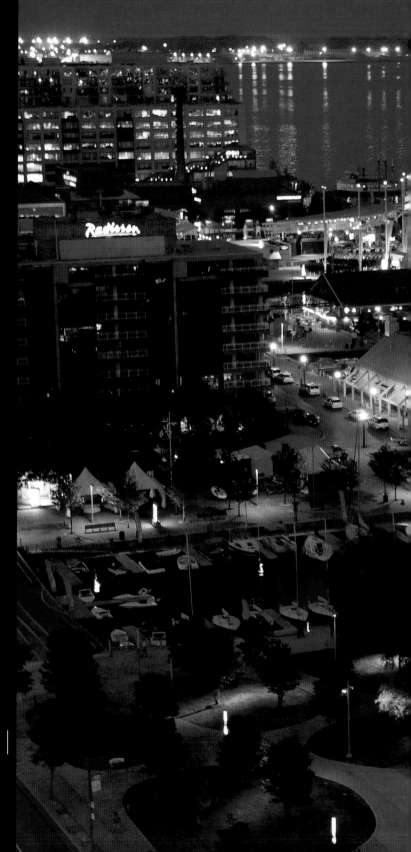

THE DOCKS AT HARBOURFRONT

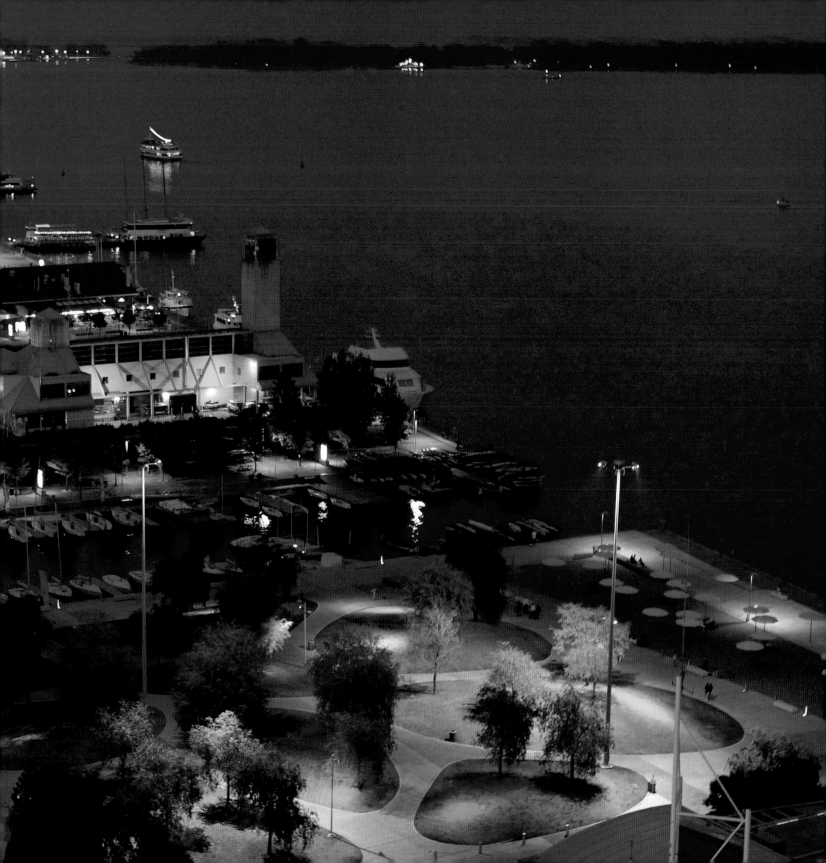

A MORNING MIST BLANKETS LAKE ONTARIO

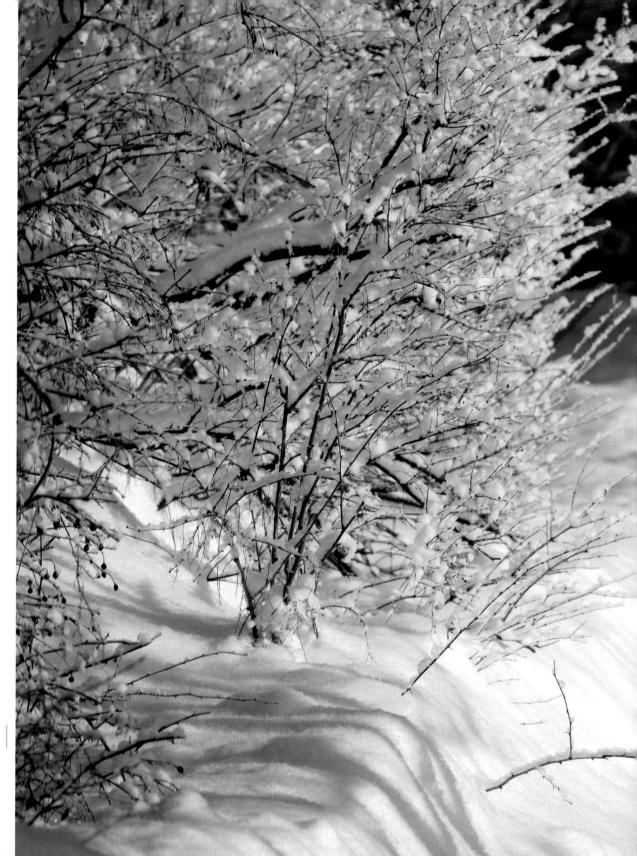

A FRESH SNOWFALL
IN HIGH PARK

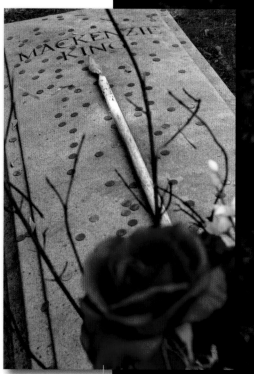

WILLIAM LYON MACKENZIE KING
1874-1950

A MAUSOLEUM IN MOUNT
PLEASANT CEMETERY

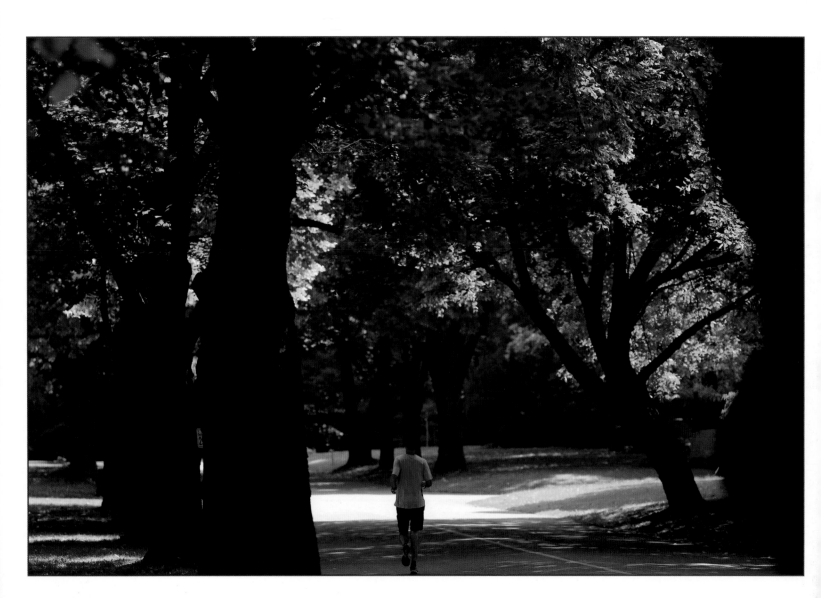

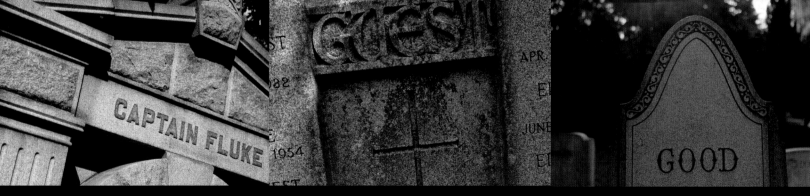

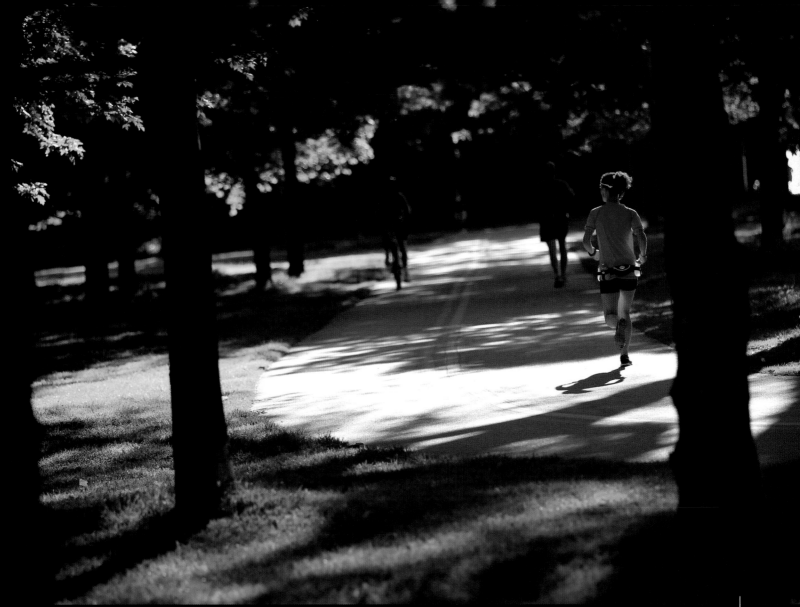

STAYING FIT IN THE BEACHES

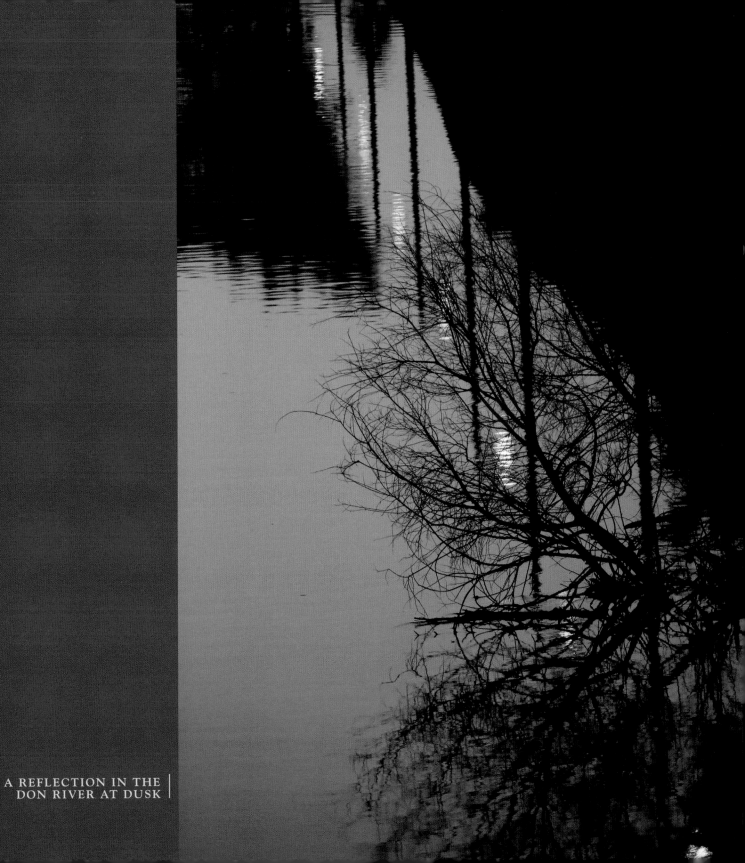

A REFLECTION IN THE
DON RIVER AT DUSK

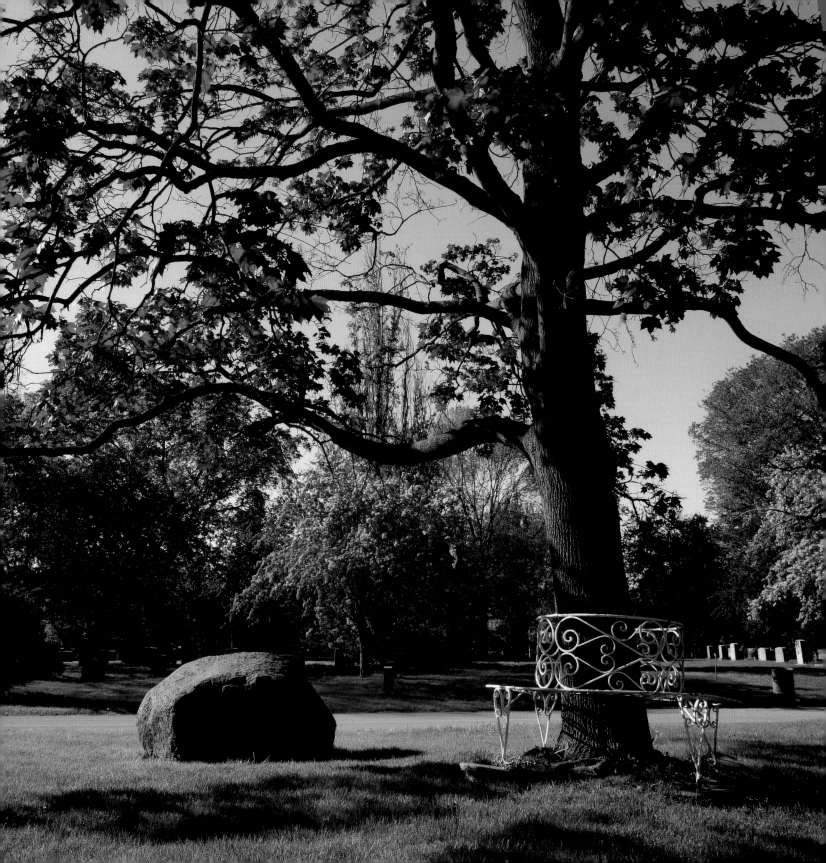

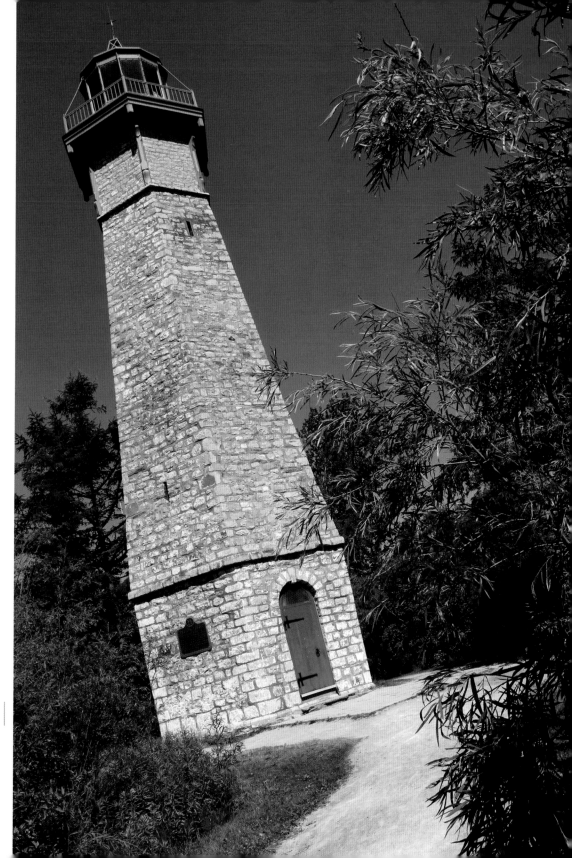

GIBRALTAR POINT
LIGHTHOUSE
Centre Island

MOUNT PLEASANT
CEMETERY

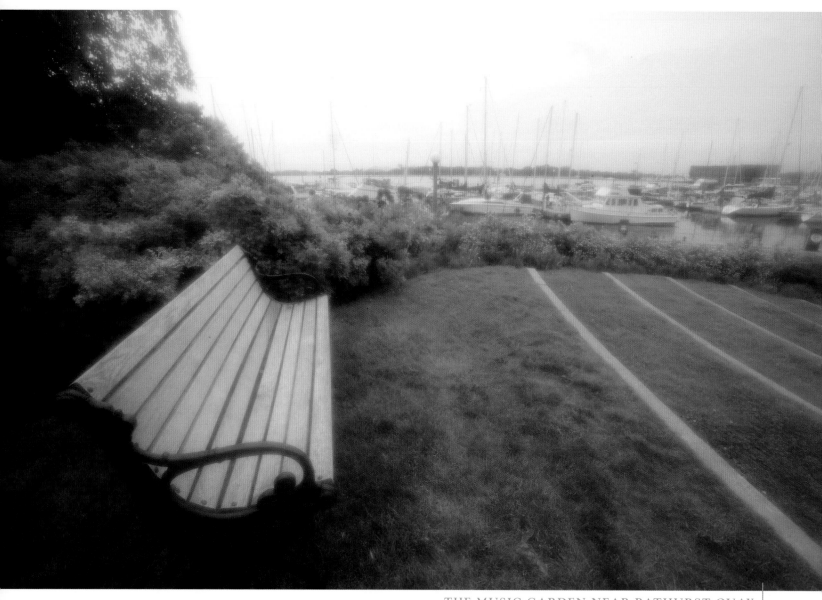

THE MUSIC GARDEN NEAR BATHURST QUAY

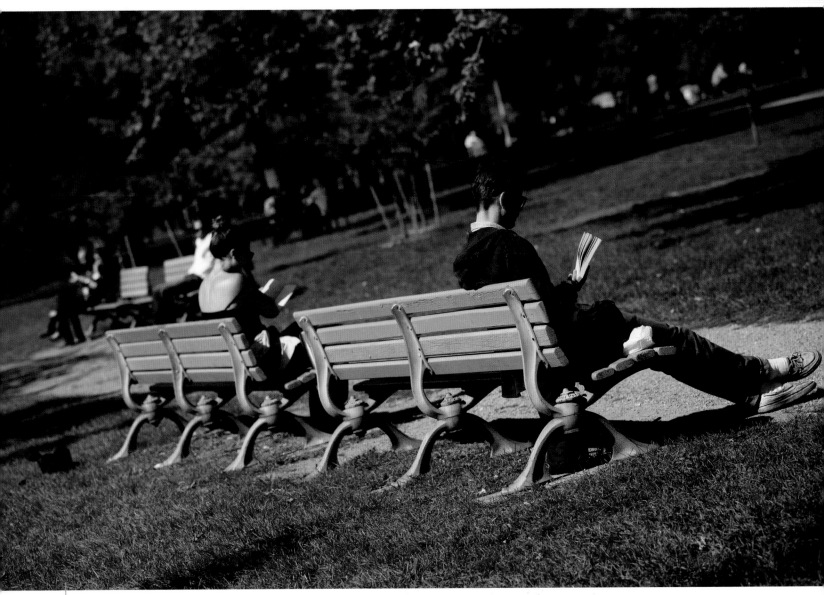

TRINITY BELLWOODS PARK

ROUGE PARK

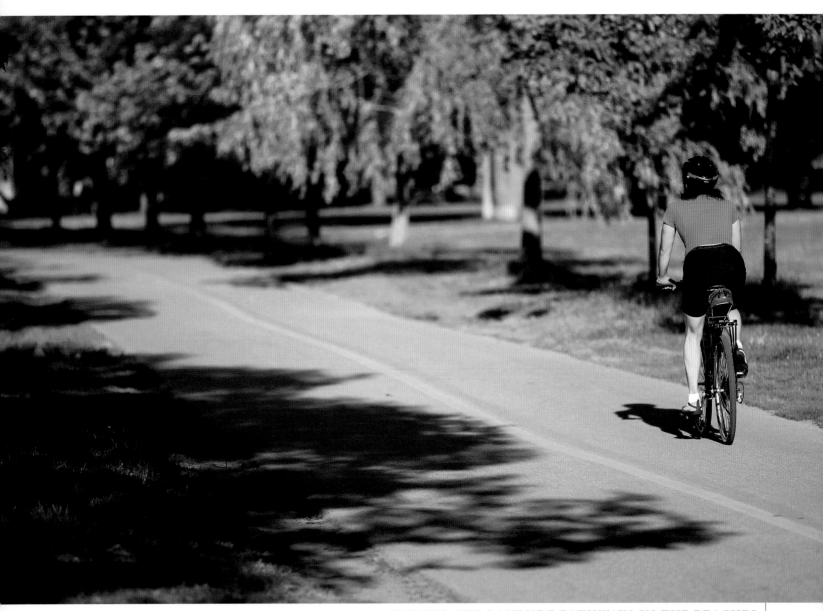

CYCLING THE LAKESIDE PATHWAYS IN THE BEACHES

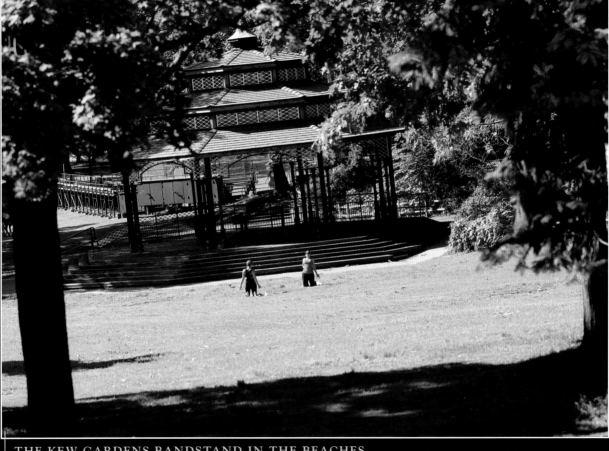

THE KEW GARDENS BANDSTAND IN THE BEACHES

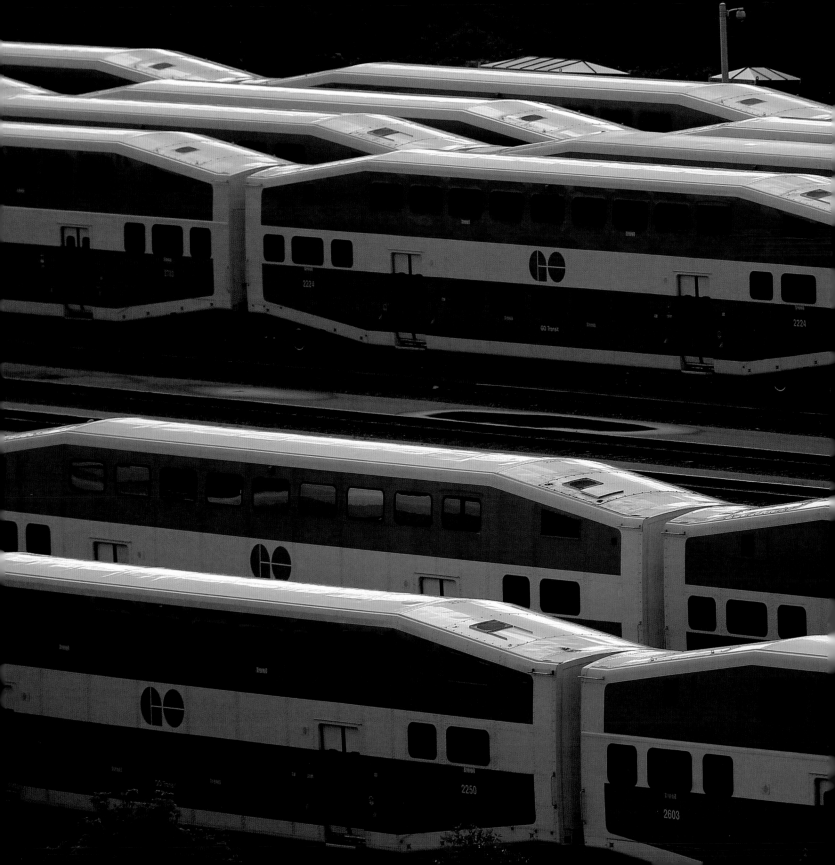

GO TRAINS AT REST NEAR UNION STATION

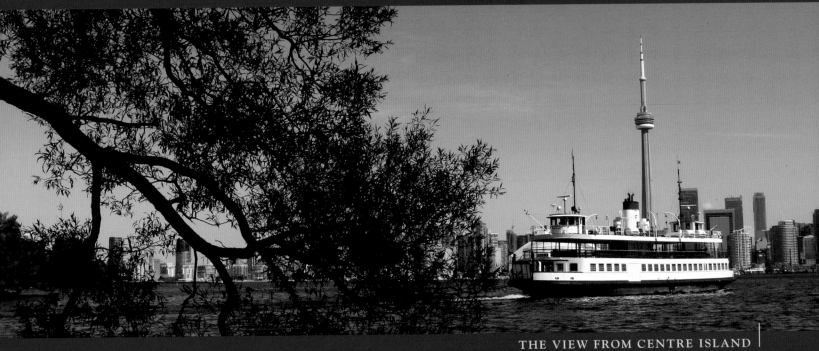

THE VIEW FROM CENTRE ISLAND

III LAKESCAPES

East of the old City of Toronto, just past the newly trendy district of Leslieville, lies The Beach – or The Beaches, as most people call it. The community itself hinges on Queen Street East, and is bordered by Woodbine Avenue at the west and Fallingbrook to the east, with a northern border of Kingston Road. But what matters is less the district than the beach proper which lends it its name, a sandy expanse of Lake Ontario shoreline that stretches nearly four uninterrupted kilometres, from the southern tip of Woodbine Park all the way to the R.C. Harris Water Treatment Plant (or the Water Works, as it is locally known). Technically four separate beaches make up the whole: Balmy, Scarborough, Kew, and Woodbine. They are contiguous, and so very nearly is the wide boardwalk that follows their collective shoreline, a favourite for joggers and dog walkers. A paved path alongside serves cyclists well. And on the beach proper, hot days bring volleyball matches and Frisbee and all the usual madness of a nice beach – including swimming, in the improved local waters (three-quarters of the Beach – Kew, Balmy, and Woodbine – are typically proclaimed clean enough for swimming). Those who speak disparagingly of the Toronto waterfront and its haphazard evolution do not know the Beach – they are thinking of downtown, and Harbourfront. But that is changing, too – and quickly. At the foot of Cherry Street, Cherry Beach has the best water quality of any Toronto beach, which helps make it a local favourite for windsurfing and kitesurfing. The summer of 2012 brought more revival in the form of Sugar Beach, at the foot of Jarvis Street alongside Corus Quay and the Redpath Sugar Building. No swimming here, but plenty of sand, umbrellas, Muskoka chairs, and imaginative lighting. Formerly a mere parking lot for the Jarvis Street slip, the park north of the beach now hosts open-air concerts. The west end has Sunnyside Beach, which hosts Dragon Boat races and rowing competitions. And then there are the islands – Centre and Ward's – each a short ferry ride from downtown and a perfect escape for a hot summer's day, with tree-lined parks, picnic areas, and even an amusement park for tiring out the kids before returning them to a hot night in the city.

THE CENTRE ISLAND FERRY
REFLECTED IN LAKE ONTARIO

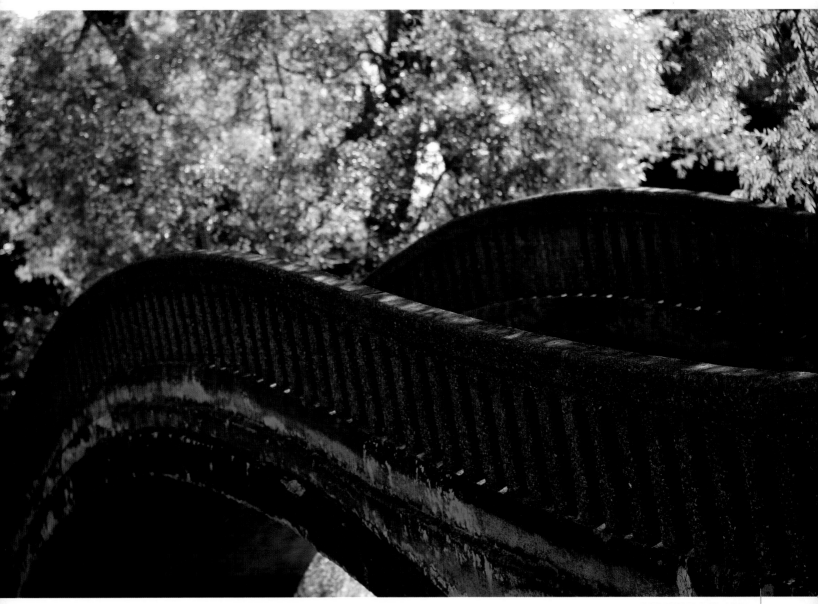

CENTRE ISLAND

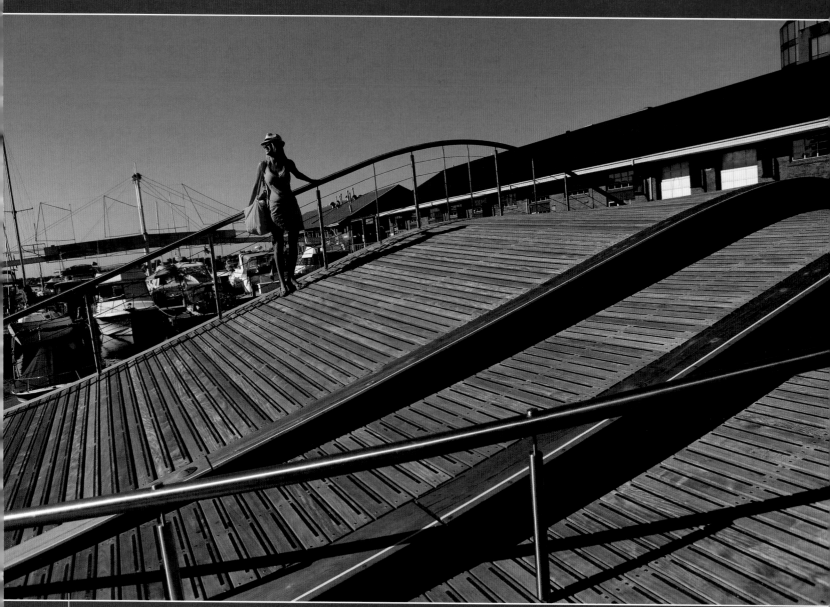

SIMCOE WAVE DECK AT HARBOURFRONT

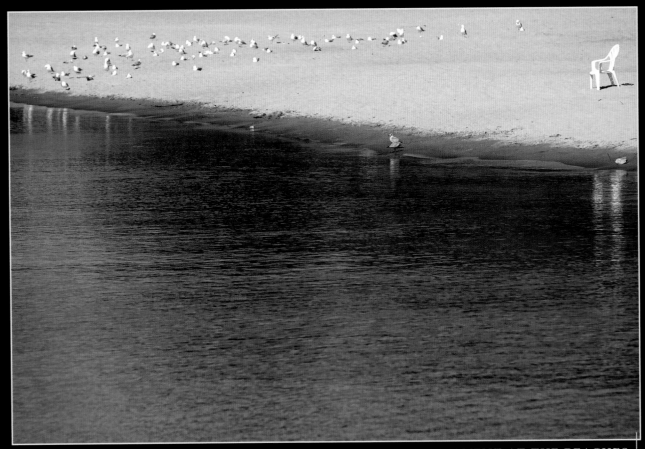

A QUIET MOMENT AT THE BEACHES

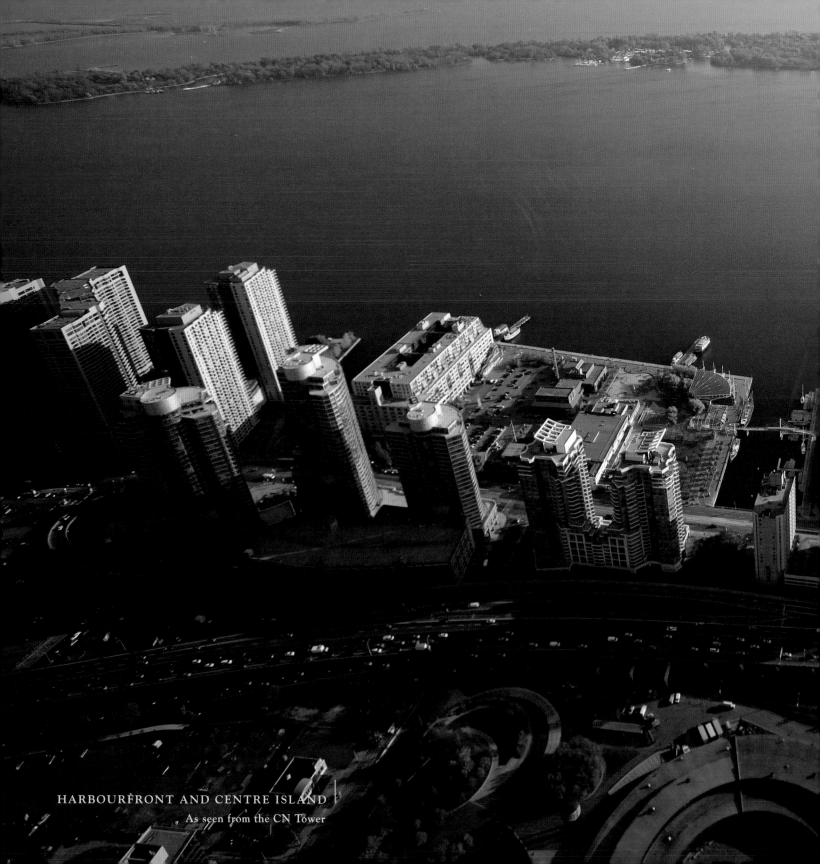

HARBOURFRONT AND CENTRE ISLAND
As seen from the CN Tower

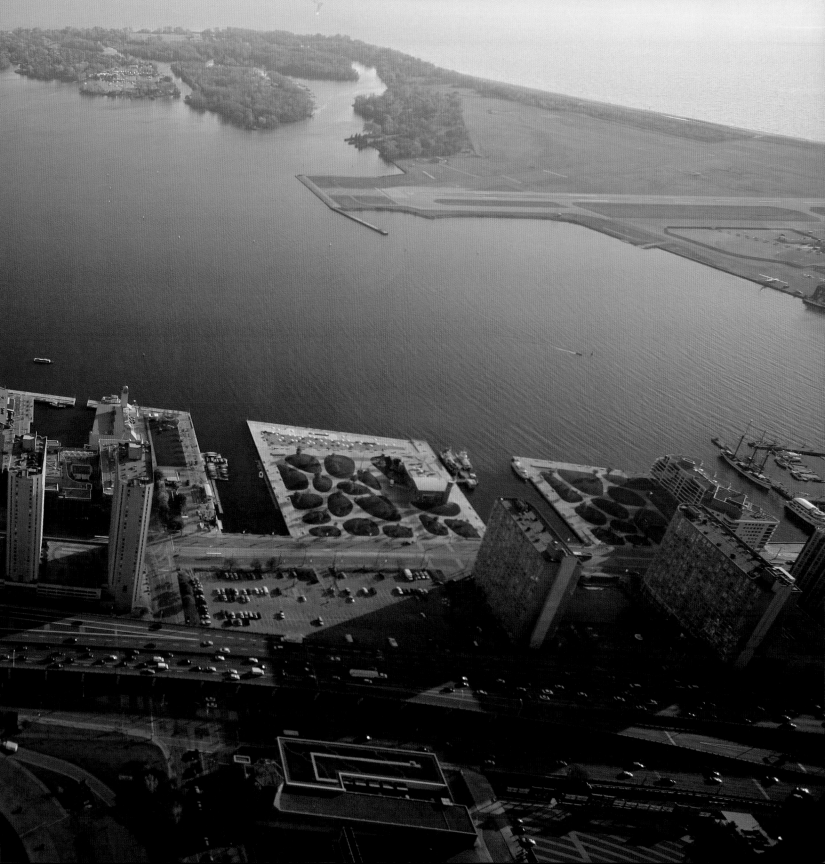

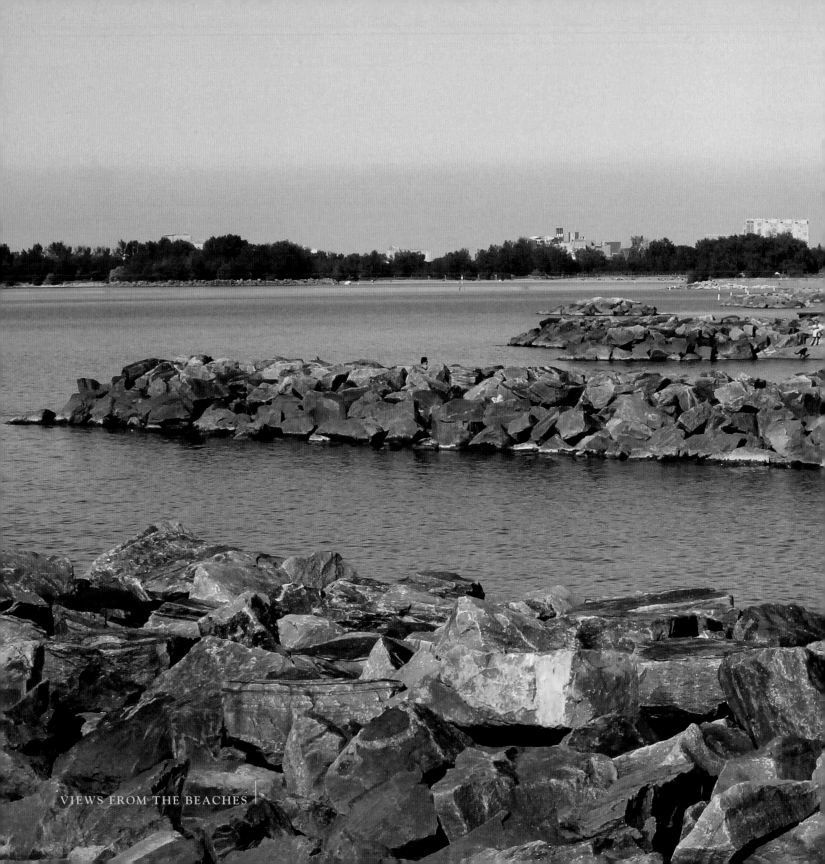

VIEWS FROM THE BEACHES

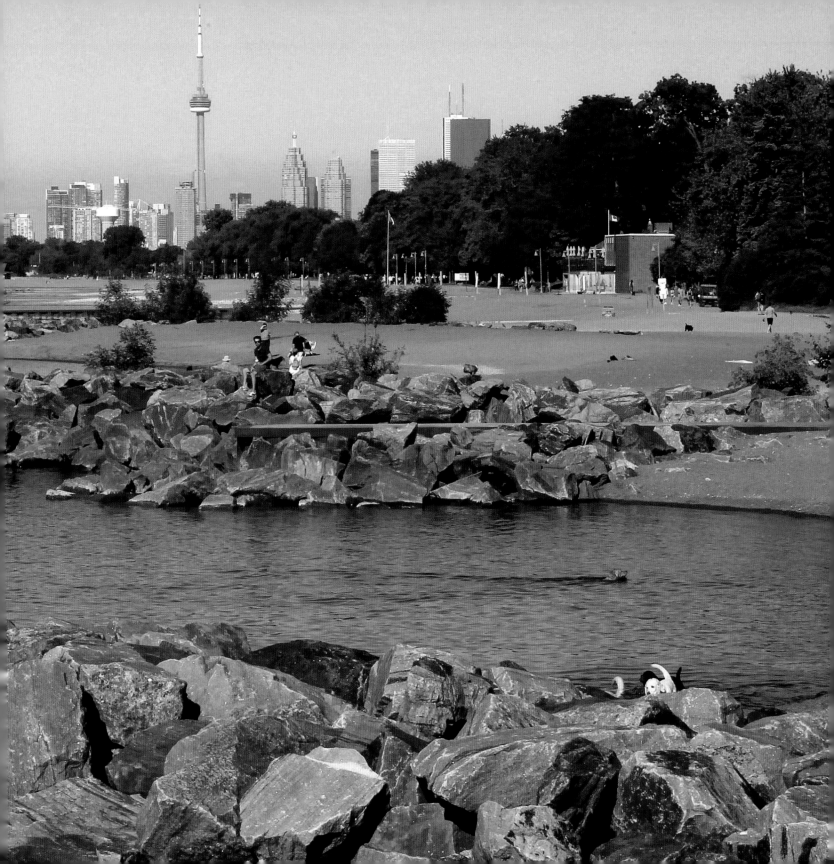

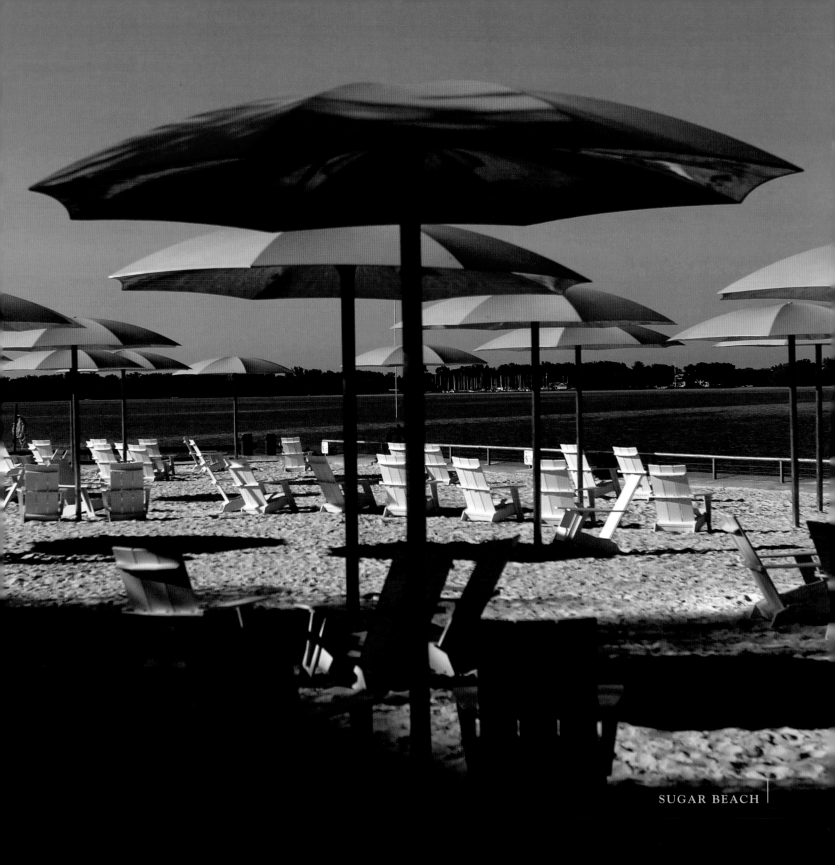

SUGAR BEACH

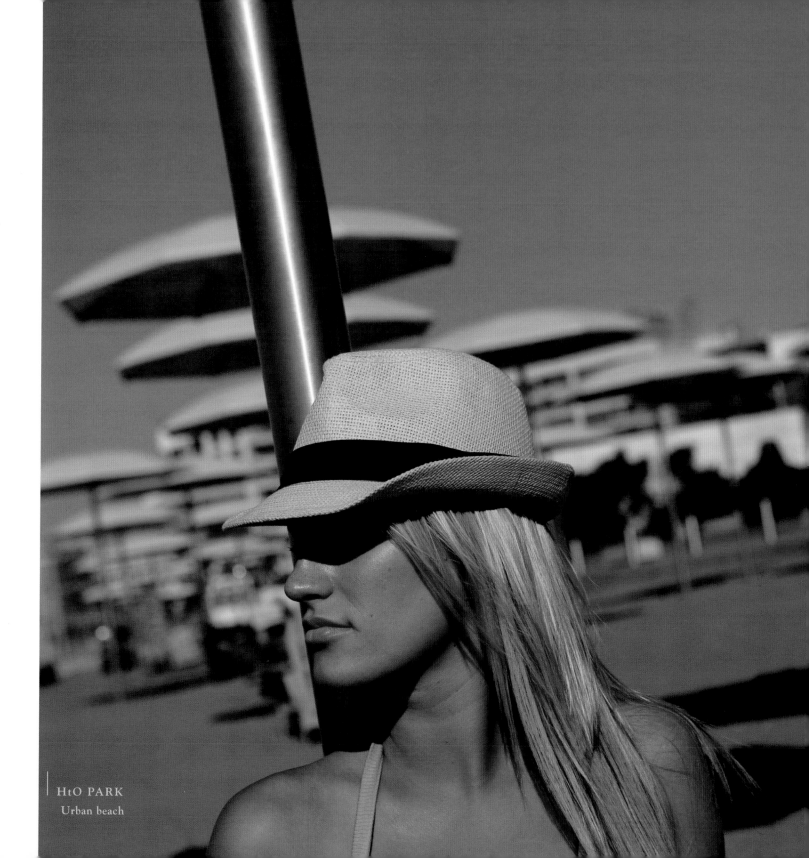

HtO PARK
Urban beach

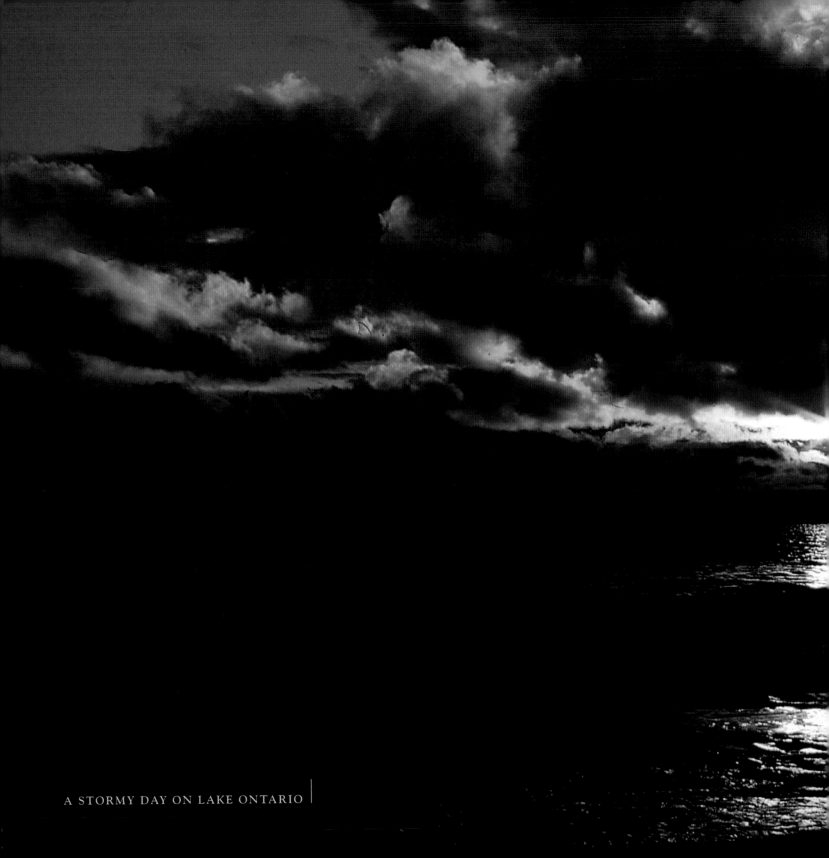

A STORMY DAY ON LAKE ONTARIO

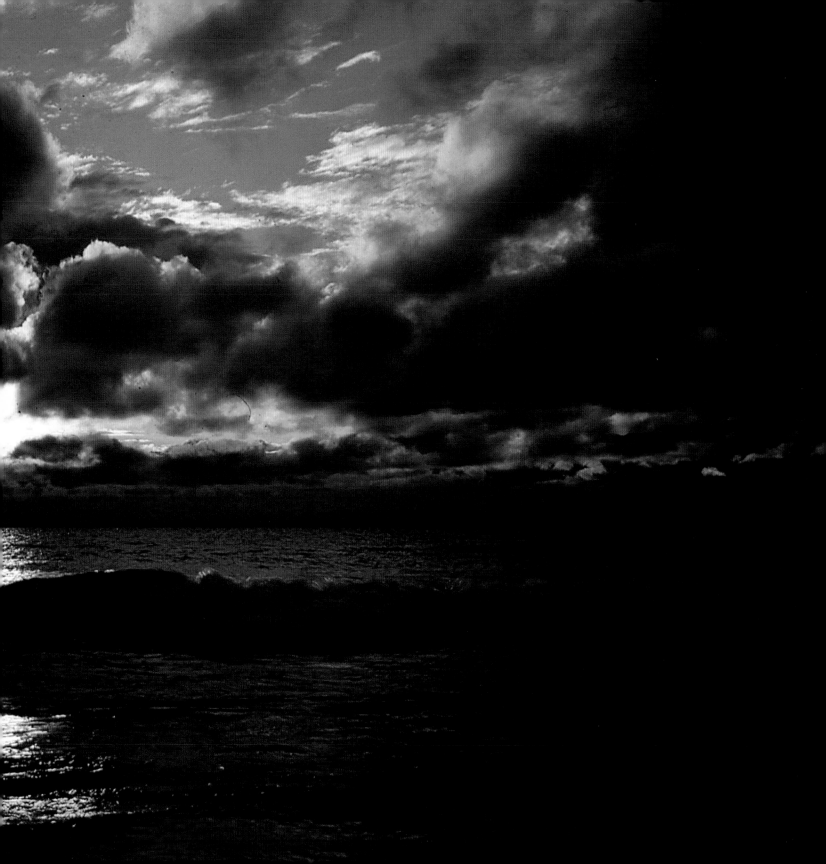

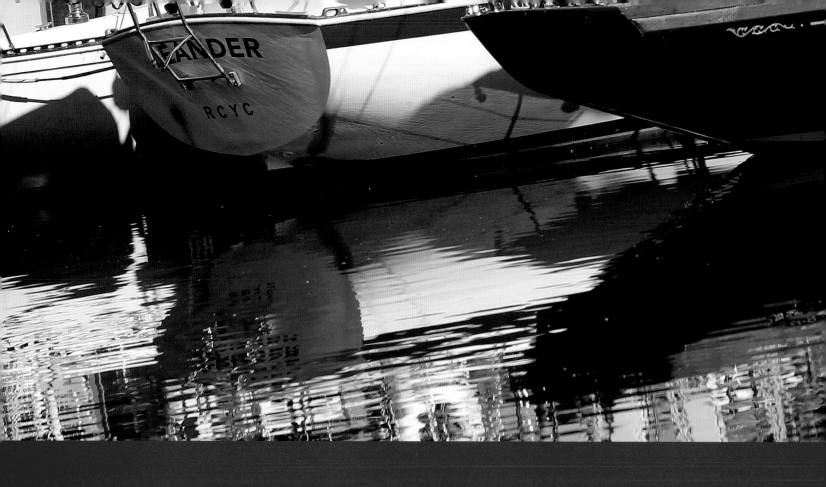

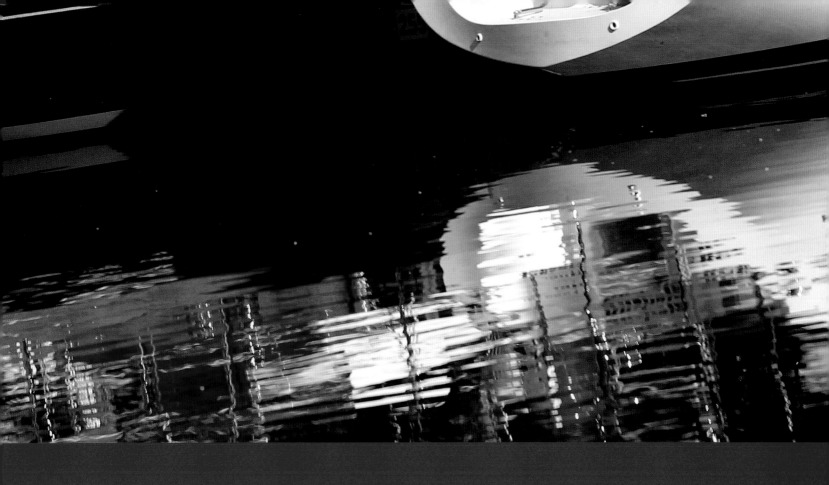

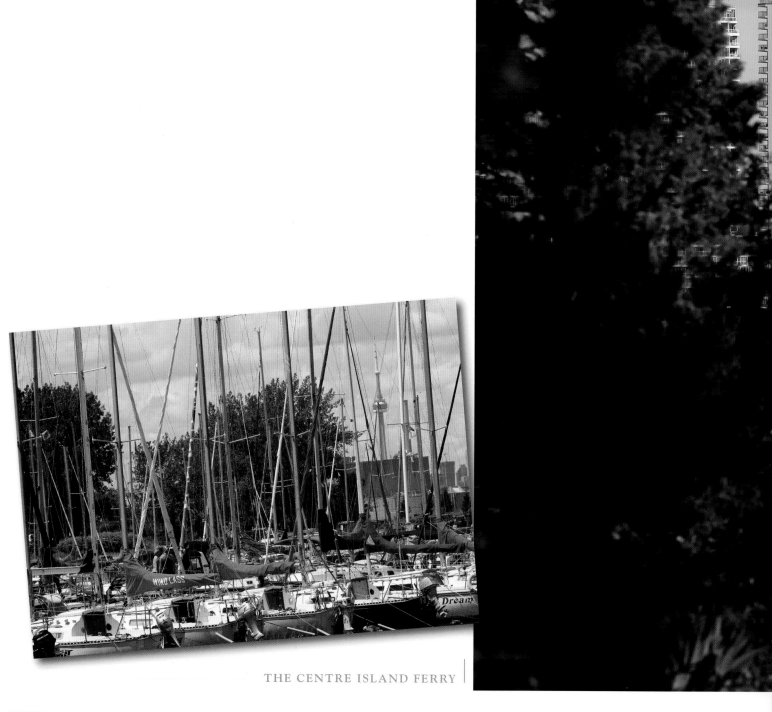

THE CENTRE ISLAND FERRY

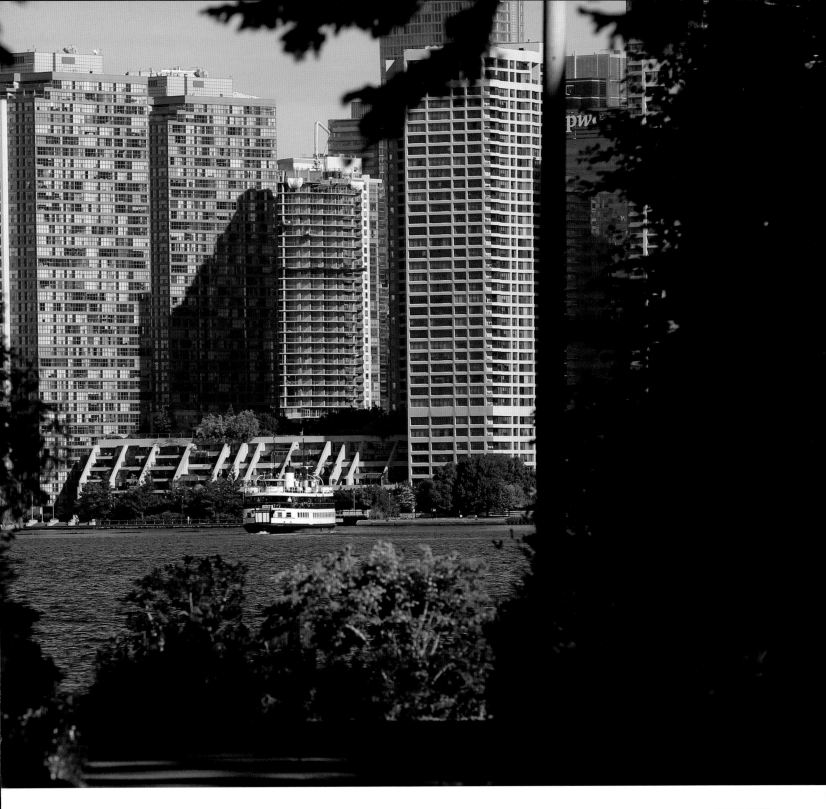

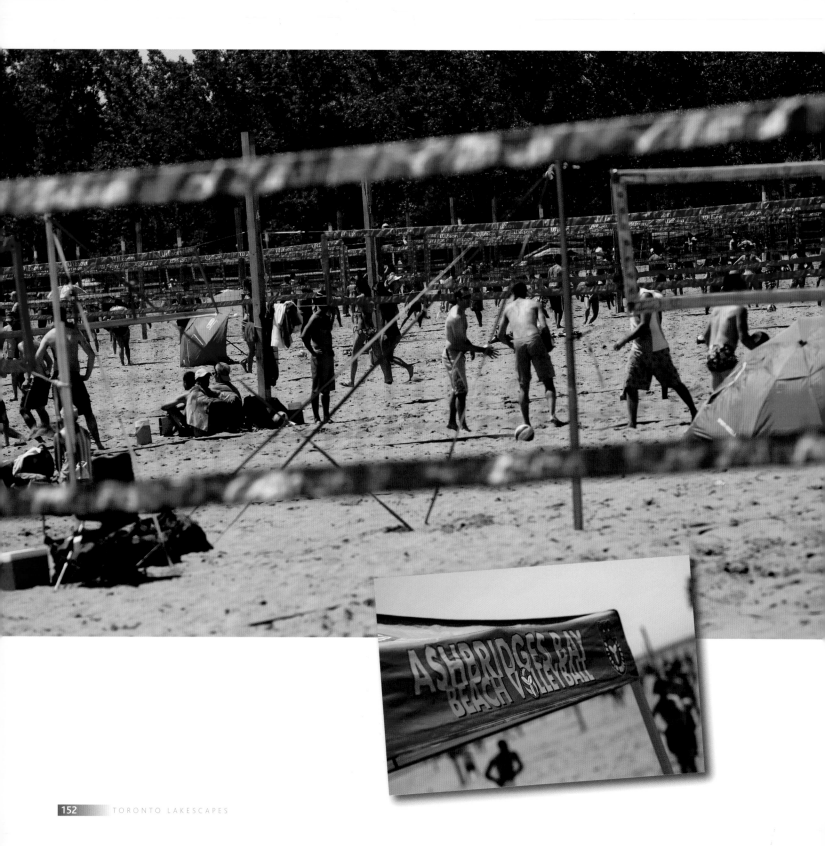

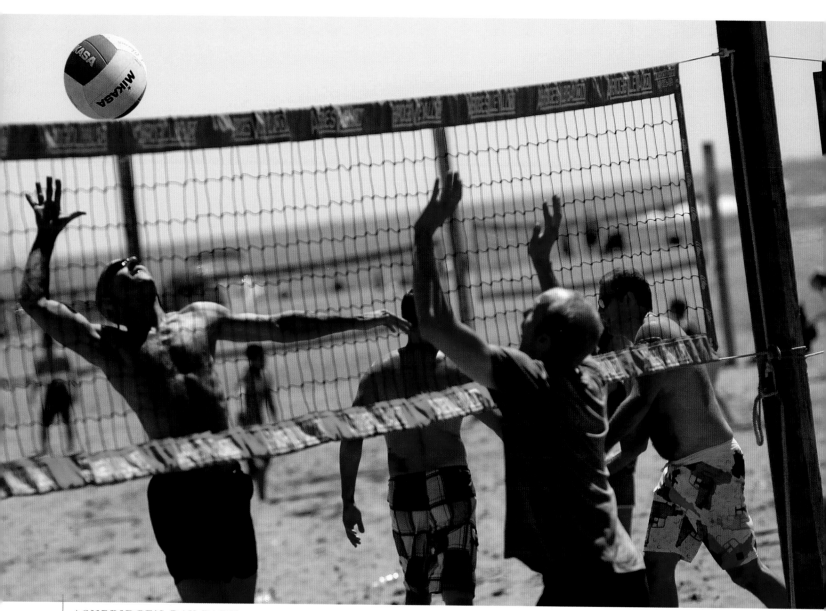

ASHBRIDGE'S BAY PARK

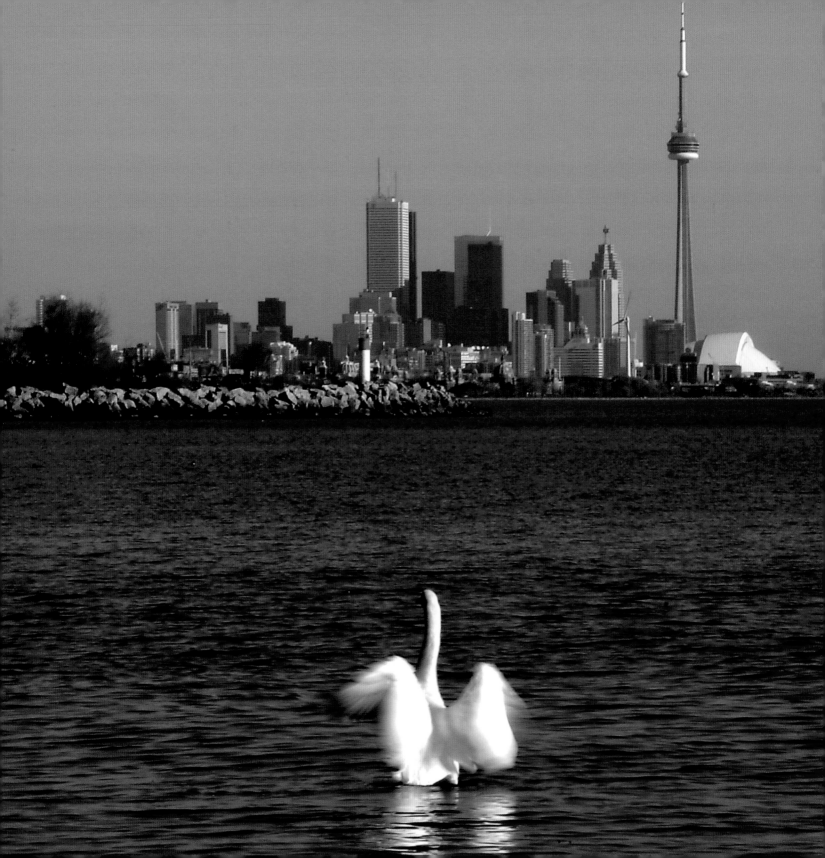

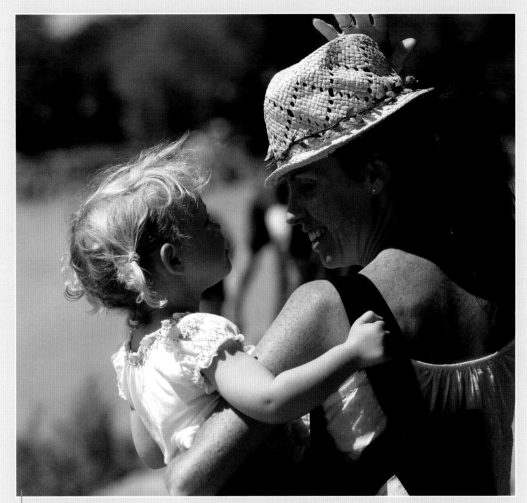

A SUNDAY MORNING STROLL ON THE BEACHES BOARDWALK

THE VIEW NORTH-EAST
from the historic neighbourhood of Mimico

THE MANY WAYS TO ENJOY HARBOURFRONT ON THE WATER

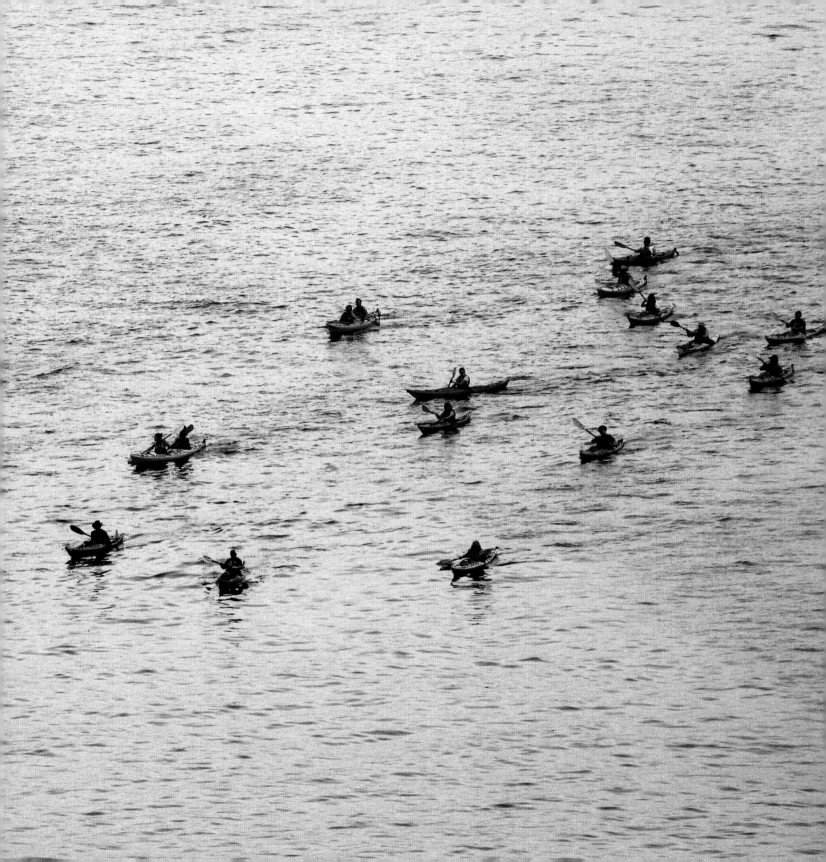

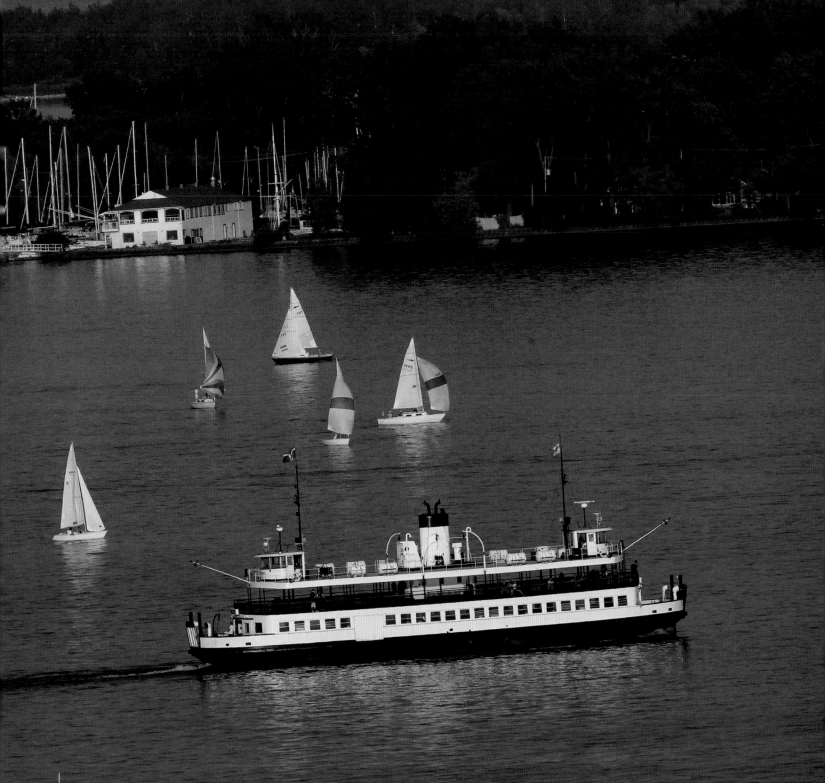

BOATING AT HARBOURFRONT

SUMMER IN THE BEACHES

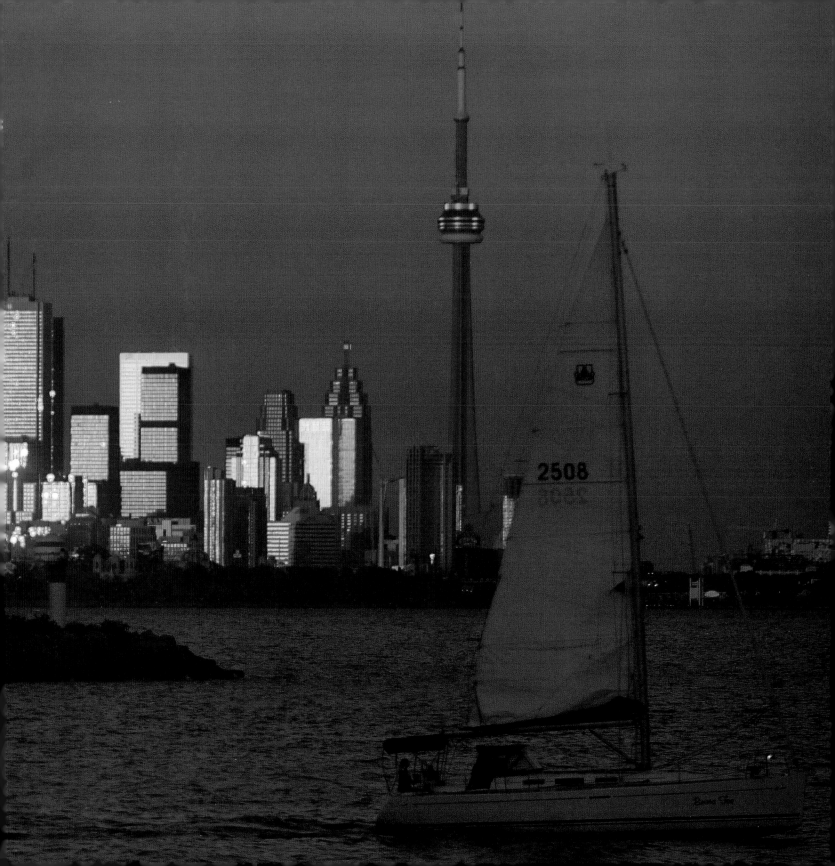

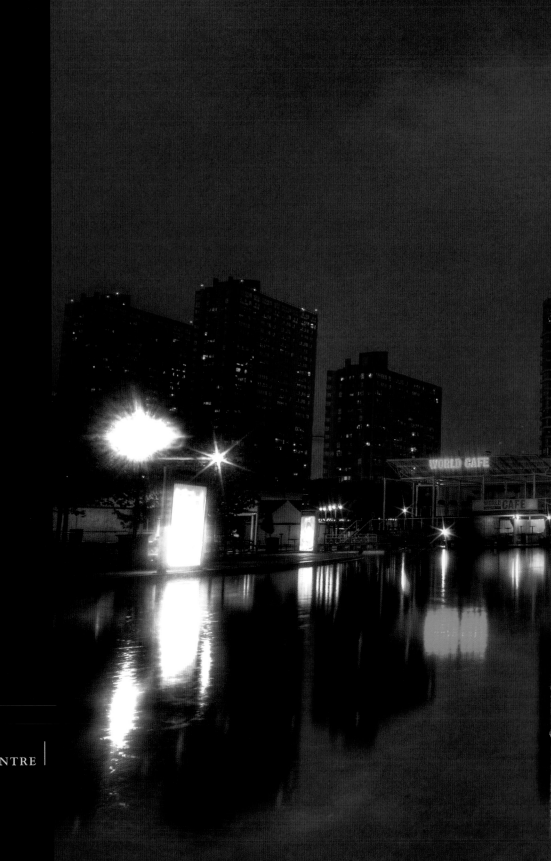

WATERFRONT CENTRE

LAKESCAPES

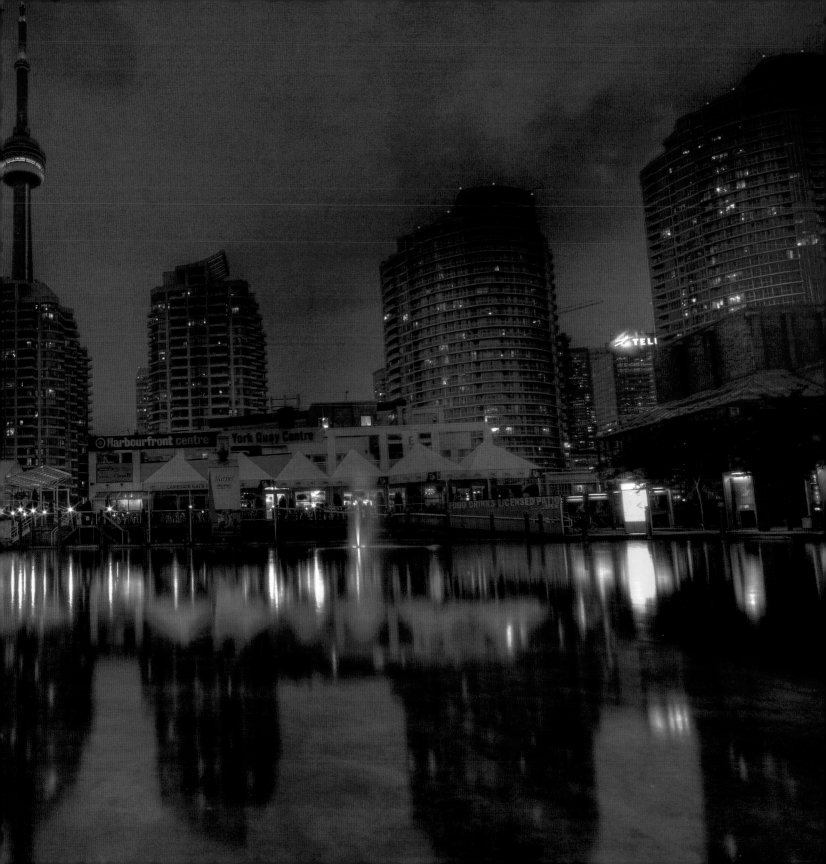

ESCAPES

IV

A walk along a meandering, hilly path in High Park, beneath a canopy of pink cherry blossoms is springtime at its most magnificent. But then in those 161 hectares of west Toronto John George Howard bequeathed to the city there may be some other activity you prefer: a hike beneath the black oaks of its oak savannah, a stroll past the gardens of Colborne Lodge Road, a spot of fishing in Grenadier Pond. While High Park is the largest and grandest of the city's parks, it has a lot of company. The sixty hectares of Sunnybrook feature a spectacular network of bike paths and trails, to be enjoyed on bike or foot or from the vantage of a borrowed steed from Sunnybrook Stables. But escaping urban life is not all about pretending that you are in the countryside. Some of the best diversions on offer here are celebrations of our urban life itself – namely in the form of a summer-long procession of festivals that commemorate the city's nearly incalculable diversity. The spectacular arts scene spans the country's best theatre and opera house to the casual groove of the annual Toronto Jazz Festival. The multicultural face of the city finds joyful and inclusive expression in festivals from the Scotiabank Toronto Caribbean Carnival (Caribana) to the Taste of the Danforth, while sexual freedom is celebrated by just about everyone but the mayor at Pride Week, built around the largest gay parade in North America. Then there are the sporting arenas like the Rogers Centre, home to the Canada's only professional baseball team. For those who need to get away in the more literal sense, Niagara Falls is but an hour's drive away. And of course Pearson Airport is a gateway, offering more direct flights to more desirable destinations than any other Canadian hub – and come next year, will finally even boast a few decent places to eat while you wait for your flight out of town.

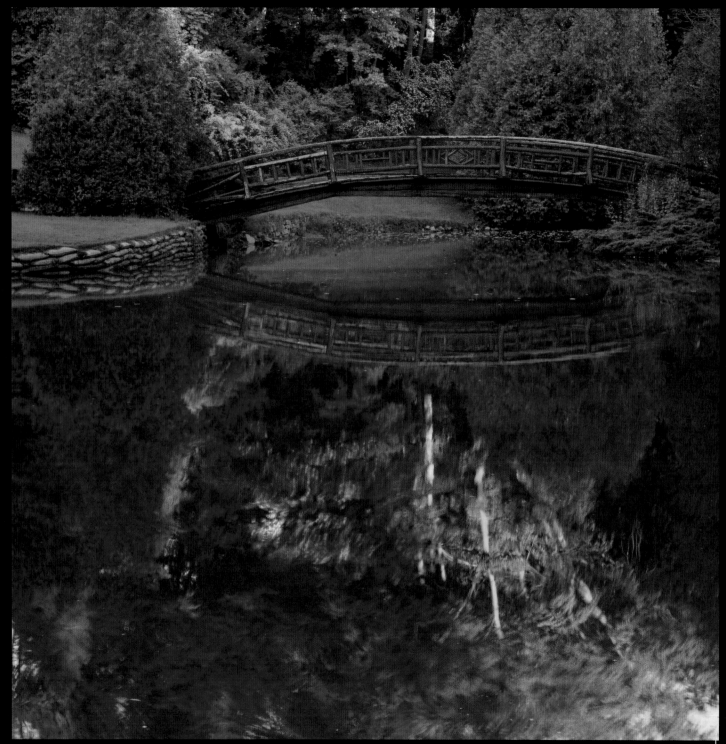

EDWARD'S GARDENS

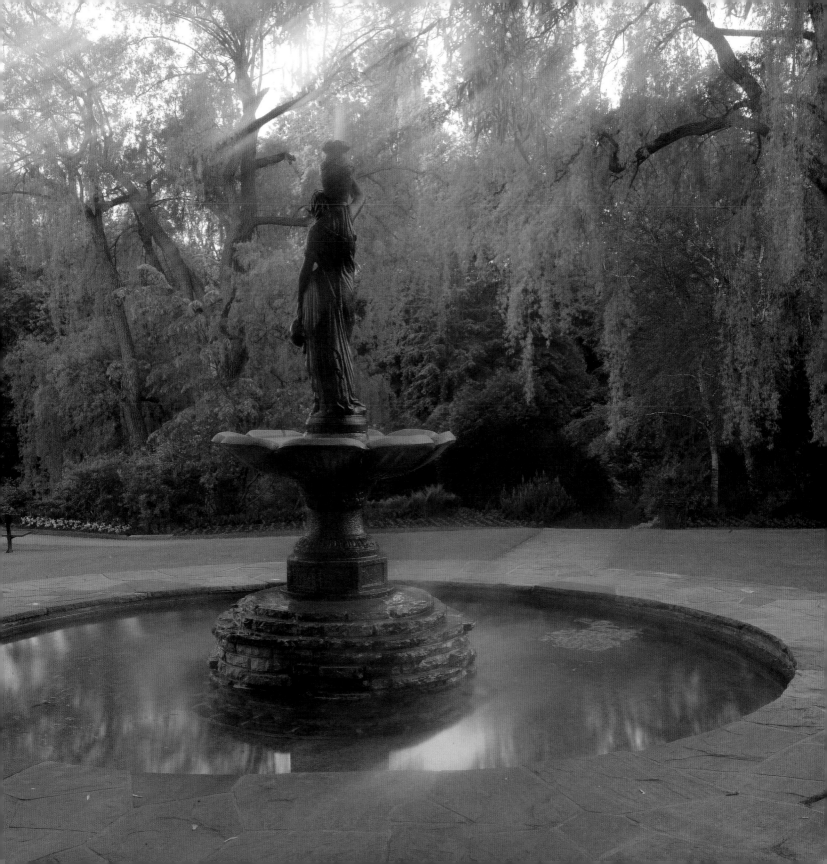

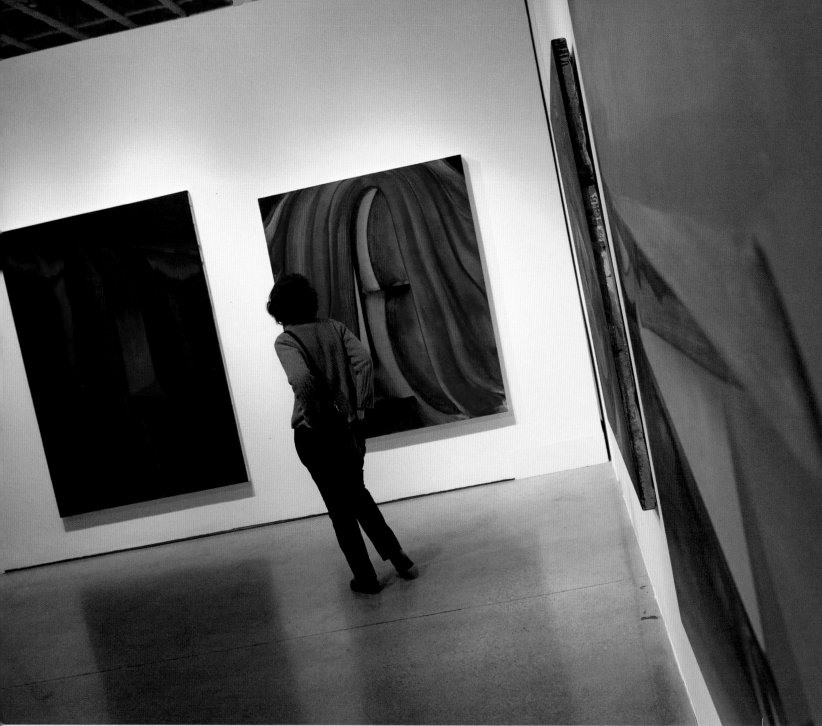

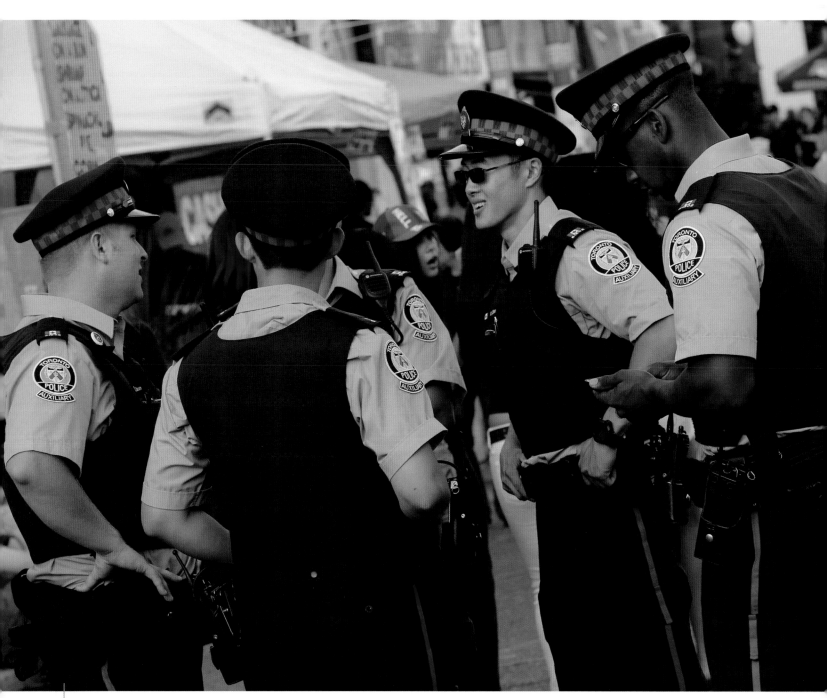

TORONTO'S FINEST ENJOY THE TASTE OF THE DANFORTH STREET FESTIVAL

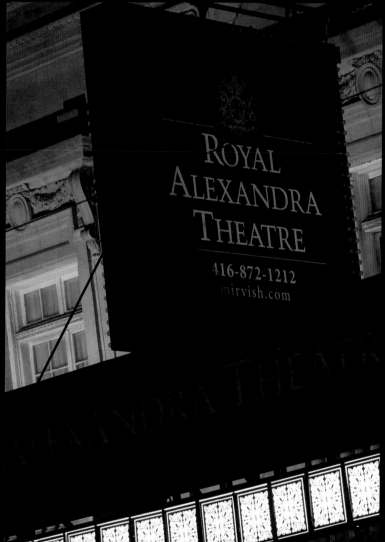

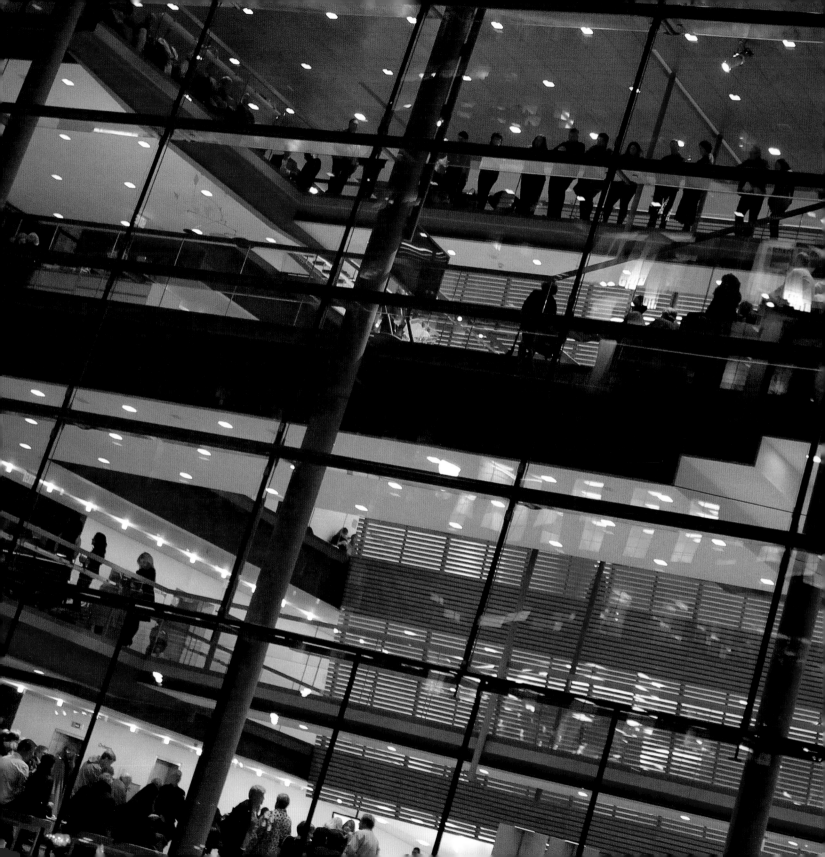

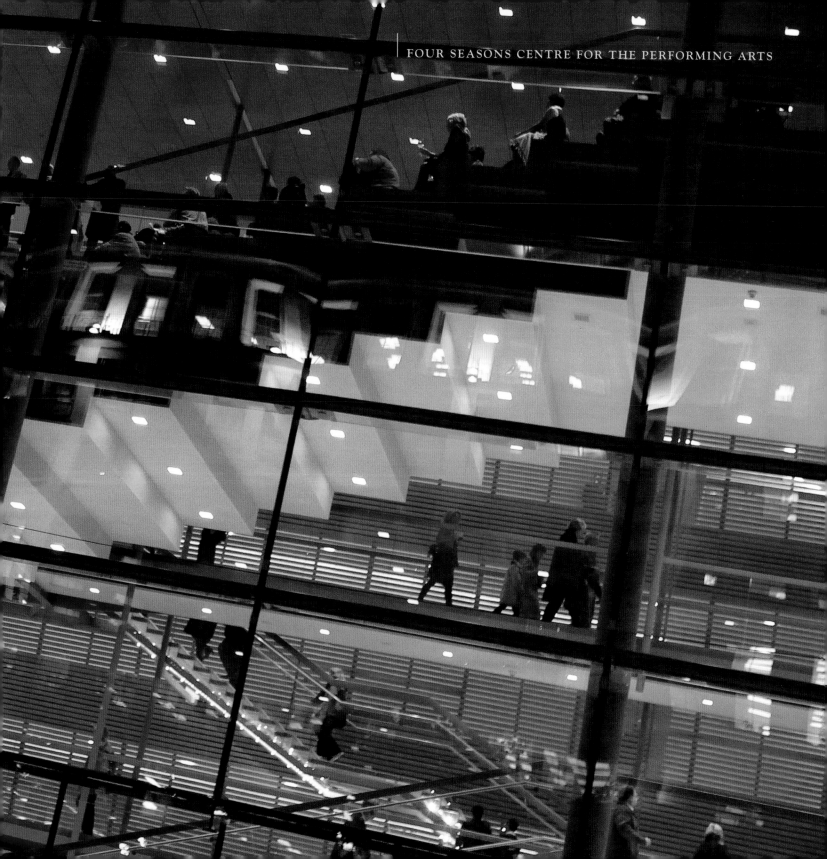

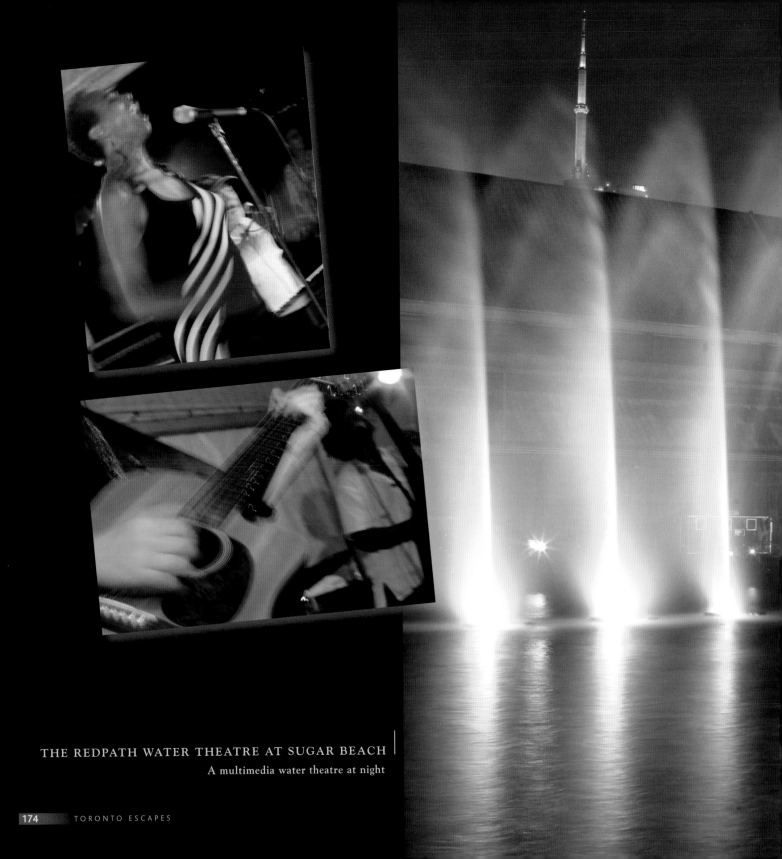

THE REDPATH WATER THEATRE AT SUGAR BEACH

A multimedia water theatre at night

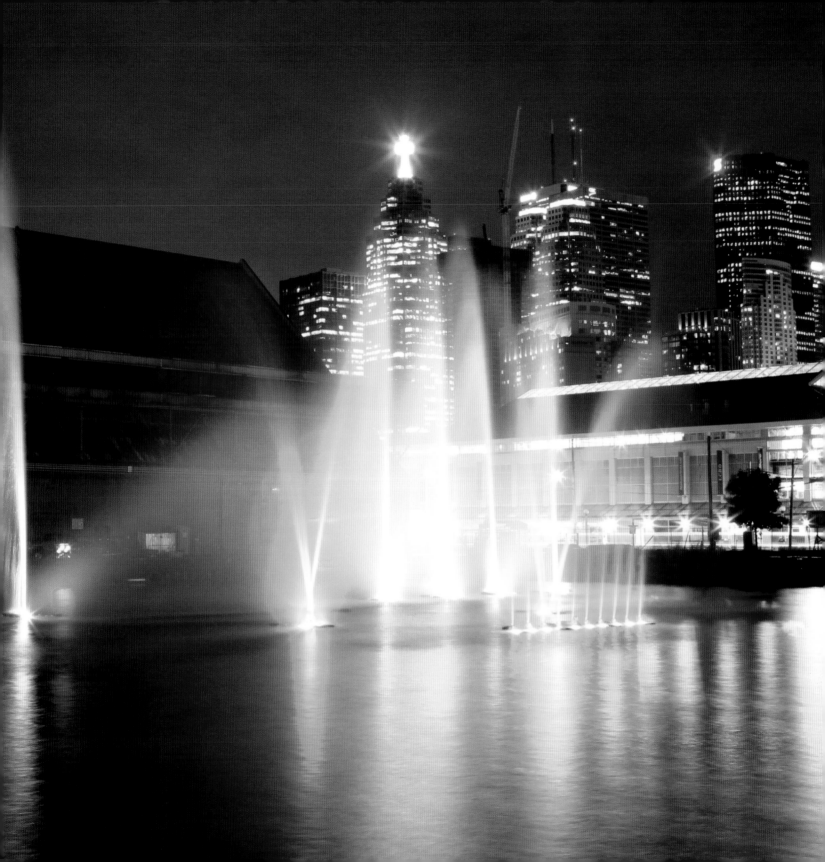

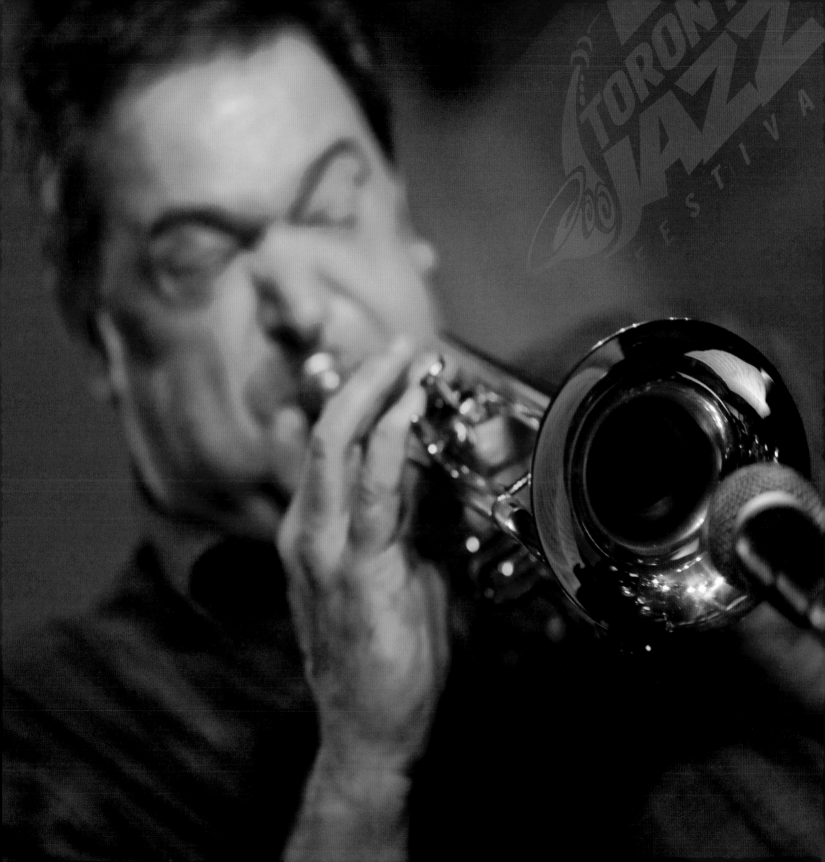

THE JAZZ
FESTIVAL
at the Rex

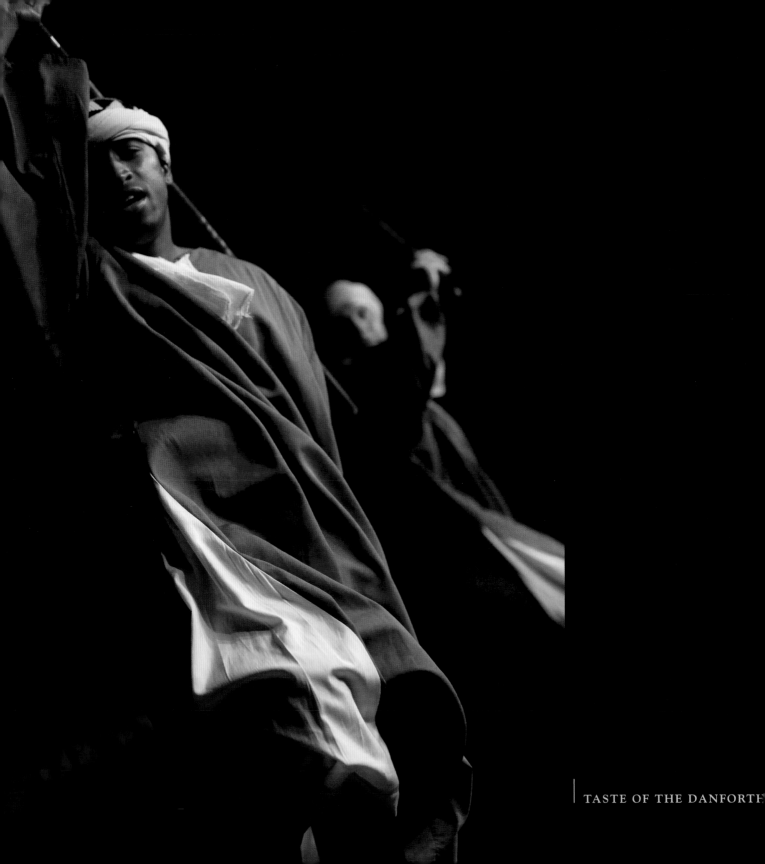

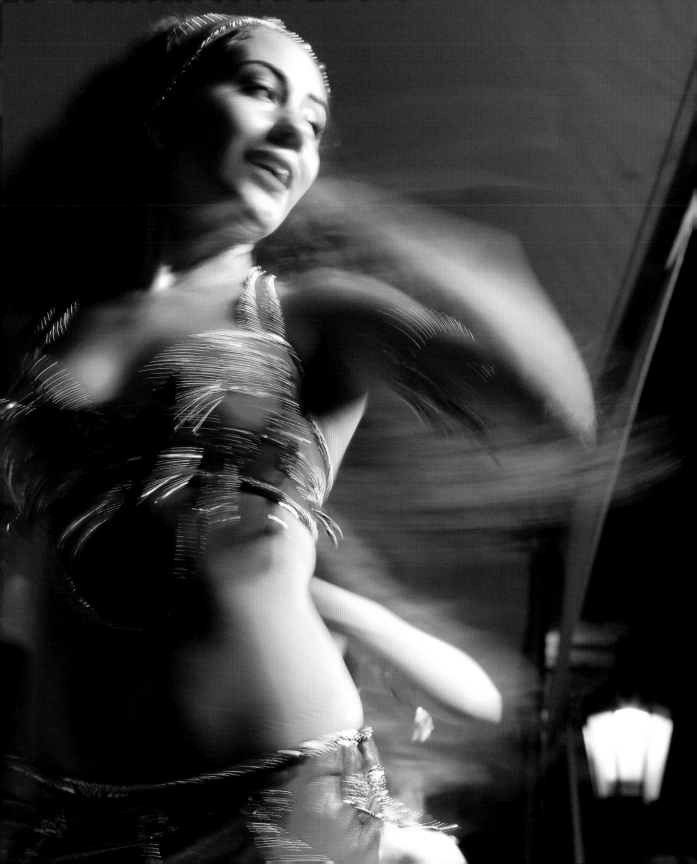

THE SCOTIABANK CARIBBEAN CARNIVAL

better known as Caribana

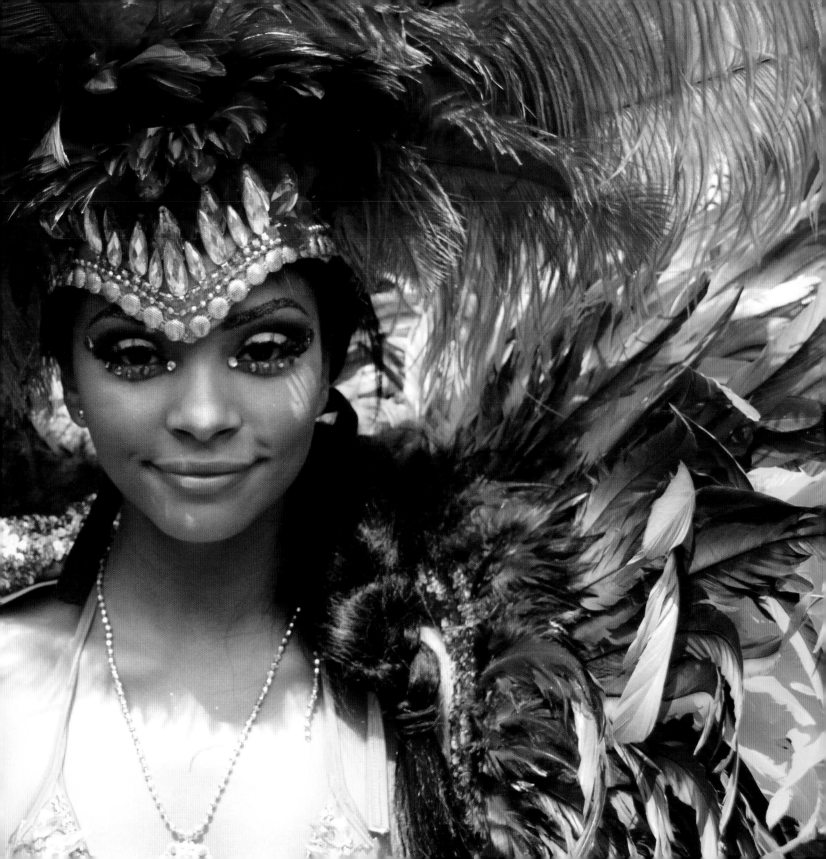

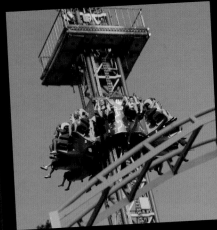

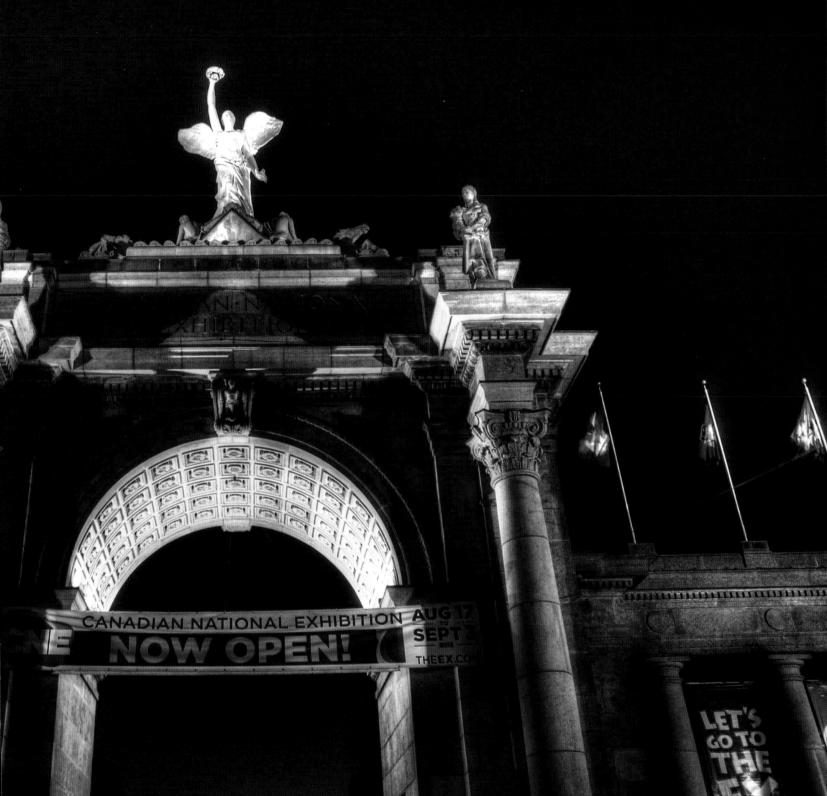

CANADIAN NATIONAL EXHIBITION – CNE

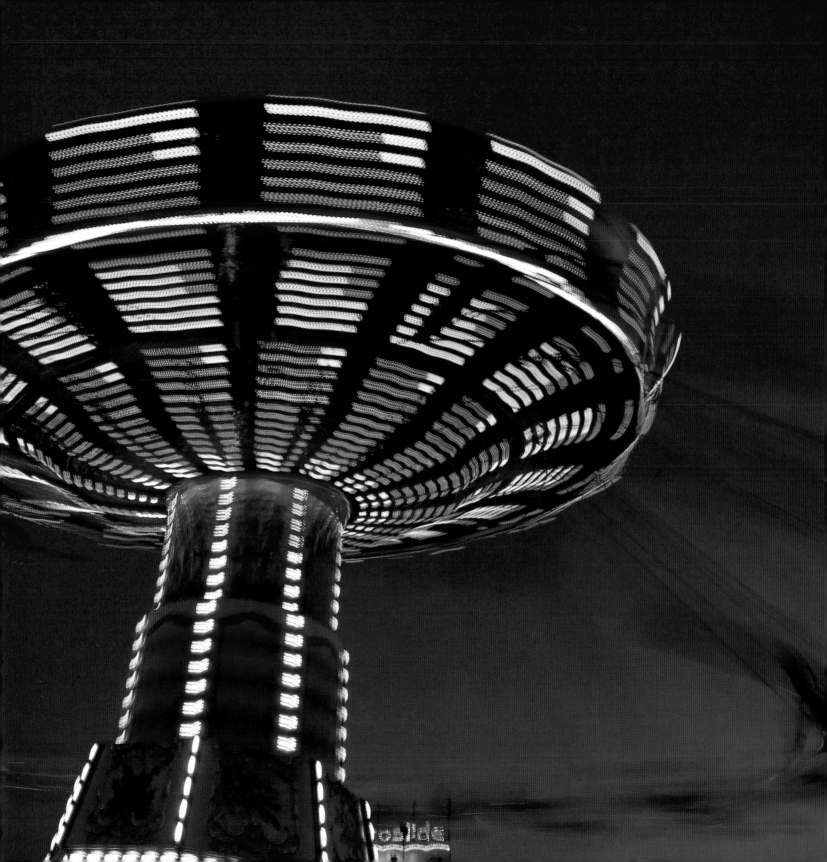

THE LAST CROP OF THE SEASON TO REACH THE FARMERS' MARKETS

DON VALLEY BRICK WORKS

aka Evergreen Brick Works

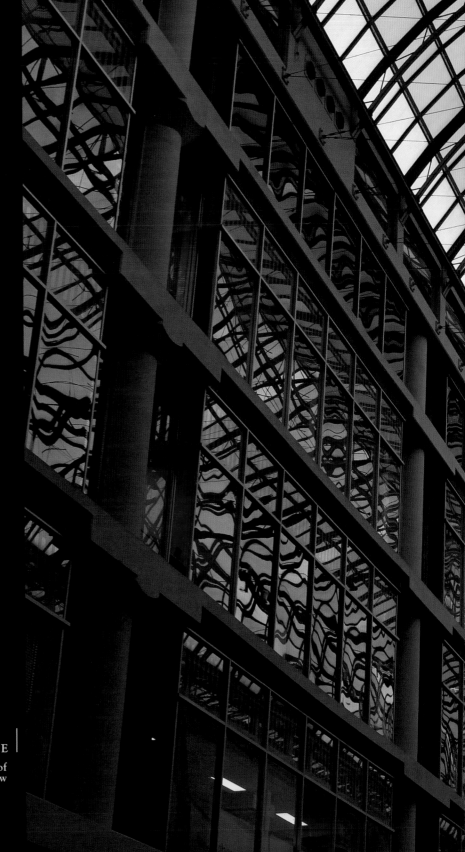

THE EATON CENTRE

The glass-domed galleria features a mobile of Canada Geese, Flight Stop, by Michael Snow

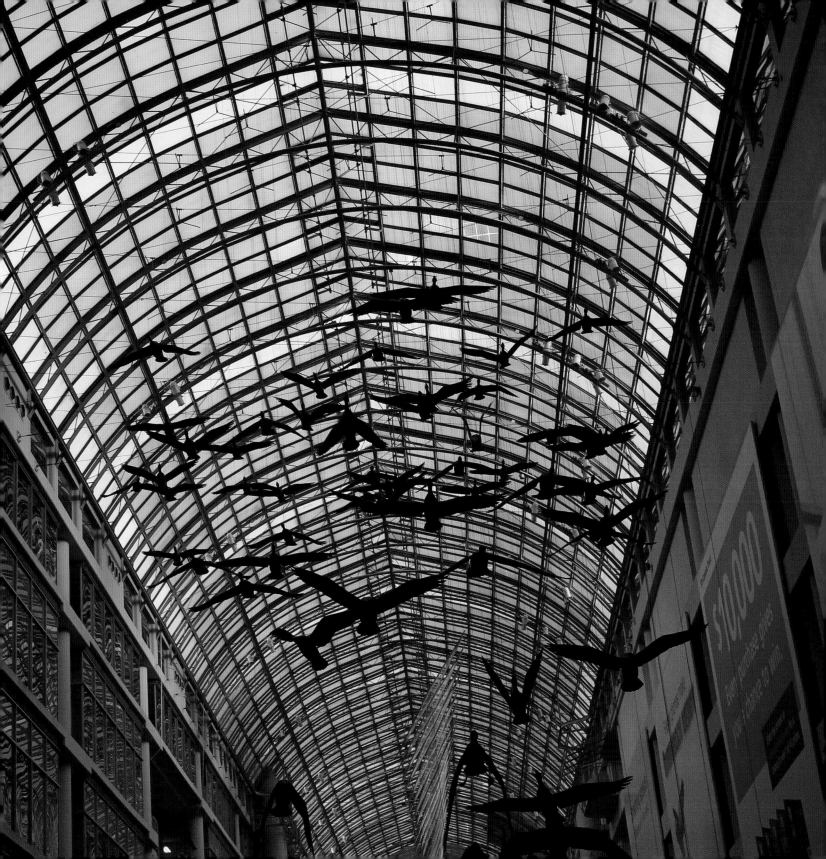

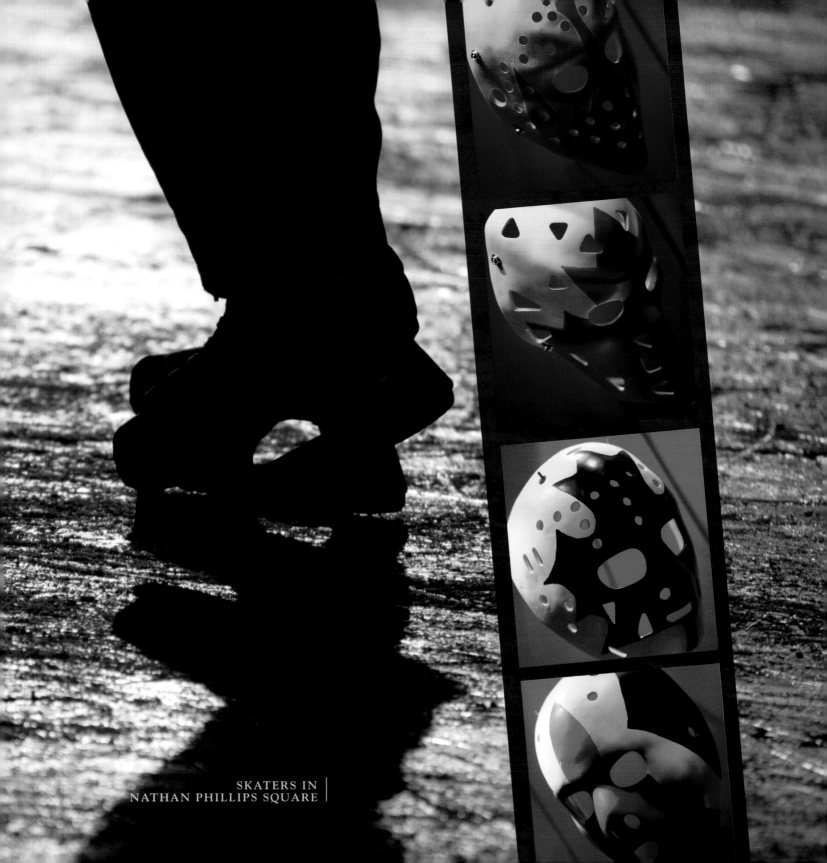

SKATERS IN
NATHAN PHILLIPS SQUARE

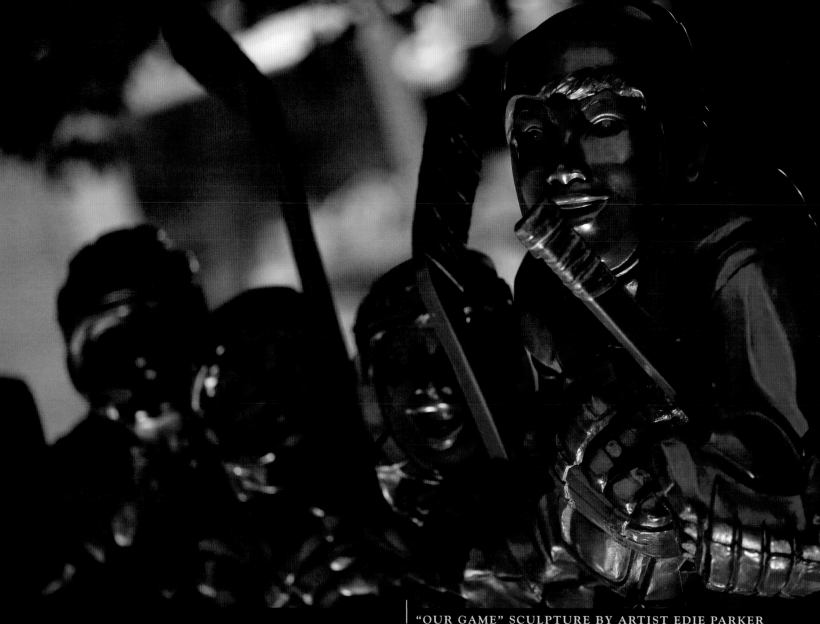

"OUR GAME" SCULPTURE BY ARTIST EDIE PARKER
The most photographed icon in Toronto after the CN Tower

SPIRIT of HOCKEY

VINTAGE MASKS
Mask Column, The Hockey Hall of Fame

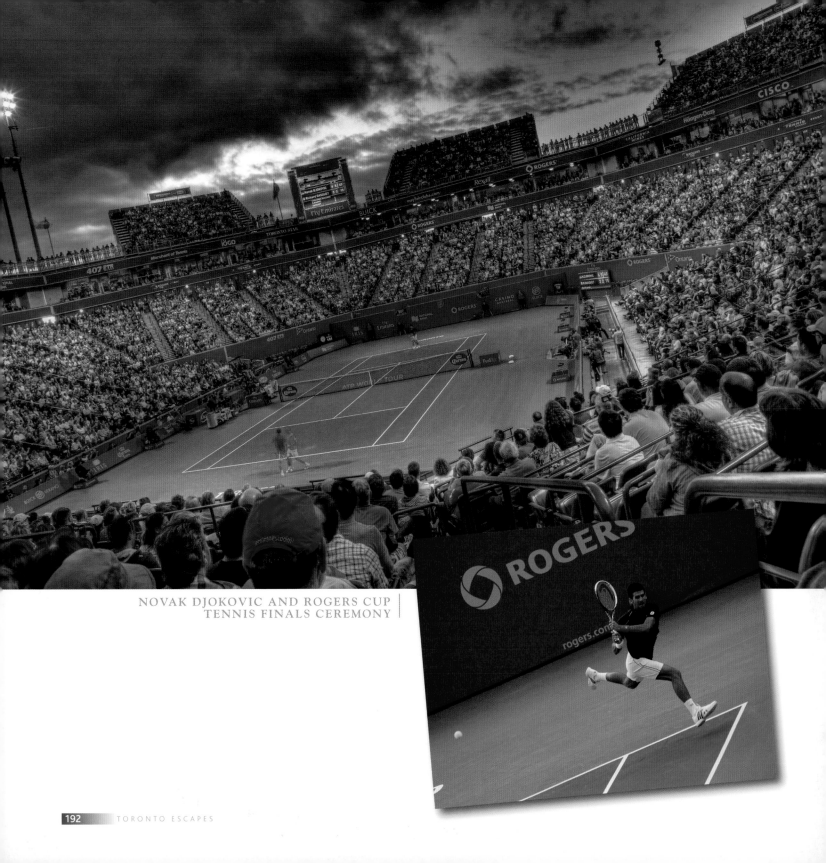

NOVAK DJOKOVIC AND ROGERS CUP
TENNIS FINALS CEREMONY

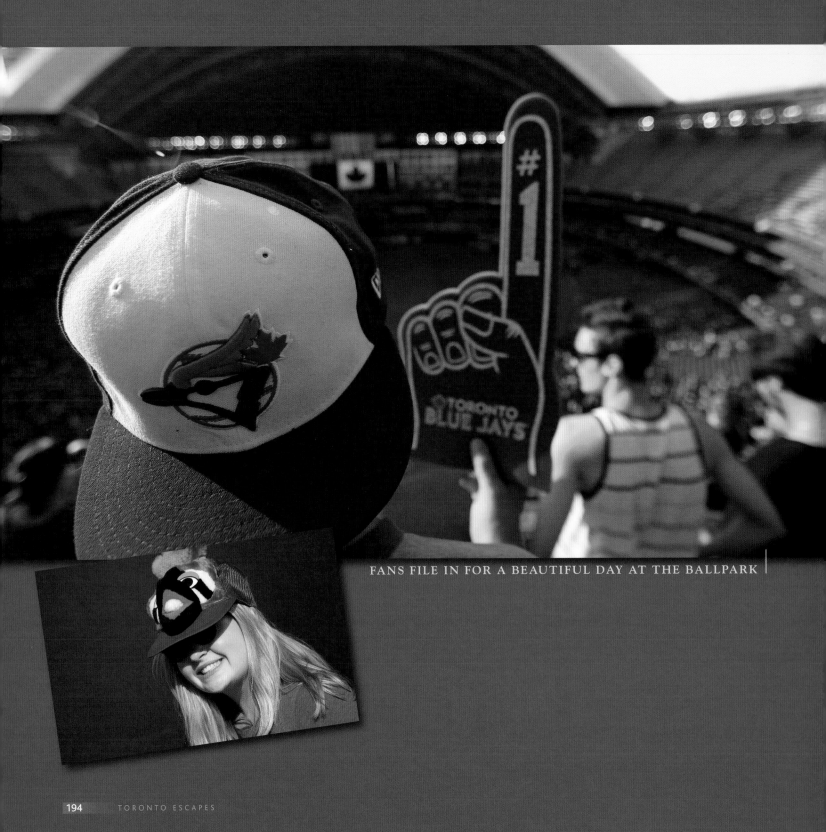

FANS FILE IN FOR A BEAUTIFUL DAY AT THE BALLPARK

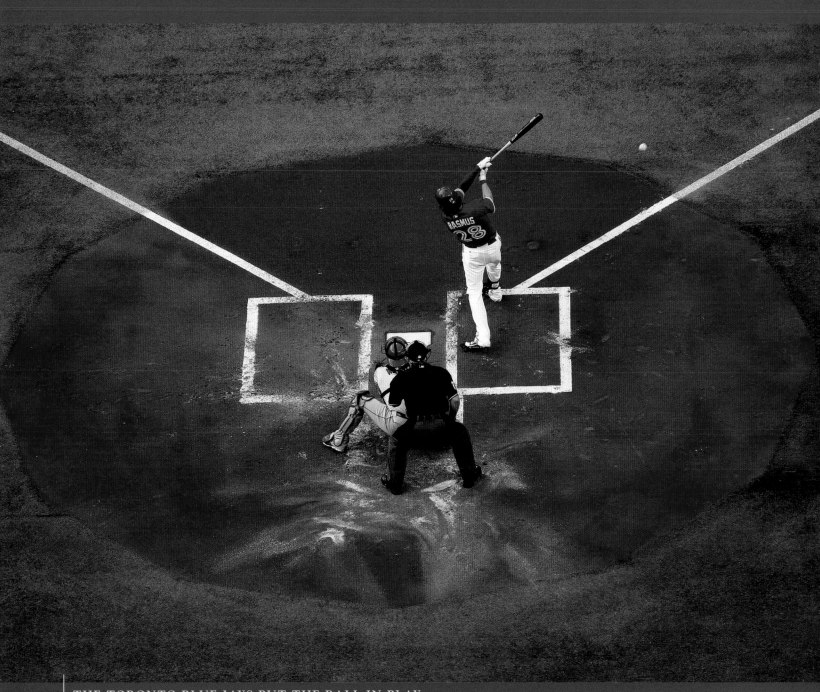

THE TORONTO BLUE JAYS PUT THE BALL IN PLAY

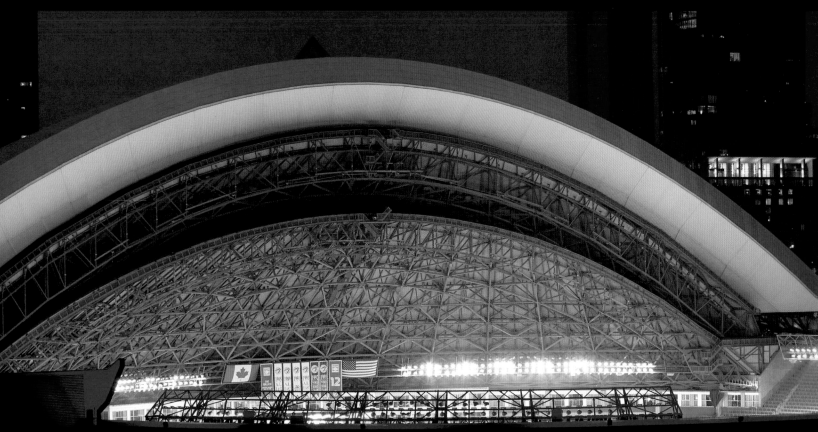

ROGERS CENTRE

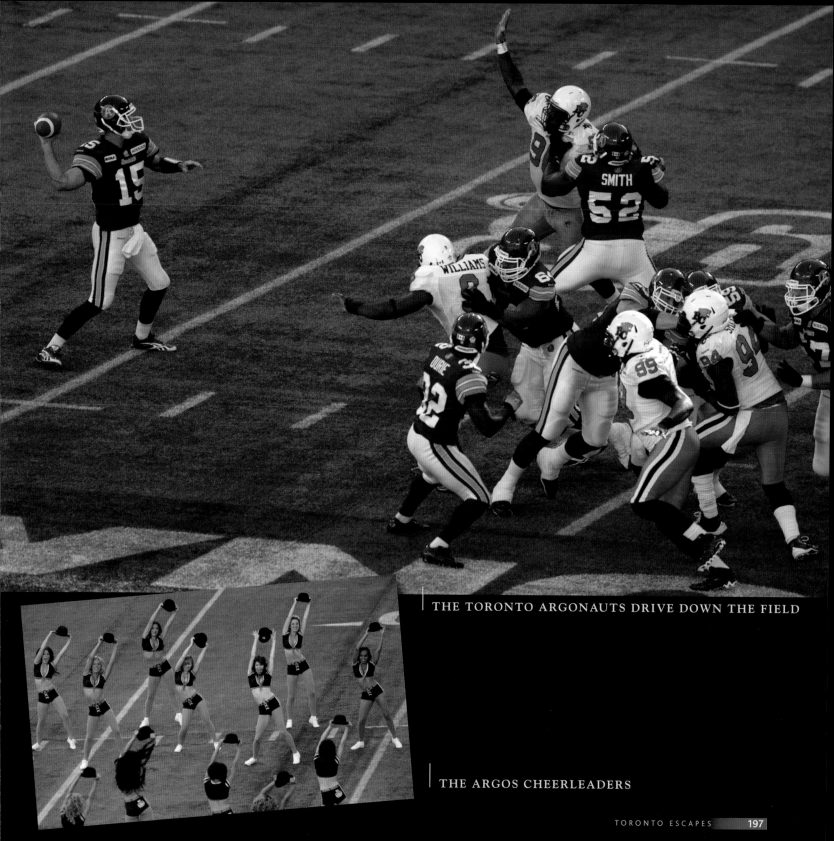

THE TORONTO ARGONAUTS DRIVE DOWN THE FIELD

THE ARGOS CHEERLEADERS

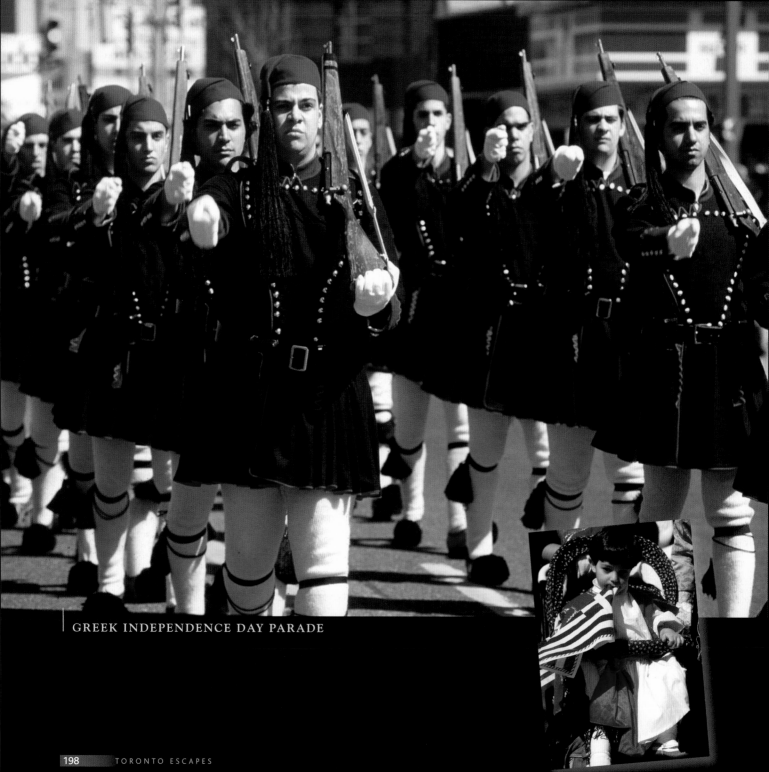

GREEK INDEPENDENCE DAY PARADE

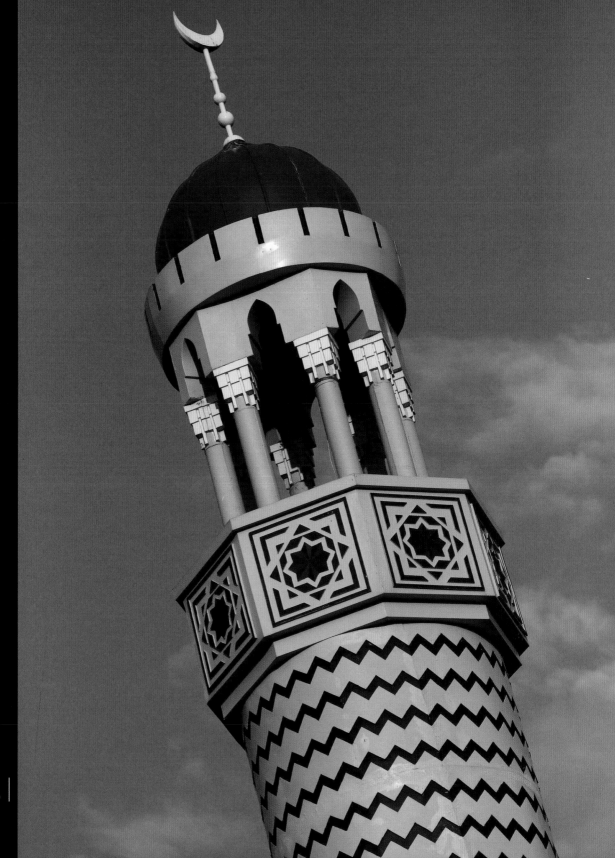

ADINA MASJID

'HOT SPOTS' FOR ENTERTAINMENT AND CLUBBING

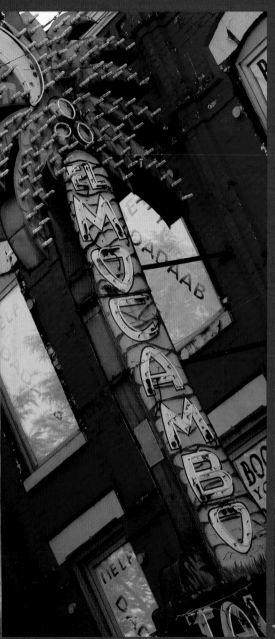

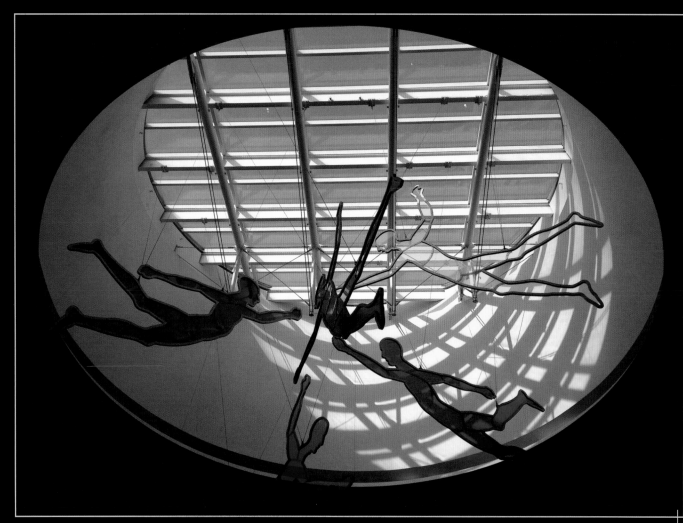

"I DREAMED I COULD FLY" 2003, SCULPTURE BY JONATHAN BOROFSKY
Toronto Pearson International Airport

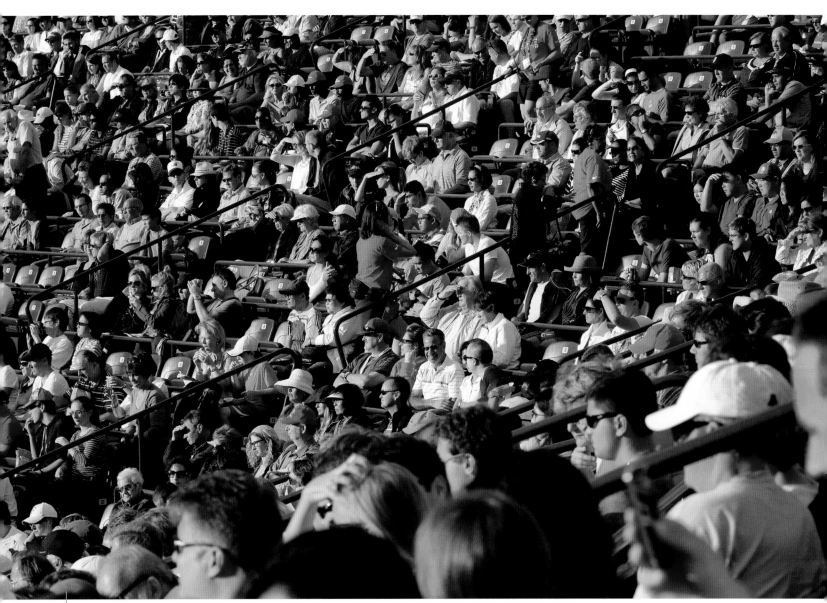

FANS AT THE ROGERS CENTRE

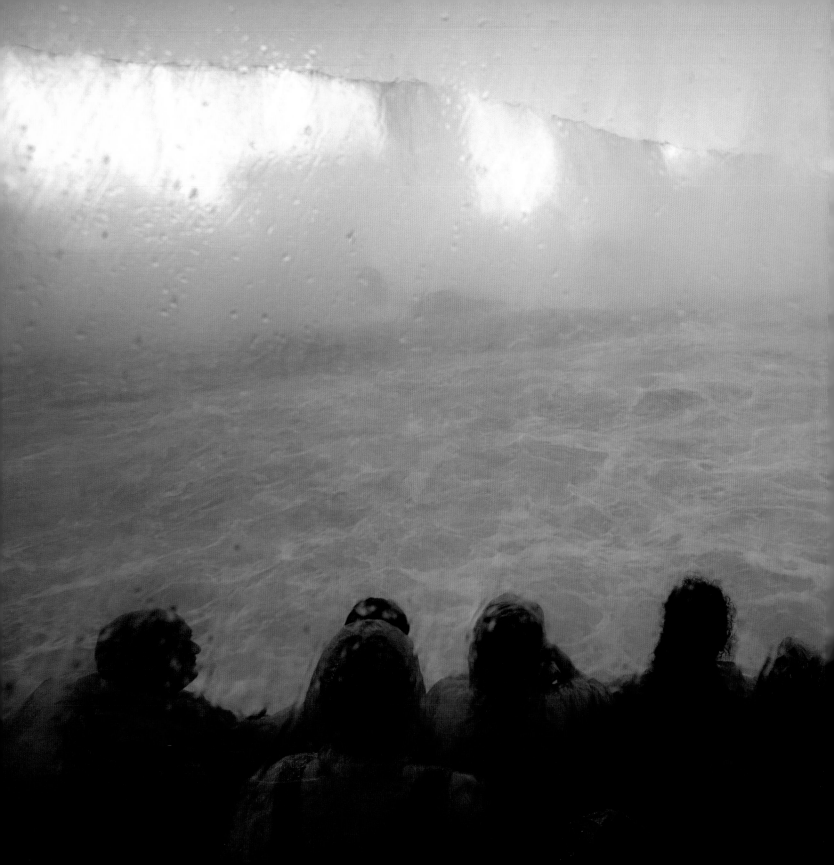

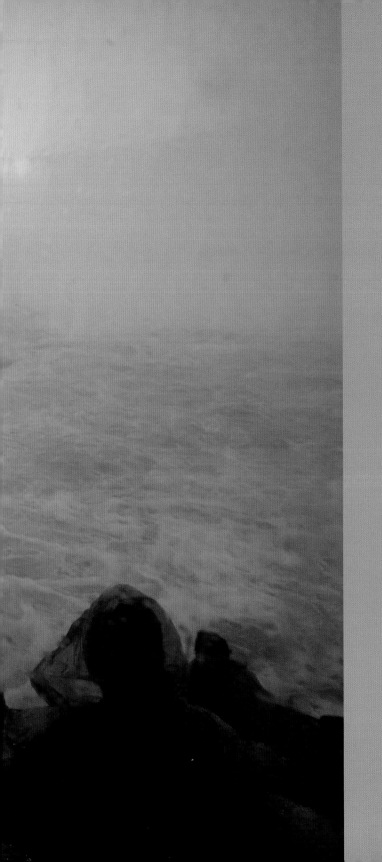

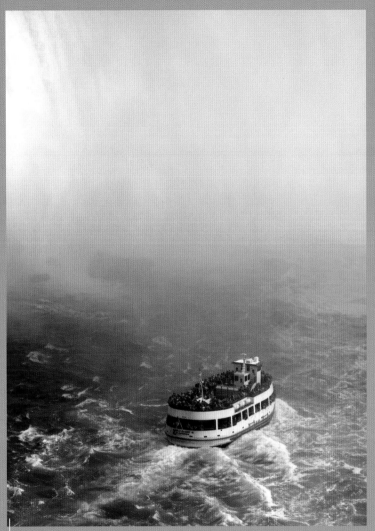

ABOARD THE MAID OF THE MIST

Niagara Falls

ASHBRIDGE'S BAY PARK

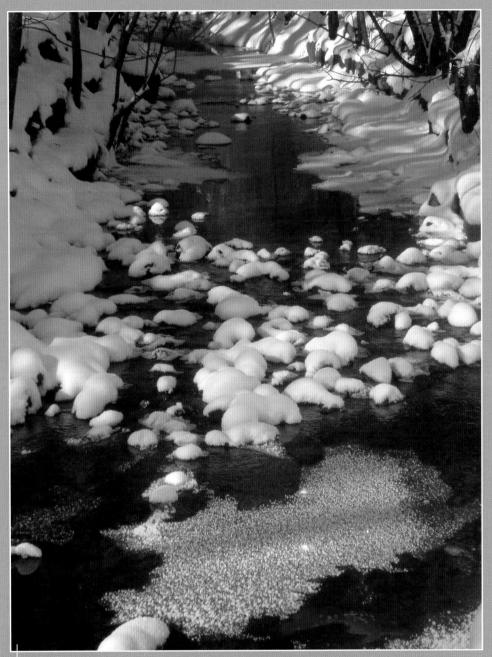

THE DON RIVER

This river watershed is 38-kilometers long
and is one of the most urbanized in Canada

LAKE ONTARIO FALL COLOUR

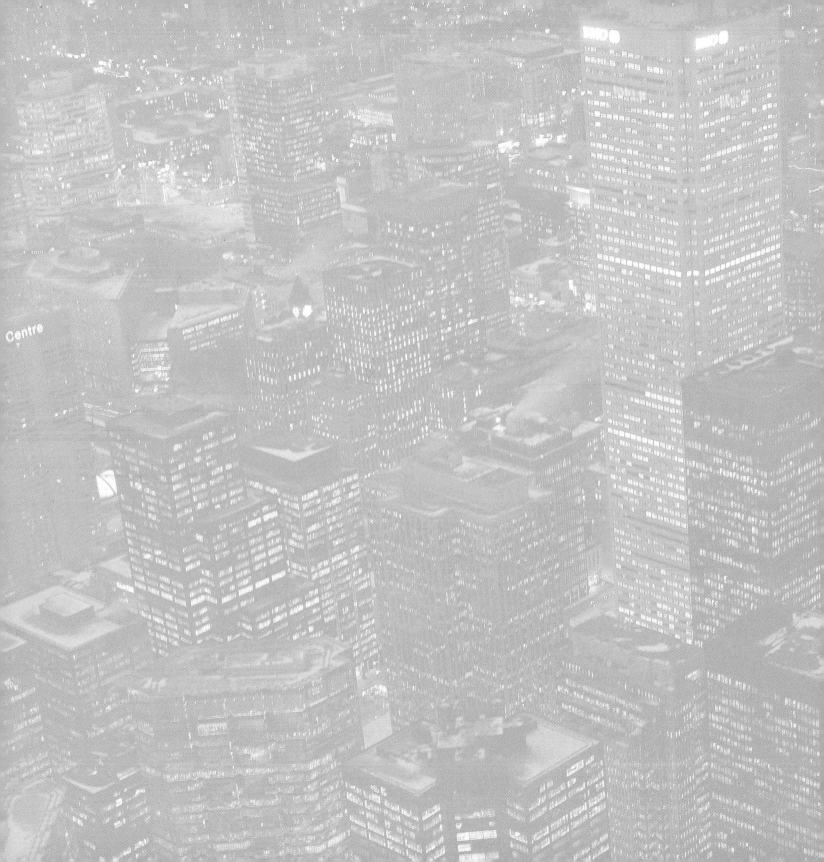